Bits and Pieces

Bits and Pieces

Screening Animal Life and Death

Sarah O'Brien

UNIVERSITY OF MICHIGAN PRESS
ANN ARBOR

Published in the United States of America by the
University of Michigan Press
Manufactured in the United States of America
Printed on acid-free paper
First published July 2023

A CIP catalog record for this book is available from the British Library.

Library of Congress Cataloging-in-Publication Data

Names: O'Brien, Sarah, 1982– author.
Title: Bits and pieces : screening animal life and death / Sarah O'Brien.
Other titles: Screening animal life and death
Description: Ann Arbor : University of Michigan Press, [2023] | Includes filmography
 (pages 161–164, 187), bibliographical references and index.
Identifiers: LCCN 2023003042 | ISBN 9780472076253 (hardcover) | ISBN 9780472056255
 (paperback) | ISBN 9780472903573 (ebook other)
Subjects: LCSH: Animals in motion pictures. | Animal welfare. | Animals—Social
 aspects. | Animal rights. | Violence in motion pictures. | Documentary films—
 History and criticism. | BISAC: PERFORMING ARTS / Film / General | ART /
 Subjects & Themes / Plants & Animals
Classification: LCC PN1995.9.A5 O27 2023 | DDC 791.43/662—dc23/eng/20230406
LC record available at https://lccn.loc.gov/2023003042

DOI: https://doi.org/10.3998/mpub.12042218

The University of Michigan Press's open access publishing program is made possible
thanks to additional funding from the University of Michigan Office of the Provost and
the generous support of contributing libraries.

Cover: Photograph © Louis De Belle, from the series "Failed Dioramas" (2015).
Courtesy of the artist.

For Terry, Freddy, Tricks, and Abby

Contents

Digital materials related to this title can be found on
the Fulcrum platform via the following citable URL:
https://doi.org/10.3998/mpub.12042218

Illustrations

Acknowledgments

This book was written in bits and pieces in apartments, libraries, and coffee shops in Toronto, Atlanta, Charlottesville, and Atlanta again. It would doubtless have remained a heap of enigmatic fragments were it not for the sharp insights and unwavering encouragement of my colleagues, friends, and family.

This book wouldn't exist in any form without Eva-Lynn Jagoe, who made me so damn excited to talk about books and movies from my first day of grad school, and who stuck around as a careful reader and friend long after she was obligated to do so as my dissertation adviser. Corinn Columpar and Jennifer Fay also strongly shaped this book (and my professional trajectory) through feedback that was as challenging as it was kind.

The people and resources of several institutions left their marks on this book. I was surrounded by dazzlingly smart professors and peers at the University of Toronto, particularly at the Centre for Comparative Literature. Seminars with Eric Cazdyn, Angela Cozea, Barbara Havercroft, and Sara Salih planted many of the long-germinating seeds of this book. At the Cinema Studies Institute, Charlie Keil reintroduced me to the joy of paying close attention to film form, and James Cahill helped me really, truly understand film theory. At the Jackson Humanities Institute, I had the immense fortune of spending a year talking about images with Tania Ahmad, Eddie Bacal, Stefan Dolgert, David Francis Taylor, and Atsuko Sakaki, among others. At Georgia Institute of Technology, Angela Dalla Vache and Jennifer Hirsch offered professional guidance and opportunities and Christina Colvin, Jennifer Forsthoefel, Dustin Hannum, Anna Ioanes, Lauren Neefe, Eric Rhettberg, Melissa Sexton,

and Clint Stivers were wonderful colleagues and friends. At the University of Virginia, I was surrounded by thoughtful colleagues in the Writing and Rhetoric Program, including Steph Ceraso, Anastatia Curley, devin donovan, T. Kenny Fountain, Lindgren Johnson, Kate Kostelnik, Cory Shaman, Kate Stephenson, and Patricia Sullivan. Alison Levine welcomed me into UVa's film studies community, while Samhita Sunya and Caitlin Wylie helped me carve out time to write semiregularly in their wonderful writing group. Katherine Churchill, my research assistant in the English Department, meticulously collected and prepared the images that appear in this book. Students in my courses in Toronto, Atlanta, and Charlottesville continuously suggested new ways to consider my research.

Many conversations, collaborations, and communities—some sustained, some more fleeting—informed the ideas in this book and kept me working on it. Nigel Rothfels encouraged my first real stab at writing it, and Susan McHugh provided several serendipitously timed nudges to keep going. Nora Gilbert was a wise, friendly mentor. Nicole Shukin was an incredibly generous coauthor, and Michael Lawrence and Laura McMahon's stewardship of the *Animal Life and the Moving Image* volume cemented my sense of the importance of this area of study. At the School of Criticism and Theory, Amy Villarejo gave me sage publishing advice, and I got to spend a summer hanging out with the brilliant Hailey Haffee, Kate Morris, Jonathan Mullins, and Jennifer Spitzer. Jody Berland, Matthew Brower, Robert McKay, Tom Tyler, and the rest of the Digital Animalities research group helped me think across media. I developed this book in presentations at numerous conferences, the most generative of which sparked the first chapter and set in motion the last one: the Taking Animals Apart conference at the University of Wisconsin in 2012 and the Serial Formations: Species, Race, Structure, Screens panel, convened by Ted Geier, at the Society of Cinema and Media Studies meeting in 2019. The ideas in this last chapter were strengthened by feedback from Derek Maus and James Donahue, and part of this chapter appears in their superbly edited collection *Greater Atlanta* (forthcoming, University of Mississippi Press). Laura Portwood-Stacer showed me how to turn book-writing experience into book-editing magic (and back again), and the many authors I've had the pleasure of working with as an editor have inspired me to keep plugging away at my own writing.

The University of Michigan Press made the publication process a joy. Sara Cohen saw promise in this project and helped me put the pieces together. The anonymous peer reviewers gave me perceptive feedback

and invaluable suggestions for revision. Anna Pohlod helped me fix many things at the last minute. Kevin Rennells and the production team made this into a beautiful book.

My friends and family supported me with endless jokes, meals, visits, patience, and love. Myra Bloom, Christy Brozowski, Kevin Driscoll, Ronald Ng, Bradley Rogers, Catherine Schwartz, Lana Swartz, Kay Tappan, Ruthie Yow, and Martin Zeilinger—your friendship means the world to me. Mark O'Brien and Katie Hitt have supported me in everything, always. Laurie O'Brien made me curious about all kinds of stuff, but especially writing and animals. Frederick Nagurney provided the best company I could ask for as I finished writing this book. Terry Nagurney always cooked me dinner and made me laugh, and never let me quit. Thank you all.

Introduction

For those members of the human population with the comparative privilege of being able to shelter in place amid the crushing spread of the zoonotic COVID-19 virus in the early 2020s, daily life has largely been experienced as a recalibration and intensification of screen time: much of white-collar work, education, and the mundane and momentous proceedings of institutional life now filter through an array of videoconferencing platforms and apps, with office and class meetings, court proceedings, medical appointments, therapy sessions, religious gatherings, weddings, funerals, first dates, and fitness classes unfolding on screens that splice participants from disparate places together in neat boxes. Leisure time, if such a thing remains distinguishable from the time of labor, is dominated now more than ever by the constant consumption of popular media. With movie theaters shuttered during the pandemic and then sputtering to reopen, film exhibition networks took screenings and festivals online to safeguard the long-threatened practice of going out to the movies—whether this temporary move will further domesticate cinema in more enduring ways remains to be seen. Meanwhile, the wholesale reconfiguration of television production necessitated by the virus renewed the qualities of intimacy and contingency long celebrated as fundamental to the TV-viewing experience: Trevor Noah, unshaven, delivering his searing *Daily Show* monologues from his couch; a toilet flushing during a live stream of a Supreme Court argument.[1]

Nonhuman animals have been vital, if characteristically unremarked, actors in the pandemic's rapidly shifting media flows. In the early days of the shutdown, videos of wild animals roaming emptied

city streets began to circulate along with live streams of zoo animals newly unencumbered by the disciplining gaze of in-person human visitors, forming what Amanda Hess identifies as the "coronavirus nature genre." In its suggestion that widespread human withdrawal might make space for the regeneration of nature, this new genre seemed to offer a hopeful respite from the mounting death tolls crawling across 24/7 news channels. And it offered new forms of tele-intimacy. Of course, as Hess points out, the genre "rest[s] on total human exile. It is not a pastoral vision; it's a post-apocalyptic one."[2] In this particular post-apocalyptic world, human life persists but only because it is walled into homes, kept behind screens, and afforded a "socially distant" surveilling gaze.[3] This mode of survival is, of course, only available to a select group of humans with the material resources, family supports, and employment structures required to sustain prolonged at-home viewership; the various forms of remote broadcasting adopted during the pandemic address an "imagined community" that, as Laurie Ouellette puts it, "excludes . . . people who don't have time to watch TV because they are delivering groceries, or they're essential employees, or they don't have a stable home—they're not part of this self-quarantined population."[4]

Adjacent to the coronavirus nature genre are media featuring humans and animals cohabitating before and during the pandemic. The pandemic was a boon for animal rescues, as many people seized on their newfound abundance of time at home to foster or adopt pets.[5] *Tiger King*, a Netflix docuseries that luridly details a violent feud between zookeepers who are far more charismatic than the mega-cats languishing in their keep, became a breakout shared text of the early quarantine, spinning out memes and infiltrating other media such as *Animal Crossing: New Horizons*, a Nintendo Switch game that seized popular attention by inviting users to simulate living, socializing, and bartering in a "raccoon economy" on personal islands that they can remake into virtual homes. The pandemic's transformation of domestic screening practices has produced "new expressions of the deathscape" (digitally broadcast funerals, drone footage of mass burial) that allow death and dead bodies, long exiled from the home under modern public funerary practices, to reenter domestic space through platforms designed for entertainment and workplace collaboration.[6] The quotidian rhythms of *Animal Crossing* have extended to encompass new rituals around death: at least one funeral has been hosted virtually in *Animal Crossing*, for a gamer who died of complications related to COVID-19, and many users customize their vir-

tual space to include tombstones (a "craftable object" within the game) memorializing lost loved ones.[7]

As time wears on, these outwardly more comforting narratives and mediations of the coronavirus have been joined by reports and images of animals—real, material animals and metaphorical animals—that underscore the inequalities churning beneath the pandemic's decimating effects on people of color, the working class, the elderly, and other marginalized communities. Along with nursing homes and prisons, slaughterhouses immediately emerged as the deadliest incubators of the virus. Dozens of the largest meatpacking plants shuttered in March 2020, leading to breakdowns in supply chains and the extermination of millions of animals that could no longer be sold as meat, even as lines at food banks stretched ever longer; President Trump quickly ordered slaughterhouses to remain open under the Defense Production Act, yet federal and state governments provided little direction to protect workers amid the stifling conditions of meatpacking production lines.[8] The industry's rapid return to business as usual attests to the lack of value it places on the lives of its predominantly immigrant human workers and the singularly economic value it places on animal lives. This story's short life-span in the twenty-four-hour news cycle is in keeping with mainstream media's unwillingness to pay sustained attention to the meat industry.

In the early afternoon of Memorial Day, 2020, the "first domino" fell in a sequence of events that would set off protests against systemic racism, and particularly racist policing, on a scale not seen since the 1960s: cell-phone footage began circulating online of an encounter between Chris Cooper, an African American man out birding in New York's Central Park, and Amy Cooper, a white woman so incensed by his request that she leash her dog that she called the police to report an "African American man . . . threatening me," a false accusation that, given the realities of rampant police violence against African American men, endangered his life.[9] Hours later, in Minneapolis, an African American man named George Floyd was accused of using a counterfeit $20 bill to buy cigarettes. One of the police officers called to the scene, a white man named Derek Chauvin, held his knee to Floyd's neck for eight minutes and forty-six seconds, killing him. The ensuing protests—which would grow to an international scale and be sustained well into the summer of 2020—initially took a destructive turn, with flames fanned by more police violence. President Trump threatened that the Secret Service would sic "the most vicious dogs" on protesters outside the White House.[10] In a speech urging peaceful protest, the rapper and activist Killer Mike pro-

claimed that Floyd "died like a zebra in the clutch of a lion's jaw, and we watch it like murder porn, over and over again."[11] Less than two weeks later, on June 12, Rayshard Brooks, an African American man who had fallen asleep in his car in a Wendy's drive-thru in Killer Mike's city of Atlanta, was shot and killed by a white police officer called to the scene. Documentary footage filmed several months earlier surfaced of Brooks reflecting on his experiences with the criminal justice system: "Look at us as individuals. We do have lives, you know—it's just a mistake we made . . . and not just do us as if we are animals."[12]

Unfolding in several months of "unprecedented" change, these fragments call attention to the ways in which film and television make animal life and death visible, accessible, and consumable—and how these processes of meaning-making inflect the mattering of human life and death. Concentrated as they are in domestic spaces, the pandemic's media flows condense and bring to the surface this book's interest in the cultural, material, and historical processes through which moving images define the boundaries of the home and establish who and what does and does not belong within it. These flows and their domestic interfaces literalize John David Rhodes's observation that "houses are built to be lived in, but also to be looked at."[13] Rhodes makes this point in reference to cinematic spectatorship, particularly the increasingly endangered form of it that takes place in public theaters, yet it applies as well (if not even more aptly) to television, a medium inseparable from the home in its material presence and representational content. The widespread (which is not to say even) shift to videoconferencing platforms in 2020 recasts the home as a new kind of televisual/televised space, making our own houses and those of coworkers, friends, classmates, expert talking heads, media personalities, and celebrities "to-be-looked-at." "Zoom is now television," Amelie Hastie observes, and this means "we're moving between homes in these really strange ways, which is very much of television's liveness, its presence, and its domestic space as well."[14] This reordering of domestic space as screening space throws into relief long-standing understandings of film and television spectatorship as experiences marked by the sense of "being alone, together."[15] Inspiring at once a sense of intimacy with strangers and seclusion from the outside world, the screening practices that emerged from shelter-at-home orders, Lynne Joyrich asserts, simultaneously bring us together and keep us apart: "We are offered a screen that opens out seemingly to everything, even as this is all, precisely, screened and thus as obscuring as it is clarifying."[16]

Bits and Pieces explores how film and television screen animal life and

death. Film scholars have compellingly demonstrated that cinema possesses distinct capacities to both make visible and obscure our knowledge of and relationships with animals.[17] I expand this line of inquiry and analysis by examining how film and television simultaneously expose and disavow the routinized killing of animals—a duality borne out in the pandemic's media flows. This book argues for an understanding of cinema and television as media that collect, domesticate, and facilitate the consumption of animals. It gathers pivotal and more mundane moments, dispersed across a predominantly Western history of moving images, in which animals materialize in—often only to be violently expunged from—movies and TV shows, from iconic scenes of cattle slaughter in early Soviet montage to quandaries over hunting trophies in recent home-renovation reality TV series. By carefully (re)viewing these fragments in dialogue with germinal texts at the intersection of animal studies, film and television studies, and cultural studies, I foreground the capacity of moving images to unsettle the ways in which audiences have become habituated to viewing animal life and death on screens, and, more importantly, to understanding these images as more and less connected to the "production for consumption" of animals that, following Jacques Derrida, is specific to modern industrialization and the "*unprecedented* proportions of [its] subjection of the animal."[18] The book begins from the belief that the prevailing values ascribed to animals—particularly to animal bodies regarded as consumable material—in contemporary Western societies urgently demand rethinking. Moving images have already begun to shape this transformation in substantial ways. By looking back at films and TV series in which the places and practices of killing and keeping animals enter, occupy, or slip from the foreground, this book takes seriously the idea that cinema and television have the capacity not only to catch but to challenge and even to change viewers' regard for animals.

Fundamentally a project of media history, *Bits and Pieces* considers how audiovisual media nest together and enfold ways of looking at animals. My comparative media approach allows me to cast a wide net for images of animals and to look beyond the nature/wildlife programming that has thus far driven much scholarly discussion, particularly of television and animals. I attend more broadly to media and media histories that are grounded in the mode of the *tour* and bound by more and less explicit forms of *touristic vision*: tours of slaughterhouses, pamphlets that guide them, and documentary films that reprise them; televisual tours of city spaces and of renovated homes featuring taxidermy and other

animal curios; advertisements that tout audiovisual media's provision of armchair tourism. Defined by the *Oxford English Dictionary Online* simply as a "manner of presenting or exhibiting anything," a "tour" is more precisely a kind of mobile view that, in appealing to uninitiated viewers, purports transparency yet, by dint of its careful selection and sequencing of elements on display, can never achieve a totalizing view.[19] Tours are thus affined with glass windows (indeed many tours occur behind glass windows) in that they function as both "aperture and frame."[20] In their cinematic and televisual forms, tours are exemplary screening media. The subtitle of this book, *Screening Animal Life and Death*, invokes this duality.

Touristic media overlap with what Salomé Aguilera Skvirsky has recently theorized and historicized as the *process genre*, a way of representing processes characterized by a distinctively sequential syntax, a focus on depicting human and/or machine labor ("capaciously understood"), and the production of absorptive wonder in the spectator, along with a sense of having acquired "knowledge about the world."[21] Although the process genre appears across durational media, it is fundamentally a "ciné-genre" given "the medium's constitutive capacity to visually and analytically decompose movement and to curate its recomposition."[22] Much of my formal analysis in *Bits and Pieces* focuses on the strategies or "sites of curation" that attract Skvirsky to representations of process (namely, editing and framing), and my attention frequently lands on the filmic modes or genres (industrial, educational, and ethnographic film, as well as heist movies); paradigmatic films (Charlie Chaplin's *Modern Times*, Frederick Wiseman's *Meat*); and film historical contexts (Eadweard Muybridge's chronophotography) that are central to Skvirsky's book *The Process Genre*.[23] My perspective diverges from Skvirsky's in that, whereas she is interested in representations of process insofar as they disclose "*how* it is done," I am equally if not more concerned with how such representations reveal *what* is done.[24] "Touristic media" designates a category of representation that is marked by a deictic quality of exhibition. In the films and TV series that I discuss, the *what* being pointed to is the routinized killing of animals and the reliance on dead animal bodies for the millions of mundane acts of consumption that structure our lives; understanding *how* these media make these acts visible is important, but so too is renewing our perception of *what* is being killed and consumed. Thus, where Skvirsky is drawn to the process genre as an "*aesthetic of labor*" that produces fascination and even mesmerism, I am interested in touristic media as fronting an *aesthetic of consumption* (itself a form

of labor) that generates not just rapt attention but also affects like horror, surprise, shock, revulsion, and disgust.[25] What interests me about the tour is its capacity to break down or turn in a different direction, thus producing unanticipated affects and effects. As Skvirsky suggests in her epilogue, "The Spoof That Proves the Rule," the value of analyzing generic conventions lies in grasping the potential afforded by deviations from them. *Bits and Pieces* aims, in this spirit, to discern deviations, digressions, failures, and interruptions to more and less conventional touristic views of various processes of breaking down and reconstituting animal bodies as material for human consumption.

As a narrative mode of visual presentation/exhibition that crosses genres, the tour is crucial to my study because it links representational strategies with material practices. Throughout *Bits and Pieces*, my comparative media approach moves between close textual analysis that is attuned to issues of representation, and a consideration of the ways in which film and television connect with two technologies of animal disassembly and reassembly that bring animals into our homes: industrial slaughter and taxidermy, respectively.

Cinema and slaughter operate along uncannily similar trajectories: the kill floor and packing lines of modern slaughterhouses mechanically break down animal bodies and repackage them as consumable flesh, whereas movies disassemble the profilmic world into discrete shots and reassemble these bits and pieces—or "blocks of reality," to use Christian Metz's turn of phrase—into more and less coherent narratives.[26] Chapters 1 and 2 of this book interrogate the formal repercussions of film's easy alignment with the linear logics of industrial animal "processing." In a move that accentuates this symmetry, in chapter 1 I introduce the term *slaughter cinema* to claim a capacious category of films that are—and are not—"about" the places and practices of animal slaughter. This act of reclassification discloses the remarkable intensity with which indexical images of animal slaughter figure in the history of cinema; urges a rethinking of the genres that typically enclose animals on screen; and invites consideration of the potential of a heterogeneous body of films to (re)shape audience's relationships to the practices and products of slaughter. Centered on a sustained reading of a sequence in Dziga Vertov's *Kinoglaz* (*Kino-Eye*, Soviet Union, 1924) that uses reverse-motion to reanimate a slaughtered bull, this chapter introduces my investment in re-viewing texts and practices that implicate the killing of animals, and initiates the book's ongoing exploration of how formal strategies and viewing practices can unsettle habitual modes of viewing animal life and

death on screen. The chapter concludes by reviewing the nineteenth-century practice of slaughterhouse tourism, which Nicole Shukin recognizes as "one of North America's first 'moving pictures'" insofar as these remarkably popular tours capitalized on the thrilling view of "animals hoisted onto moving overhead tracks and sped down the disassembly line."[27] This discussion establishes a historical framework for understanding the tensions between distance and proximity, as well as invisibility and visibility, that structure slaughter cinema.

In the twentieth century, cinema increasingly took up the pedagogic, entertainment, and consumerist functions initially articulated by slaughterhouse tours, as well as the expository mandate of political documentaries. Chapter 2 examines films that take differing approaches to documenting industrial slaughterhouses. Titled "Glass Walls," the chapter calls into question the faith in the galvanizing power of transparency and shocking revelation that characterizes dominant approaches to documenting industrial animal slaughter, not only because this approach presumes a benighted public whose enlightenment will translate directly into changed habits of consumption, but because its performance of apocalyptic rhetoric (it is frequently framed as unveiling) presents slaughter as disconnected from daily life. Through comparative analysis of *This Is Hormel* (F. R. Furtney, US, 1965), the Hormel Corporation's educational tour of its Austin, Minnesota, meatpacking plant, and *American Dream* (Barbara Kopple, US, 1990), a cinéma vérité look at a union strike at the same facility, I extend Jonathan Burt's critique of what he calls a "slaughterhouse aesthetic"—a set of cinematographic and editing conventions that disconnect slaughter from daily life and disassociate the spectator from the slaughtered animal body.[28] My reading of these films attests to the power of these conventions to shape films with very different messages, yet also suggests that they hold a productive critical potential insofar as they are open to deviation.

To the mechanical movement of slaughter's production lines and the fluid unfolding of the film strip, taxidermy and television present as forms of heterogeneous collection and flow. Chapters 3 and 4 explore the affinities between these latter two media. In chapter 3, I locate the origins of both TV and taxidermy in early modern cabinets of curiosity (a form of collection and exhibition that also informs the country house tour),[29] and I historicize both as domestic media that couple the banal and exotic as they simultaneously impose order and celebrate miscellaneity. Television, I argue, joins taxidermy in maintaining and extending the presence of animals and other forms of digestible difference in the

home in the twentieth and twenty-first centuries. Here I build on the work of cultural historians of television such as Cecilia Tichi and Lynn Spigel, who have excavated the ways in which popular discourse around television in postwar America "naturalized" the new technology by "visually associating TV sets with elements of natural décor . . . , and referring to television as the new 'family pet.'"[30] Returning to the midcentury home magazines that are among Tichi's and Spigel's primary texts with a new focus on the nonhuman beings that animate them, I find that a variety of animal figures in fact escorted television into the American home. By examining the animal figurines, on-screen animal spectacles, companion animal viewers, and taxidermic mounts that appear in postwar advertisements for television sets, I show the varied but insistent ways in which television discourse calls on animals to invite viewers to look acquisitively at its heterogenous content. These advertisements evidence that television, like taxidermy, relies on animals to sell itself as a form of "armchair travel"—a way to effortlessly experience exotic lands, peoples, and fauna without incurring the expense or discomfort of leaving home.[31] This dependence anchors both taxidermy and television in the project of imperialism and its attendant vicarious visual pleasures, the legacies of which persist today in a racialized, acquisitive gaze that is seldom recognized as such.

After establishing the historical, material, and cultural connections that bind taxidermy and television in chapter 3, chapter 4 turns to animals as they appear on television and, more precisely, to television's longstanding reliance on animals to produce "color" and "flow," qualities central to the way the medium has been understood as apprehending forms of difference within the home. One of my primary goals in this final chapter is to expand the limited scholarly focus thus far on animals in the genre of nature/wildlife documentary. To do so, I look at *Atlanta* (Donald Glover, FX, 2016–), a TV series that satirizes (among other animal figures) the trope of the "Black buck"—that is, the stereotypical image of a hypersexualized Black man who is defiant of white authority. In conversation with the contemporary films *Get Out* (Jordan Peele, US/ Japan, 2017) and *Sorry to Bother You* (Boots Riley, US, 2018), *Atlanta* turns this trope into a subversion of the racialized, acquisitive gaze born, in large part, from television's taxidermic inheritances—that is, from the medium's long-standing reliance on animals as colorful bits of difference that hold together its procession of easily digested content.

Several currents connect this book's medium-specific tracks of inquiry into film and television. First, I take an eclectic yet consistent

approach to my material, integrating formal analysis of movies and TV shows, as well as of the paratexts (e.g., advertisements, commercials) that frame viewers' experience of them; reconsideration of touchstone texts in film and television theory; examination of material and cultural histories; and attention to everyday language and etymology. In line with this approach and my interest in challenging touristic vision, I seek out media that invite ways of upending the dominant view that, in modernity, animal life exists apart—out there, separate—from human life. To this end, I consider the capacity of formal elements such as camerawork and editing to incorporate animals into the fabric of spectators' daily lives. This exploration links back to material sites and practices of killing, collecting, and consuming animals. Taxidermy developed precisely to bring animals into the home, and it thus enmeshes animals in viewers' quotidian lives and even promises to provoke their awareness of the myriad ways in which they are materially reliant on dead animals. Yet much like slaughter, taxidermy is a mode of producing and using dead animal bodies that operates as a spectacular industry. Whereas slaughter's spectacular economy generates a sense of separation, the logic of taxidermy positions animals as instantly accessible and viewable. Slaughter and taxidermy thus operate in opposing directions, yet to similar effect: they reproduce animals as infinitely consumable.

Second, my attention to media representations and their historical contexts opens up ways of understanding the co-implications of human and nonhuman animal difference on screen, particularly as they relate to race and, in the American context that is largely my focus, to this country's deep, violent history of metaphorically and materially yoking together African Americans and animals. Questions about collection and consumption, as well as the different yet intersecting ways in which African Americans and animals are alternately made invisible and hypervisible on screen, drive this connection. Here again the tour and touristic vision as structuring narrative and visual devices are key, as they facilitate consumption by at turns homogenizing and othering the human and nonhuman players on display. My discussion of slaughterhouse tourism in chapter 1, for example, considers how practices of "mimetic management" deployed in nineteenth-century slaughterhouse tourism inform the framing strategies used in more conventional cinematic documentations of animal slaughter; these strategies not only involve (mis)representing the human labor of industrial slaughter as primarily white, but are moreover organized to solicit the spectator's identification with a white gaze.[32] Race takes on more sustained significance in my examina-

tion of television and taxidermy, as I examine the curious recurrence of symbolically suggestive taxidermic mounts in recent home-renovation series, Black horror films, and *Atlanta*. My interest in this motif develops into an extended argument that television inherits colonialist values of "wonder and acquisitiveness" from taxidermy (and other early forms of animal collecting and display) and reframes them as specifically consumerist desires to bring nonthreatening forms of difference into the home.[33] Appreciating the ongoing entanglement of these media and their enduring ideological values sheds light on overlooked sources and structures of meaning that work in service of white supremacy, racial violence, and the commodification of hypervisible Blackness—particularly Black masculinity. It also calls attention to films and television series that challenge or resist these incursions on certain forms of human and non-human life.

As its title underscores, *Bits and Pieces* mines the material in- and outputs of the processes of disassembly and reassembly that bind slaughter and cinema, taxidermy and television. The book's title most immediately calls to mind the fleshy fragments of offal left over in processes of animal slaughter, and the miscellaneous animal parts, skins, and mass-produced materials (glass eyes, glue) that compose taxidermic specimens. In its attention to these remains, the book attempts to surface the violated animal bodies that persist, frequently unremarked, in language and images. So much of how we talk about and look at animals—particularly the animals we eat—is cloaked in euphemism, and thus a central aim of this book is to renew our perceptions of the very real animal bodies that animate our conversations and representations of them. To this end, *Bits and Pieces* engages the economizing imperatives of industrial modes of animal killing. In Upton Sinclair's *The Jungle*, a tour guide ambivalently sums up this unremitting economic logic when he introduces the novel's central family to the Chicago stockyards where they will soon toil, proclaiming, "They use everything about the hog except the squeal."[34] His line can be read as a condemnation and as a celebration of the meat industry's edict to repurpose all of its material resources, whether in pursuit of the lowest bottom line or under a "snout to tail" ethos; it can thus be taken as either an indictment or a justification of a system that will continue to (re)produce vast amounts of its products with utmost thrift. Burt summons the refrain of "everything but the squeal" to insinuate a critique of the burden that industrialized systems of animal killing place on infrastructure and environment: "Just as all parts of the animal are used for everything . . . , so too are all the networks of modernity—

transport, labour, technologies—implicated in the manufacture."[35] I too enter this economizing circuit as I re-view media that implicate the killing of animals in hopes of renewing awareness of the networked systems in which they are enmeshed. Like Sinclair's tour guide, I remain ambivalent about this somewhat utilitarian approach, yet I endeavor to enact re-readings that repurpose, rather than simply reuse or stretch the uses of, these films into a critique that is suggestive and substantive enough to challenge contemporary systems of manufacturing animal death.

Slaughterhouses, prisons, and nursing homes—the crowded, ill-ventilated places to which many of society's most marginalized members are relegated—were the first hotspots identified as contributing to the spread of COVID-19 in the spring of 2020. While the inhabitants of these places remain incredibly vulnerable, in the winter holiday season of 2020, in a turn familiar to fans of horror films, alarms increasingly began to sound that the call was coming from inside the house. Attention shifted to the American home, particularly as it functions as a site for social gathering, as the most threatening vector of the virus. Readers of *Bits and Pieces* will encounter this book in the long shadow of this recognition of the home as perilous—as a space where "unmasked people . . . sitting too closely in kitchens and living rooms" can contribute to mass death.[36] (To be sure, for many people, particularly those who experience domestic violence or housing insecurity, experiencing home as dangerous is not new, and it is more accurate to say that the pandemic at once intensified and laid bare the home's already profound insecurities.) The shadow of the pandemic foregrounds the centrality of domestic space in mediating our visual knowledge of animals, in that it discloses that the home is constituted, in part, by bringing certain forms of death inside while carefully excluding others.

As forms of animal death that are welcomed into the home, slaughter cinema and taxidermic television circulate among trends such as boutique butchery classes and quirky taxidermy for sale on sites such as Etsy. Around $100 will buy a class on artisanal sausage-making or a mouse mounted on a tiny stripper pole; rumor has it on Reddit that, for an undisclosed amount, you can even purchase taxidermied beetles styled as characters from *Jurassic Park* (Steven Spielberg, US, 1993).[37] If these items sound destined for a minuscule group of eccentric, morbid consumers, consider that chandeliers made from cut-off antlers are a signature piece of decor in homes designed by Chip and Joanna Gaines for HGTV's *Fixer Upper* (2013–17), who have leveraged their status as middle-class taste-makers into a home-furnishing line for Target, one of the surest marks of having made it to the mainstream.

Like the media discussed in this book, these fads promise to provide the kind of proximity to and even intimacy with animal bodies that has arguably been eliminated from modern life, and they thus present an antidote to the alienating systems of mass-produced death and consumption that I critique. Yet, as I will suggest throughout this book, they ultimately serve to further commodify animal death. In the extended wake of COVID-19, these trends join intensified appeals to consume—to return to and even exceed prepandemic levels of consumption in a collective act of "recovery." Although these current calls and their ensuing protocols are marked as temporary, extraordinary measures, they can be situated within a long-standing visual arena of consumption that is informed by regimented logics of public sanitation, personal hygiene, and spatial distance. In chapters 1 and 2, I demonstrate the importance of in-person and, later, filmic tours of slaughter to reimagining animal slaughter in ways that are visually pleasing to consumers. Billed at the time and now largely remembered as vehicles for "real" visual horror, slaughterhouse tours in fact served complex and at times ambivalent purposes: in addition to sating visitors' cravings for macabre spectacle, they trained the public, some demographics of which already consumed meat on a daily basis, to desire specific cuts, brands, and types of meat; they sought, moreover, to impress the public with their sanitary, efficient, and modern modes of production. The public needed convincing, particularly after the publication of *The Jungle* in 1906 revealed the extent of modern meatpacking's insalubrious practices and settings. Tours were part of broader efforts to not just sanitize slaughter, but to make that sanitariness visible to consumers. As Kara Wentworth observes, "This privileging of imagined future consumers—'customers' to business and 'constituents' to government—over workers persists today and is built into the very details of daily work in a slaughterhouse."[38] The pandemic has retrained consumers to hold specific expectations about the cleanliness—and, indeed, to expect instantly accessible visual proof of the cleanliness—of the places that produce and sell consumer goods, particularly food. Just as Wentworth notes that attention to consumer rights has come as the expense of workers' in the arena of meat processing, the current foregrounding of COVID-19 sanitation protocols backgrounds all other interests, namely those of workers employed in agricultural, industrial, and service jobs, as well as environmental concerns.

Some of the public sites of commerce and cultural consumption to which we are being urged to return are in fact former slaughterhouses. Dorothee Brantz explains that many of the first industrial slaughter-

houses have been reconfigured as "aestheticized space[s] for consumption and entertainment," including museums, libraries, clubs, restaurants, and loft districts.[39] New York City's stockyards are now home not only to hip artists' spaces and lofts, but also, as Mick Smith points out, to "that repository of *human* rights, the United Nations building."[40] Paris's paradigmatically modern slaughterhouse, La Villette, is among the most famous of these transformations: it was dismantled in the 1970s and rebuilt as La Parc de la Villete, a giant park that contains many cultural venues, including Europe's largest science museum; the park's architect, Bernard Tschumi, sought Derrida's input for his deconstructivist designs. Some of these industrial sites repurposed as spaces of consumption are more suburban not only in location but also in function and aesthetic. In the late oughts, Toronto's Union Stockyards were converted into an outdoor shopping mall named the Stock Yards Village. Home to retailers such as Dollarama, Bulk Barn, and Winners, and fleetingly anchored by the Canadian flagship Target store, the complex sparked my interest, as a graduate student shopping for affordable housewares, in understanding the marketing decision to name a shopping mall after a place where living animals were once bought and sold by the thousands so that they could be killed and turned into meat. This book is my attempt to answer this question—to think through the at turns banal and brazen presence of dead animals in contemporary visual culture.

When I visited the Stock Yards Village's website a decade later, during the city's second shutdown in December 2020, I was invited to partake in "curbside collect" and assured by a page detailing enhanced safety protocols, a requisite addition to every business site in the era of COVID. Skvirsky attributes her apprehension of the process genre, a form of representation that is bound up with quintessentially modern modes of industrial and artisanal production, to her positioning in "the context of an advanced capitalist consumer society in which production is ever more distanced in space and time from consumption [such] that the interest and eventfulness of processual representation is heightened and amplified."[41] That is, ongoing developments in distantiating technology (automation, immaterial labor) make it "possible to now apprehend a category of representation that so far has gone nameless."[42] The acceleration of virtual life spurred by the pandemic throws touristic media and the process genre into even sharper relief. The chapters that follow demonstrate that, whether we are filling our carts virtually or on the grounds of former slaughterhouses, our habits of consumption are shaped by complex cinematic and televisual histories of screening animal death.

CHAPTER 1

Slaughter Cinema

This book begins by looking back at cinematic documentations of violent animal death, and so I begin by looking back at a film that is not only among the first to document industrial animal slaughter, but that takes as its central formal gesture the act of looking back at that process; I then cast a backward glance at the history of slaughterhouse touring, a practice that demonstrates the historical contingencies of slaughter's (in)visibility and thus informs filmic approaches to showing slaughter. Dziga Vertov's *Kinoglaz* (alternately translated as *Kino-Eye, Cine-Eye, Cinema Eye, Life Unrehearsed, and Life Caught Unawares,* Soviet Union, 1924) acclaims both the virtues of collectivized labor and the virtuosity of the cinematic apparatus. Generically indefinite (its opening credits proclaim it to be "the first nonfiction film thing"), the film unfolds a series of vignettes centered on the Young Pioneers' unflagging efforts to promote communism in the era of Lenin's New Economic Policy. Although the film strives to capture the quotidian reality of an increasingly industrialized state, Vertov's growing investment in cinema's technical capacities of revelation accommodates his intermittent use of unconcealed staging and conspicuous postproduction manipulations.[1] The most remarkable instances of these truth-seeking artifices occur in several reverse-motion sequences that, interpolated into the chronicle of the Pioneers' activism, chart the undoing of everyday activities: the undiving of swimmers, the unbaking of bread, and the unslaughtering of a bull. This last undoing anticipates Noëlie Vialles's speculation, made in her 1994 ethnography of abattoirs in southwest France, that "seeing round an abattoir in the opposite direction would be like watching a film backwards; it would

mean reconstituting the animal from the starting point of the carcass, and that would be at least equally disturbing."[2]

The reverse slaughter sequence, the first and longest of *Kino-Eye*'s reverse-motion sequences and the most compelling proof of its "nonfiction film thingness," commences as several lines of action converge at a privatized meat market: two girl Pioneers hang a placard at the market's entrance; inside, vendors count change and heft pieces of meat; a boy Pioneer inquires into the cost of beef (exorbitant, answers the vendor's scowl); a woman bargains; another woman studies the placard. This last woman's gaze reveals the sign's exhortation to shop instead at the cooperative, and the film's smooth shift into reverse motion signals her compliance; her steps take her back to the cooperative, where she is absorbed in a fade. Next, an intertitle explains that the co-op obtains its meat directly from the slaughterhouse. Freed from the limitations of the woman's embodied perspective, the film asserts its autonomous powers of reanimation with an intertitle that reads, "Kino Eye moves time backwards." Several reestablishing shots locate the spectator outside a gated building, and a static medium shot of an imposing statue of a bull, facing screen left (that is, looking back), announces that it is the slaughterhouse (fig. 1). A medium close-up of hanging slabs of beef brings the spectator inside, and another intertitle identifies the quivering masses as "What twenty minutes ago was a bull."

Allow me to hit pause on this intertitle. Vertov opens his magnum opus, *Chelovek s kino-apparatom* (*Man with a Movie Camera*, Soviet Union, 1929) with, irony of ironies, a title card boasting of its creation "without the help of intertitles." In *Kino-Eye*, however, he makes regular use of this blunt tool of expository guidance. It is as if he does not yet trust the Kino-Eye's power to show and thus also relies on the intertitles to tell the audience (to narrate) what they are being shown. This didacticism turns out to have a certain advantage for twenty-first-century spectators who, long habituated to the manipulations of reproductive visual media, need reminding that these operations often serve, or at least are intended to serve, very particular functions. We may also need reminding that cinema's once novel modes of revelation retain their capacity to astonish. To this end, the arguably redundant intertitles solicit a renewal of wonder, helping the viewer, as Tom Gunning puts it, to "recover something of [this technology's] original strangeness."[3]

The following series of shots neatly reconstitutes the animal: its not-quite-inert flesh becomes a skinned and disemboweled carcass; a dressed and intact corpse; a convulsing, prostrate body; and, finally, a living, mov-

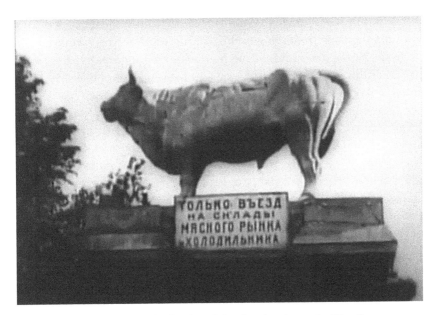

Fig. 1. A statue of a bull marks the site of the slaughterhouse in *Kino-Eye*

ing animal. Intertitles declaring the Kino-Eye's powers of reanimation punctuate these shots: "We give the bull back his entrails," "We dress the bull in his skin," and "The bull comes back to life." The bull is then led from the holding pen into the stockyard, absorbed into a herd of cattle, packed onto a freight train, and dispatched to the farm from whence it came. The train masks the transition back to forward motion. Abstracted in close-up shots, it is impossible to tell whether this machine (second in Vertov's oeuvre only to the camera) is coming or going; thus, as the train returns the cattle to the field, the film fluidly rights itself in a forward progression.

All the sequential reversals of *Kino-Eye* enthrall, with each step back playing to the spectator's curiosity: what will happen is known but how the reanimation will look remains a mystery, and thus each incremental move backward is astonishing. Yet because it overturns the movement from life to death, the reverse slaughter sequence exceeds the terrain of mere novelty. Just as Vialles predicted seventy years later, it is disturbingly affective. Her speculation is easily tested by a second-order reversal: a simple push of the rewind button on a VCR transforms the sequence into a quickened version of the conventional syntax of death.[4] More precisely, hitting rewind enables a comparison of Vertov's reversal and the standard forward march of filmic representation that it overturns. If righted

or rewound (that is, made to play from life to death), the sequence does not hold the same power: it merely confirms what is already known.[5]

Nadia Bozak observes that the reverse-motion sequences of *Kino-Eye* prefigure the stunningly aseptic long takes of *Unser täglich Brot* (*Our Daily Bread*, Nikolaus Geyrhalter, Germany, 2005), which neatly realize the "eco-conscious society's urge to render transparent the industrial processes embedded in our common consumer goods—in this case what we eat."[6] Bozak compares two films roughly contemporaneous with *Kino-Eye*: in *Rien que les heures* (*Nothing but Time*, Alberto Cavalcanti, France, 1926), a bourgeois man's glance at his plate gives way to a superimposed image of the slaughterhouse that produced his cut of meat; John Grierson's *Drifters* (United Kingdom, 1929), meanwhile, reconstructs the journey of North Atlantic herring from sea to market as "an epic of steam and steel," to use the intertitles' descriptive terms. Bozak's comparison extends to more commercial recent fare such as *Fast Food Nation* (Richard Linklater, UK/US, 2006) and *Food Inc.* (Robert Kenner, US, 2008). Vertov's reversals of meat- and bread-making introduce one of the central questions asked by these later films and by the larger critique of industrial food production and consumption to which they belong: do you know where your food—and particularly your meat—comes from? Bozak is quick to point out, however, that whereas Vertov's reverse-motion sequences rhetorically pose this question in order to answer with a "celebration of collectivization and socialized labor," more recent films frame their response as an unsettling "exposure of the guts of what might be considered quite the opposite—industrialized agri-business, whose cheap and anonymous migrant workers put cheap food in the mouths of anonymous citizens located offsite, off camera, elsewhere."[7] These bloody exposés counter the training in this foundational process subgenre that many viewers are likely to receive watching *Sesame Street* (PBS / HBO / HBO Max, 1969–), many episodes of which include segments tracing the origins of all manner of food—but never meat.[8]

The most striking effect of Vertov's intervention lies in its disclosure of the surreal material practicalities of animal slaughter. The reversal of the bull's disembowelment, for example, recalls the operation of hurriedly packing a suitcase: the Kino-Eye "give[s] the bull back its entrails" and then deftly zips it up.[9] Linear progression drives mechanical (dis) assembly, pushing the commodity or "thing" through stages of refinement. Conventional cinematic representations of animal disassembly abide by this logic, resulting in what Jonathan Burt describes as an aseptic "slaughterhouse aesthetic."[10] The reversal of linear progression in

Kino-Eye turns the process in on itself: the bull becomes too much of a "thing" or, rather, its "thingness" becomes absurd. This reversal or reiteration thus introduces an estranging effect into the typical rhythm of mechanical animal disassembly. Rephrased as the piece-by-piece reassembly of a dead-then-living animal, the sequence brings into focus the surreal (in the term's literal sense, the "super real") mechanics of taking animals apart. Fundamentally an act of defamiliarization, this look back (or look again) invites spectators to perceive a procedural logic of killing as if they were seeing it for the first time.

Proffering a substantially more disturbing viewing experience than that of the many procedurally sequential filmic documentations of slaughter that it inaugurates, *Kino-Eye*'s rewound slaughter sequence introduces a central question guiding this book, particularly in its first two chapters: how do documentary images of violent animal killing unsettle the ways in which audiences have become habituated to viewing (or not viewing, as the case may be) animal life and death within modern regimes of animal slaughter? Through thick descriptions of film's formal qualities (namely editing, but also mise-en-scène, cinematography, and sound) and attention to the technological conditions that structure viewing practices, I consider how films generate different syntactical views of slaughter, and how spectators, in their viewing practices, might incorporate these images and their corresponding values into the fabric of their everyday lives.

As my initial remarks on *Kino-Eye* indicate, I am most invested in films and ways of watching films that interrupt or disturb the routine procession/processing of animal disassembly. To this end, my analysis turns on the "slaughterhouse aesthetic" that Burt identifies in films ranging from People for the Ethical Treatment of Animals' (PETA) documentaries to Frederick Wiseman's *Meat* (US, 1976). Yet more than echo his critique of this detached mode of linear representation, I will focus on the constitutive role that deviation plays in it. Burt finds that images of industrial slaughter, even those from disparate filmic modes and genres, are regularly submitted to a "static aesthetic frame" that is produced by mechanized tracking shots and rhythmic, linear editing, with the effect being that these stylistic choices reproduce the alienating effects of mechanized animal disassembly.[11]

The slaughterhouse aesthetic structures what might be considered the first animal slaughter film, Louis Lumière's *La charcuterie mecanique* (*The Mechanical Butcher*, France, 1895), a static one-shot gag film shot in the year credited with cinema's birth. Less than a minute long, the

film depicts four men stuffing a live pig into a box labeled "charcuterie mecanique" (mechanical butcher) and immediately pulling out discrete cuts of meat; only when the cuts begin to pile up on the adjacent table do the men appear to crank the lever that ostensibly motors the process. Pao-Chen Tang identifies *The Mechanical Butcher* as initiating a "peculiar genre" of "sausage-making films" that includes *Making Sausages* (George Albert Smith, UK, 1897), *Sausage Machine* (American Mutoscope and Biograph, US, 1897), *Fun in a Butcher Shop* (Edwin Porter, Edison, US, 1901), and *Dog Factory* (Edwin Porter, Edison, US 1904). All of these are essentially remakes of *The Mechanical Butcher*, with the difference being that their "magical butcher machines" process cats, dogs, inanimate objects, and—in a gesture of breathtaking racism—a man who appears to be Chinese.[12] These films are devoid of the key elements of the slaughterhouse aesthetic (mobile camerawork and more complex forms of editing were still to come), yet their humor, particularly for twenty-first-century viewers, hinges on familiarity with the progressive mechanical movement of animal slaughter that the aesthetic mimics. The films' joke lies precisely in their nonadherence to the rules of this process—namely, their slapdash violations of the linear breakdown of living animal into commodity parts—and their winking acknowledgment of the process's oscillation between visibility and invisibility. Tang points out that "the shape of the machine and the act of cranking the machine recall film shooting with a hand-cranked camera: a living object goes in, and out comes a chain of units (the shape of sausage links also somewhat resemble film cells)."[13] Indeed, these butcher machines invoke cinema's capacity to break down the profilmic world and reconstitute it in images. *Dog Factory* goes further, Tang observes, by incorporating four reverse-motion sequences: links go in and whole, living dogs come out. Like the reverse slaughter sequence and the intertitles that herald it in *Kino-Eye*, these "transformations in reverse" assert cinema's dual capacities to rationalize and to reanimate.[14] Throughout *Bits and Pieces*, I remain attentive to moments of nonadherence akin to these early sausage-making films, as they open critical engagements with ingrained practices and perceptions of taking animals apart.

In its own play with the linear logic of the slaughterhouse aesthetic, *Kino-Eye* invites additional questions central to cinematic documentations of animal slaughter. Issues of spectatorial awareness and consent arise in one of the alternate translations of the film's title, *Life Caught Unawares*.[15] What are the implications of the film's decision to catch audience members "unawares"—to suddenly interrupt their view of collectiv-

ized consumption with a macabre scene of slaughter? To be sure, audiences who encountered *Kino-Eye* in the Soviet Union in the 1920s would (like audiences anywhere, at any time) have possessed socioculturally specific attitudes toward animal slaughter, and their different degrees of familiarity with the practice would have inflected their experience of this "unrehearsed" line of action. I do not attempt to recover the original viewer responses and reception contexts of earlier filmic scenes of slaughter, but rather consider, with as much self-awareness as possible, what it means to view such scenes (many of which have secured top billing in the canon—and thus the classrooms—of academic film studies) in North America in the first decades of the twenty-first century, a vantage point inflected by its own particular—which is not to say homogenous—attitudes toward and levels of awareness of the killing of animals.[16] I approach these films in a spirit akin to what James Cahill terms *strategic anachronism*: "a knowing temporal disordering that nevertheless engages thinking historically."[17] This form of thinking appreciates that it is precisely through taking liberties with the linear march of history that one may shake loose meaningful resemblances and reverberations across film history.

In the current context, both formal decisions and exhibition strategies of catching audiences unawares cater to the dominant rhetorical logic of shocking exposure. Many of the contemporary documentaries I discuss rest on the assumption that spectators are mostly or even wholly unaware of the regimes of animal killing that surround them, and they thus propose to incite change by exposing viewers to graphic evidence of these sites and practices. Some filmmakers and activist users of film go farther, taking film to the street and taking passersby (i.e., persons who have not elected to be spectators) by surprise with shocking slaughter imagery.

To screen its film *Farm to Fridge: The Truth behind Meat Production* (Lee Iovino, US, 2011), an undercover exposé of factory farms and slaughter plants, the animal-rights organization Mercy for Animals outfitted a truck with three eighty-inch video screens and embarked on a tour of forty American cities, where the activists parked and gave more or less impromptu screenings in densely populated public spaces, while volunteers circulated and screened the video on iPads attached to their T-shirts. *The Cove* (Louie Psihoyos, US, 2009), an Academy Award–winning documentary exposé of Japan's interlocking trade in dolphin meat and captive dolphins, enacts shocking exposure both within its narrative and as an exhibition strategy: the film ends with its central pro-

Fig. 2. Ric O'Barry screens scenes of dolphin slaughter in the streets of Tokyo in *The Cove*

tagonist, dolphin-trainer-cum-activist Richard "Ric" O'Barry, standing in the streets of Tokyo, a screen strapped to his torso, submitting the public to undercover footage of fishermen slaughtering dolphins in the film's titular cove (viewers of the film have just been exposed to this same footage in extended detail) (fig. 2). Director Psihoyos reperformed this act of exposure the year after the film's release, when he enlisted local activists in mailing DVD copies of *The Cove* to every resident listed in the Taiji phonebook.[18] In their literal approach to exposing the public to moving images of animal abuse, Psihoyos and Mercy for Animals partake in practices of mobile screening that have been with cinema since its inception, recalling in particular the Soviet state's practice of deploying "cinema trains" to exhibit revolutionary films in the early days of the Soviet Union.[19]

To even begin to answer questions of consent in relation to viewing animal slaughter, it is necessary to question the nature of our unawareness. Are the passersby who fall into the orbit of O'Barry's spray of shocking footage unsuspecting or, as closer inspection of the fast-motion city scenery suggests, unmoved? Is industry discourse on slaughter to blame for fostering the public's ignorance of how animals are made into meat, or is the public merely indifferent? Or does outward indifference disguise other responses—willful disavowal, affective overload? Given these questions, what do cinematic tactics of exposure accomplish? My resis-

tance to these strategies does not lie low beneath the surface, yet I cannot deny that they can achieve remarkable results: the Japanese Association of Zoos and Aquariums banned the trade of dolphins procured in Taiji's cove in 2015, for example, and *Blackfish* (Gabriela Cowperthwaite, US, 2013), an exposé of Seaworld's cruel treatment of orca whales, pushed the theme park to end its breeding program for the species in 2016.[20] These successes invite substantive reflection on cinema's political efficacy: are such blunt-forced representational and screening strategies the price we must pay for the concrete gains made by these documentaries? Must filmmakers take them up if they are to capture the kind of far-reaching attention needed to spur change?

Returning one last time to *Kino-Eye*, we observe that Vertov's reverse slaughter sequence unspools questions about the supplementary logic of cinematic representations of animal slaughter, a concept foundational in scholarship on animals and animal death. The film's three reverse-motion sequences collapse in a speculative statement made by André Bazin, the film theorist to whom this book is most indebted: "I imagine the supreme cinematic perversion would be the projection of an execution backward like those comic newsreels in which the diver jumps up from the water back onto his diving board."[21] Bazin's wager, made in his 1958 essay "Death Every Afternoon," echoes Vialles's hypothesis, but with a significant species difference: Bazin envisions an *execution* (typically understood as the state-sanctioned putting to death of a human) to be the ultimate "perversion" of cinematic representation. Does the slaughter of a bull count as an execution? Does viewing its death in reverse strike spectators as more or less perverse than a rewound scene of a human being killing would? Viewed in hand, *Kino-Eye* and Bazin's speculation accord with how cinema has long negotiated demands for documentary evidence of human death by offering up—in essence, by sacrificing—images of animal death.

Naming *Slaughter Cinema*, Naming *Slaughter*

The term *slaughter cinema* claims a capacious category of films that are—and are not—"about" the places and practices of animal slaughter. I use this phrase to designate my comparative analysis of disparate filmic documentations of slaughter, from germinal scenes of Soviet montage alongside recent Academy Award–winning documentaries. In taking this approach, I attempt to reckon with the fact that documentary—or, to be more precise, indexical—images of animal slaughter figure with remark-

able intensity in the history of cinema. Throughout *Bits and Pieces*, I use the terms *indexical* and *documentary* interchangeably, and readers may initially be perplexed by my usage of these terms in reference to fiction films; in these instances, I refer to shots, scenes, or sequences that document or index animal slaughter in the extrafilmic world, and that are interpolated into fictive diegeses. My usage of "indexical" accords with Charles Sanders Peirce's phenomenological typology of signs. Mary Ann Doane's gloss clarifies the distinguishing feature of Peirce's indexical sign: "Unlike icons and symbols, which rely upon association by resemblance or intellectual observations, the work of the index depends upon association by contiguity (the foot touches the ground and leaves a trace, the wind pushes the weathercock, the pointing finger indicates an adjoining site, the light rays reflected from the object 'touch' the film)."[22]

A quick perusal of the filmography in the appendix attests to the weight of violent animal killing in film history and indeed reflects cinema's abiding fixation with documenting violent animal death. Images of animal slaughter appear in situ in the small yet often critically significant corpus of fiction and nonfiction films set, in whole or in part, in and around slaughterhouses: *Le sang des bêtes* (*Blood of the Beasts*, Georges Franju, France, 1949); *Meat* (Frederick Wiseman, US, 1976); *Killer of Sheep* (Charles Burnett, US, 1978); *American Dream* (Barbara Koppel, US, 1990); and *Our Daily Bread*. Some but not all of these films may be considered animal-rights films or what Burt terms "pro-animal films"— films that critique modern regimes of animal exploitation and killing and, in doing so, advocate for improved living conditions for animals (in what is often described as a welfarist approach) or for overturning the speciesist hierarchies that authorize animals' exploitations (a rights-based approach).[23]

To this list of feature films set in slaughterhouses, we could add "sponsored films" shot in slaughterhouses—that is, educational, industrial, and institutional films that are sponsored (rather than authored) by corporate or institutional bodies.[24] This category encompasses films that address very different audiences. Readers are likely most familiar with graphic video exposés of slaughter facilities sponsored by animal-rights organizations, yet meat processers also sponsor films, including advertorial videos that showcase their hygienic and humane means of production to audiences of consumers, as well as instructional videos that are used to train audiences of workers. Slaughterhouse training films constitute an obscure yet significant subgroup of sponsored films about slaughter and meat production. In his account of his undercover work in an

Oklahoma slaughterhouse in the early 2000s, Timothy Pachirat explains that much of his training, particularly as it concerned hygiene and safety, came from videos produced by lobbying groups such as the American Meat Institute.[25] Burt, meanwhile, describes a film that straddles the line between instructional and advocacy filmmaking: produced in the 1920s by the British Council of Justice for Animals and the Humane Slaughter Association, the untitled short explains the proper methods for slaughtering a pig.[26] It would have been screened and discussed at the societies' public meetings, where some audience members would have found it informative, while others would have been horrified by it.

Images of animal slaughter are to be expected in dramas and documentaries about meat production; after all, they define the mise-en-scène. In a more perplexing phenomenon, images that document the slaughter of animals repeatedly crop up in films that often have very little to do, setting- and subject-wise, with animal slaughter. Among the most oft-remarked of these films are *Stachka* (*Strike*, Sergei Eisenstein, Russia, 1925), *La règle du jeu* (*The Rules of the Game*, Jean Renoir, France, 1939); *Unsere Afrikareise* (*Our Trip to Africa*, Peter Kubelka, Austria, 1966); *Andrei Rublev* (Andrei Tarkovsky, Russia, 1966); *Week-end* (Jean-Luc Godard, France, 1967); *Touki Bouki* (*Journey of the Hyena*, Djibril Diop Mambéty, Senegal, 1973); *Apocalypse Now* (Francis Ford Coppola, US, 1979); *Cannibal Holocaust* (Ruggero Deodato, Italy, 1980); *Sans soleil* (*Sunless*, Chris Marker, France, 1983); *Los muertos* (*The Dead*, Lisandro Alonso, Argentina/France/Netherlands/Switzerland, 2004); and *Caché* (*Hidden*, Michael Haneke, Austria/France/Germany/Italy/US, 2005). Whereas films set in/around slaughterhouses attest to slaughter in the form of more and less mechanized butchery, many dramatic and experimental films document processes or modes of slaughter that fall outside the logic of (post)industrial food production: artisanal butchery, ritual sacrifice, sport hunting. And whereas images of slaughtered animals perform a very literal role in the diegeses of films set in slaughterhouses, they circulate as portable metaphors in this more diffuse set of fictional feature films.

These images are "portable" insofar as they function as discrete, mobile units within the film, and, in Leo Braudy's sense of the term, their transmission to disparate audiences (linguistic or otherwise) requires little to no translation. Braudy defines portability as "the circumstances that allow the products of one culture to be absorbed and even co-opted by another," and he maintains that Hollywood—and Western artistic production at large—has long deployed images of nature to

create portable texts that can be read by globally diverse audiences.[27] Nature and wildlife films are highly portable, as Cynthia Chris observes, because their focus on imagistic, nonverbal activities requires little to no translation.[28] Imagery that is portable is often taken to be interchangeable, and, indeed, bits and pieces of both nature and wildlife films and of slaughter cinema sometime serve as "stock animal footage" that is reused in multiple films.[29]

Documentary images of animal slaughter and of animals in nature are outwardly incongruous, yet as Anat Pick contends, "The veritable trend in art-house productions to include the real slaughter of animals [is] closely aligned to the remarkable flourishing, in quite other quarters, of the wildlife film."[30] In a footnote, she explains that the prevalence and visually absorptive appeal of animals in pain, on one hand, and animals moving freely through the wild, on the other, makes sense in the context of cinema's long-standing "fascination with the animal body as pure moving image" and its realization that "(as far as is legally possible), the animal continues to provide the ideal disposable body as a cinematic 'attraction.'"[31] One of the primary argumentative through lines of *Bits and Pieces* follows from Pick's call to attend to the "attractional" values of animals and animal death across film genres (and, in this book, across media to include television). A number of frequently competing conditions—visual pleasures and even sadistic desires; scientific, philosophical, and political epistemologies; and generic and technological constraints—shape the way we view animal death and slaughter on-screen. These differences spill over from their given genres and mediums, inflecting experiences at large of watching animals die on-screen. By juxtaposing readings of disparate films, I aim to provoke insights into these differential meanings.

In line with my comparative approach, my method aligns with what Laura Mulvey terms "pensive" and "possessive spectatorship." Conceived in contrast to the fetishistic, voyeuristic spectatorship she so famously identified and critiqued in her 1975 essay "Visual Pleasure and Narrative Cinema," these are modes of "delayed" viewing in which the spectator actively halts the flow of images so that she can contemplate and guard them. Delayed cinema also plays on the idea that the act of viewing film is always already delayed—that is, it occurs at some temporal remove, however long, from the time of production—and the conditions of delay can work to develop new meanings. Explicit in Mulvey's theory of delayed cinema is the idea that spectators replay and review these captured images, searching out "some detail [that] has lain dormant, as it

were, waiting to be noticed."[32] I maintain that similarly quotidian, repetitive habits of viewing film and television have the potential to generate new and different perceptions; I practice this habit by returning to key films throughout the book, rereading them in different contexts and in response to different questions.

Viewing practices are inseparable from the technologies that make them possible. Mulvey stresses the significance of time-shifting technology such as VCRs and DVD players, the advent of which enabled at-home spectators to pause and rewind films so that they could linger over favored images or review sequences again and again, unearthing "hitherto unexpected meanings."[33] I am more interested in video-sharing sites and platforms like YouTube, which not only make a multitude of films—or, more frequently, clips or "units" of films—accessible to spectators who would otherwise never happen upon them, but also encourage spectators/users to view these films in ever-changing relationships with other films and film clips, as well as within the larger discursive surrounds of the internet. I have argued elsewhere that the iterable nature of cinema may press the spectator toward a recontextualized engagement with the sight of animal slaughter, and that cinema's inherently intertextual way of watching may spur her to recognize that these images index beings, practices, and institutions that are intimately connected to her own lived reality.[34] The optimistic tenor of this argument is held in check by my sustained acknowledgment that fascination with animal death—a fascination that is often expressed in the form of a trained, unrelenting scrutiny—is also driven, to a certain extent, by sadism. For some spectators, the experience of viewing animal slaughter on-screen may begin and end here, in the vicarious pleasure of watching humans inflict pain and suffering on animals.

The semiotic capaciousness of the term *slaughter cinema* motivates my reliance on it, and thus warrants elaboration. The label *slaughterhouse film* comes close to capturing the corpus of films explored in the first two chapters of this book. The formidable *New York Times* film critic Bosley Crowther hurled this epithet in his 1967 critique of the "glorification" of violence in New Hollywood films such as *For a Few Dollars More* (Sergio Leone, Italy/Spain/West Germany, 1965) and *The Dirty Dozen* (Robert Aldrich, UK/US, 1967).[35] Crowther was condemning the increase in dramatized human-on-human violence in commercial cinema and, in using *slaughterhouse* to describe performances of humans killing humans, he was drawing on the abiding metaphorical usage of the term to connote a particularly callous form of killing that processes the killed as devalued,

depersonalized material—as "animal." His choice of epithet also evokes the belief, now largely accepted as conventional wisdom in discussions of violence in popular media, that screen violence begets real violence. Applied to films that feature violent animal killing, the label of course also readily designates moving images that depict the inner workings of industrialized spaces of mechanized animal killing. Slaughterhouse films in both these literal and more figurative senses certainly fall within my purview, but, because they are not my exclusive focus, I opt instead for *slaughter*.

Both a noun and a verb, *slaughter* functions most immediately as a synonym for "killing / to kill" and "murder / to murder." The *Oxford English Dictionary Online* defines *slaughter* (sb.) as "the killing of cattle, sheep, or other animals for food"; "the killing or slaying of a person; murder, homicide, esp. of a brutal kind"; and "the killing of large numbers of persons in war, battle, etc.; massacre, carnage."[36] The primary definitions of *slaughter* (v.) likewise include "to kill (cattle, sheep, or other animals), spec. for food"; "to kill, slay, murder (a person), esp. in a bloody or brutal manner"; and "to kill or slay (persons) in large numbers; to massacre."[37] A curious but not surprising movement occurs in this sequence of meanings: with reference to animals, *slaughter* is neutrally defined by its utilitarian function (the production of food), yet when applied to humans, this very utilitarianism comes to connote brutality and vastness of scale. In other words, whereas *slaughter* works as a dysphemism when applied to humans, it functions as a euphemism when describing animals (is it always the case that one human's dysphemism is another animal's euphemism?). When coupled with adjectives like "indiscriminate" and "wholesale," the connotations of human slaughter ratchet up to include a sense of cruel arbitrariness. Yet the condemnatory connotations that attend the slaughter of humans can circle around, casting certain modes of killing animals and the killing of certain types of animals as wanton, senseless acts. Drawing on the work of Garry Marvin, Rachel Poliquin points out how the imposition—and hunters' typical obeisance—of strict rules, regulations, and conventions on hunting practices "create the necessary challenges for hunting to be considered a sporting activity and not *mere slaughter*."[38] Here, the denigration of one mode of killing (unthinking annihilation) serves to ennoble another one, with hunting emerging—by comparison to "mere slaughter"—as a knowledge-based skill or craft. Associations of slaughter with unskilled labor are of course historically contingent, and it is only with the increased automation of production in the twentieth century

that this work becomes "de-skilled."[39] These connotative tensions around *slaughter* exemplify how language that works to animalize and humanize rests on a fundamentally supplementary relationship between dysphemism and euphemism.

To slaughter an animal is, in short, not *to kill* or *to murder* it. As Burt points out with reference to current British legal codes, "'killing' in relation to an animal, means causing the death of the animal by any process other than slaughter; 'slaughter,' in relation to an animal, means the death of the animal by bleeding."[40] This narrower sense of slaughter as exsanguination—a meaning bound up with complex religious codes and industrial standards for killing animals for food—constructs the act as an almost passive allowing to die. The definition of *slaughter* as exsanguination also raises the issue of what constitutes death: the blow that strikes the fatal wound, or the flow of blood that drains the body of life? This question underpins much discussion of animal killing and its representation, manifesting in two related spheres. First, it ties directly into critiques of the workflow design of large-scale industrial slaughter, which distributes the tasks of slaughter in order to minimize workers' feelings of involvement or complicity in the business of killing.[41] Second, and on more figural ground, this question hooks into the idea that humans' modern alienation from death is realized as an increasingly incremental movement toward it (the flip side to the ongoing prolongation of life), and into the many related questions raised by cinema's endeavor to capture the instant of death.[42]

More to the point at issue here, slaughter as exsanguination identifies *slaughter* as what Derrida terms "the noncriminal putting to death" of animals, a turn of phrase by which the philosopher denounces the euphemistic functions of calling *killing* or *murder* any other name.[43] In this light, *slaughter* responds to the exigencies of euphemism when making animals into consumables.[44] Critiques of this rebranding abound: Joan Dunayer points out the effects of replacing *livestock industry*, itself a euphemism for *slaughter industry*, with the more benign-sounding *animal agriculture*.[45] Carol J. Adams, meanwhile, explains how mass terms (*beef, pork, poultry*) sanitize and objectify our perceptions of the slaughtered animals we consume on a daily basis; such language "signal[s] the *thingification* of beings."[46] To complicate matters, recent debates in the European Union over food labeling demonstrate the meat industry's insistence on retaining exclusive ownership of the term *meat*, with new legislation proposing that vegetable-based products modeled on animal-based counterparts such as *burgers* and *sausage* be marketed instead as

veggie discs and *veggie tubes*.[47] It is clear, however, that *slaughter* does not perform anything like the sleight of such terms as *concentrated animal feeding operations* (CAFOs), the name given to factory farms in agricultural literature, or *grain-consuming animal unit*, one of the US Department of Agriculture's names for animals bound to become meat.[48] As Kathryn Gillespie matter-of-factly notes, the word *slaughter* is as "inherently violent" as the act it describes:

> "Slaughter" comes from the Icelandic *slatr*, which means "slain flesh," but is a modification of *slaught* or *slaht*, which comes from the Anglo Saxon *sleaht* or *sliht*, which means "a stroke" or "a blow." These words come from the root of the English word *slay*. *Slay* may come from the Latin *lacerare*, which means literally "to tear to pieces" and is also cognate with the word *sledge* (a large hammer). Synonyms of "slaughter" are carnage, massacre, butchery, murder, and havoc.[49]

In short, *slaughter* does not slide so easily off the tongue—nor, as my exploration of slaughter cinema suggests, does it slip so easily out of sight. (That is why we pay attention to it or, more precisely, that is why it matters how we pay attention to it.) The term's ambivalent relationship to euphemism in fact explains its persistence as one of the key words of the meat industry—a discursive arena that, perhaps more than most, thrives on a mix of circumlocution and blunt denotation. The filmic analyses to come demonstrate that complex and often outwardly contradictory forces likewise drive the visual economy of filmed slaughter.

Which brings me to *cinema*. By lopping off the *house* that gives Crowther's *slaughterhouse films* its spatial specificity, I do not wish to efface the industrial affinities between the slaughterhouse and cinema, specifically their remarkably similar procedural trajectories. Truncating *slaughterhouse* also risks eliding the macabre connotations of an industrialized space—perhaps the industrialized space par excellence—that goes in the garb of domestic space (a house that manufactures animals' deaths). This sense is largely maintained, however, in the connection of *slaughter* to *cinema*, a space and practice haunted by its own connections to domesticity. Cinema as place and activity has always served as an escape from home life and a reiteration of it: we flee our lives by watching others' lives on the big screen. We no longer need to leave home to escape it: the movies took up residence with us on television, settled in on VHS and DVD formats, and have come to fully occupy our homes with on-demand, streaming viewing. A sustained interest in these and

other technologically motivated changes in cinematic spectatorship connects my consideration of viewing slaughter on film with my attention to the domestic reception of moving images of animals in television.

Finally, my recourse to *slaughter cinema* acknowledges that I perform slaughter cinema to a certain extent; that is, through my work of classification, I amalgamate bits and pieces of films from disparate contexts, traditions, countries, directors, modes and genres, repackaging them as a discrete and outwardly unified corpus: *slaughter cinema*. I do this not to prove unity, but to explore the many differential meanings I have sketched out above. Yet, in drawing together these disparate contexts, slaughter cinema necessarily absorbs other filmic genealogies. For example, films about slaughter are necessarily also about labor, and, as Belinda Smaill points out, "The documentary interest in labor does not constitute a single history or problem but is rather composed around a number of threads with differing concerns, from the pastoral rhetoric of the New Deal documentary in the United States, early Soviet documentary through to the works of Barbara Kopple."[50] In taking up these threads, I aim not to efface their specific histories and concerns, but rather to generate insights by retracing, reworking, and creating new lines of inquiry in their shared pasts.

The coherence of animal slaughter as an identifiable phenomenon in cinema is, to some extent, a matter of canon formation (a process in which my writing here and elsewhere plays a strong participative role). The publication in the early 2000s of Akira Mizuta Lippit's "The Death of an Animal" in *Film Quarterly* and his book *Electric Animal: Towards a Rhetoric of Wildlife* did much to focus conversations at the then-emergent disciplinary intersection of animal studies and film studies on questions surrounding cinema's indexical relationship to animal death.[51] In his book and, more exactly, his article, Lippit delineates a corpus of on-screen animal deaths that includes *Electrocuting an Elephant* (Thomas Edison, US, 1903) and *A Zed & Two Noughts* (Peter Greenaway, UK/Netherlands, 1985), as well as *Strike, Rules of the Game, Blood of the Beasts, Our Trip to Africa,* and *Sunless.* Subsequent discussions, the present one included, have circled back to these films, to Lippit's germinal readings of them, and to the larger theoretical issues they raise.[52] At the same time, conversations about animals in film that are more explicitly rooted in the political concerns of critical animal studies have tended to focus on film's capacity to expose the most pressing issue regarding animals: their ongoing, systematic annihilation.[53] Thus, the merger of animal studies and film studies has generated conversations that take

up different registers of speculative thought and political engagement, and that meet in their interest in cinema's abiding attention to animal death. This focus aligns with the marked interest in death that characterizes scholarship on animals in adjacent arenas of visual culture. Among edited collections are the foundational *Killing Animals* book by the Animal Studies Group (University of Illinois Press, 2006), chapters of which explore hunting, contemporary art that materially implicates dead animals, the modern slaughter industry, and euthanasia in animal shelters; *Animal Death* (edited by Jay Johnston and Fiona Probyn-Rapsey, Sydney University Press, 2013), which includes chapters on practices of animal death in, among other places, theater, zoos, veterinary clinics, and pet cemeteries; and *Mourning Animals: Rituals and Practice Surrounding Animal Death* (edited by Margo DeMello, Michigan State University Press, 2016), which takes up animal burials, taxidermy, cloning, condolence cards, animal sanctuaries, and veterinarians' and animal-rights activists' experience of mourning dead animals.

That images of animal slaughter constitute a recognizable subject of interest and trope in cinema and visual culture more broadly is not merely an effect of scholarly discourse, but an argument about the associative logic that guides our experience of this material and the comparative method I consequently adopt. I can only assert this argument anecdotally: as I have studied this material over most of the past decade, colleagues and acquaintances have readily recounted their experience of seeing an animal die on-screen for the first time; more often than not, their account leads to reaching for other examples of images indexing the killing of animals. This associative logic is not incidental. Individual experiences of watching animals die on film (be it a recent encounter with a documentary exposé on factory farming, or the prototypical childhood experience of first apprehending the off-screen death of Bambi's mother) are overdetermined by other experiences of witnessing animal death, on screen and off. These experiences are also informed by a number of frequently competing conditions: visual pleasures and even sadistic desires; scientific, philosophical, and political epistemologies; and technological constraints. Bringing together instances of slaughter cinema is, then, a necessary preliminary argumentative step: the filmography at the end of this book (a list spliced together from references dispersed across miscellaneous texts and recommendations from colleagues) and the readings herein insist that we acknowledge that images indexing violent animal death play a significant, complex role in the history and current formation of cinema, and they demand that we think

through how viewing this material informs—and potentially changes—our understanding of animal life and death.

That all said, the incorporation of so many far-flung films into a tidy list of thematically resonant films is itself a form of violence, one that risks presenting slaughter imagery—and therefore slaughtered animals—as interchangeable. This violence manifests in generalizations, decontextualized readings, and (most worrisome to me) a sort of mimetic efficiency. I maintain a critical self-awareness of these risks and address them in the following ways.

Just as "the Animal" and "animals" constitute a category so large as to be meaningless (beyond "not human"), the categories "animal slaughter" and "animal slaughter in film" smooth over many important differences. My use of *slaughter* as synonymous with killing is not meant to suggest that all acts of "noncriminal putting to death" are the same. Significant differences exist, to be sure, between industrialized slaughter, a mode of production that aims to maximize material outputs and manage the physical and affective experiences of both animals and human workers, and practices such as hunting, ritual sacrifice, and artisanal butchery, the economic logics and experiential qualities of which vary considerably. Moreover, documentary images of animals being killed produce different and differing viewing experiences, bound up as they are with spectators' variable investments in the sociocultural values attached to certain animals and practices of animal killing, and with their more idiosyncratic relationships to animals. My primary method of comparative formal analysis tempts a universalist reading that would cover over these crucial differences, and thus requires steadfast attention in grounding my analysis in my own viewing experiences and in my ethical-political investments in this material. In this light, my use of the first person should be read as both stylistically and methodologically motivated.

As mentioned, a sense of portability adheres to cinematic images of animal killing because, like animal imagery in more popular genres such as the wildlife film, they require little to no translation and are endlessly reusable and recyclable; they are quintessential stock footage. What is more, current conditions and practices of cinematic spectatorship encourage the circulation of such imagery, as we encounter it in a "media swirl" that doles out material in ever smaller "units" and invites omnivorous perusal through ever more ephemeral, algorithmically generated links.[54] This confluence invites decontextualized readings or, worse, readings that unfairly recontextualize and evaluate films according to specific, twenty-first-century Western perspectives—in my case,

the eco-conscious and anti-anthropocentric values of certain strains of contemporary humanities-based academic discourse. I resist this sort of uncritical re/decontextualization, yet acknowledge the impossibility of viewing films strictly on their own (i.e., "original") terms.

Separating Slaughter; Spectacularizing Slaughter

I conclude this chapter by pausing at the material site of the modern industrial slaughterhouse in order to explore how slaughter has come to be set apart and how visual culture has participated in cultivating that sense of isolation. Recent historical analyses of the development of the modern industrial slaughterhouse and of the once popular practice of slaughterhouse touring demonstrate the ascendancy of ocularcentric modes of witnessing or "processing" slaughter that work to contain its sensorial excesses and ultimately to dissociate it from daily life. I synthesize some of this scholarship, with a longer view to identifying possibilities for a cinematic praxis that challenges or interrupts what Shukin calls "the complicit logics of animal disassembly and filmic assembly," which she posits "are intensified when slaughter is itself the subject, or the content, of film, as in Georges Franju's *Sang des bêtes*."[55] Shukin does not discuss any films in depth, and I read her annotation as the mark where my work begins. The groundwork I lay here illuminates the slaughter industry's shifting stance on its visibility; it demonstrates, furthermore, that filmic imagery of slaughter does not merely respond to the industry's outwardly static self-image, but actively participates in shaping that image.

The very existence of the modern industrial apparatus of the slaughterhouse speaks to efforts to manage or "edit" the public's engagement with practices of killing animals. This apparatus originated in France in the early decades of the nineteenth century and was subsequently taken up, with uneven results, in other Western European countries and North America.[56] I paint a picture here of a move to systematize slaughter that spread from France to other countries in Western Europe and eventually to the United States; although many of the key factors in this narrative, such as imperatives to centralize and sanitize, did unfold consistently across these countries and cultures, significant differences exist.[57] In France, the strict separation of slaughter from city life began in 1810, when Napoleon decreed that animals would be prohibited from being brought to the center of Paris to be slaughtered and instead be directed to one of five newly built slaughterhouses or abattoirs on either side of

the Seine. Opened in 1818, the five new abattoirs replaced close to four hundred private butcher operations.[58] In his radical streamlining of the city in the 1860s, Georges-Eugène Haussmann added a sixth suburban slaughterhouse, La Villette, a complex of slaughter facilities and markets crisscrossed by railroads, rivers, and bridges. Larger and more fully industrialized than the other abattoirs, La Villette came to be regarded as the first "modern" slaughterhouse; it was considered by the baron himself to be among the crowning achievements of his reengineering and "rationalization" of Paris—a project he viewed in terms of reordering the disorderly masses.[59]

Prior to this shift in urban planning, animals were killed and butchered in small, centrally located sheds and stalls, as well as outside in yards and alleyways. The omnipresence of animal slaughter in urban life was perceived as the chief reason to relocate it to large, public slaughterhouses at the edges of cities. As Amy Fitzgerald points out, the label "public" now reads as ironic, as the new slaughterhouses "increasingly removed animal slaughter from the view of the general public."[60] Consolidation promised to protect the public in several ways. First and foremost, it would shield citizens from the distressing sights, sounds, and smells of slaughter—from animal "contaminants" that had long permeated city streets and which were increasingly considered to be not only physically but also "morally" dangerous.[61] Enacting and witnessing the everyday killing of animals threatened to disturb the morals of both workers and vulnerable bystanders (e.g., women and children), and, as Mick Smith notes in reference to the relocation of London's Smithfield Market in the early nineteenth century, so too did exposure to the "noisy presence and unrestrained expressions of animality, including openly sexual behavior."[62] Dorothee Brantz explains that the promotion of sanitation regulations in the new suburban sites of slaughter exerted a particularly substantial influence on "evolving conceptions of urban space," and they did so by "advocating a peculiar mix of morality, social welfare, and environmental control."[63] In addition to protecting the public from the polluting excesses of small-scale butchery, the move to large, secluded slaughterhouses submitted what had long been an artisanal business (i.e., one governed by tradition and the rule of guilds) to state oversight. Official governing bodies would now regulate standards of process and profit, principally for the benefit of the consumer public— and frequently to the detriment of human workers and nonhuman animals; referring to the consumer-focused response to *The Jungle*, Kara Wentworth argues that the "privileging of imagined future consumers—

'customers' to business and 'constituents' to government—over workers persists today and is built into the very details of daily work in a slaughterhouse."[64] Finally, consolidation and geographical seclusion were integral to slaughter's industrialization in more pragmatic terms: physically isolating the practice of slaughter from the city helped to meet the material needs of large-scale industrialization—namely, sufficient space for large buildings and feedlots, and access to water and transportation lines.[65]

Just as naming *slaughter* shaped the American public's perception of it, the term *abattoir* played a formative role in France's linked projects of consolidating the slaughter industry and overhauling the public's relation to and image of it. According to Fitzgerald, "*Abattoir* was introduced to refer to a specific place where animals are slaughtered for human consumption."[66] Vialles points out that the term's elision of violence must be understood as complicit with Napoleon's plan to modernize, industrialize, and sanitize the business of animal butchery in Paris: as the half-dozen new abattoirs subsumed the hundreds of stalls and shops in which discrete tasks of slaughter and butchery had been performed, so too did the term *abattoir* come to replace various (and very specific) terms like *tuerie* ("slaughtering stall"; from *tuer*, "to kill") and *écorcherie* ("skinning stall"; from *écorcher*, "to flay").[67] Vialles's etymology of the root verb, *abattre*, is striking in contrast to bluntly gruesome words like *écorcherie*:

> The general meaning of *abattre* is "to cause to fall" or "to bring down that which is standing." It is primarily a term in forestry, where it refers to felling; subsequently, it came to be used in the mineral world, where it denoted the action of detaching material from the walls of a mine tunnel. It also belongs to the vocabulary of veterinary surgery, and particularly when applied to a horse it means to lay the animal down in order to operate on it.[68]

Vialles observes the apparent euphemistic intent behind the appropriation of the term from the industries of forestry, mining, and veterinary medicine, pointing out that this appropriation served to "vegetalise" a carnivorously motivated act.[69] The verb's various meanings collectively connote passivity, even benevolence, and in this they describe the sort of effaced agency ("to cause to fall") particular to modern industry. At the same time, to anyone conversant in French, the violence of the related verb *battre* ("to beat") and *se battre* ("to fight") remains lodged in *abattre* and only slightly attenuated in its derivative *abattoir*. As with *slaughter*, an intractable violence thuds within *abattoir*. To my native US-English-

speaking ears, meanwhile, *abattoir* has always connoted an old-world, rustic grimness; the use of this word in English—that is, a speaker's choice to use it over the English *slaughterhouse*—suggests a comparable smallness of scale, only partial mechanization, and the persistence of artisanal labor (I suspect these connotations come from an American predilection for associating French culture and language with more picturesque means of production). All these submerged meanings demonstrate the impossibility of the term *abattoir*'s total reduction to a space of vegetalization. This intransigent remainder resonates in *abattoir*'s derivative, *les abats*, which includes "offal," "entrails," "viscera"—that is, the leftover bits and pieces of the slaughtered animal body.

The French *abattoir* shares with the English *slaughter* a capacious range of contradictory connotations, yet it also points to the sociocultural specificity of how slaughter is set apart. Vialles wagers that *abattoir* could not but fail as a euphemism in France, as that country—like England, Germany, and other Western European countries—sought to more comprehensively banish animal butchery from the civilized space of the city; in this light, giving it a name "still gave it too much existence."[70] In the United States, in contrast, the newly modernized (and more unevenly sequestered) slaughter industry sought a supplement in a spectacular tourist economy. Chicago, the city that emerged in the 1830s as the country's slaughter capital (America's "Hog Butcher for the World," in Carl Sandburg's words) and popularized slaughterhouse tourism, demonstrates how key differences in the American context produced a distinct form of modern slaughter.

Whereas the creation of large, secluded slaughterhouses in long-established cities like Paris, London, and Berlin required the disturbance of existing infrastructure and thus came at enormous effort and expense, Chicago benefited from being relatively inchoate, and it was easily able to allocate a separate district to what became the Union Stock Yard.[71] As Roger Horowitz explains, "Chicago's meat factories were located six miles southwest of the downtown and isolated from adjacent neighborhoods by polluted streams and acres of railroad tracks. Rather than being an integral part of the city's life, the stockyard district was an otherworldly spectacle." In contrast, cities such as New York City were unable to fully sequester slaughter due to factors in size, age, geography, and existent infrastructure, and their residents and visitors were perpetually "dismayed by the omnipresent meat business."[72] Chicago's slaughterhouses (and indeed those of America's minor slaughter capitals: Cincinnati, Kansas City, St. Louis) differed significantly from those of Europe in terms of the constitu-

tion of their workforce and oversight. In her explanation of the comparative ease with which mechanization took over American slaughterhouses, Brantz writes, "Chicago was less entrenched in the traditions of butchering. A different work structure guided production. Not individual butchers, but an easily replaceable manual work force arranged in a disassembly line turned animals into meat."[73] The nature of this work structure was of a piece with ownership. Although slaughterhouses in the United States were open to the public (indeed the public was enthusiastically invited to tour them), they were not public in a political or economic sense—that is, they were not overseen by the state in the interests of the public. Profit, rather than concerns for public welfare, motivated the private entrepreneurs who owned them.[74] The United States' particular brand of industrial capitalism, then, along with factors such as felicitous timing in urban development, shaped its burgeoning slaughter industry in specific ways, the most significant for this discussion being that it grew to accommodate a spectacular tourism economy.

Like mourning jewelry and postmortem portrait photography, slaughterhouse touring may sound to the twenty-first-century reader like another macabre nineteenth-century eccentricity—one that is markedly at odds with contemporary sensibilities, not to mention inconceivable amid the current profusion of "Ag-Gag" or "farm protection" legislation, which criminalizes activities aimed at producing visual evidence of the innerworkings of slaughterhouses and other sites that generate abuses against animals. However, Shukin, Brantz, Horowitz, and others identify the practice as a constitutive element in the development of modern forms of spectacular consumption. Shukin, in fact, reads slaughterhouse tourism as a mode of proto-cinematic spectatorship. Riffing on *The Jungle*, she complicates Sinclair's quip that modern meatpackers "use everything about the hog except the squeal":

> Chicago's stockyards . . . revolved not only around the rationalized reduction of animals to meat and the myriad commodities rendered from animal remains but around a supplementary economy of aesthetic consumption built into the line, with the kill floor doubling as a "circus amphitheater" where the raw footage of the "slaughtering machine" rushed at a staggering pace past visitors. Moreover, tours of slaughterhouses involved much more than *visual* consumption of the commotion of slaughter. The stockyards were also an overwhelming olfactory and auditory theater, filled with the "sickening stench" of blood and the death cries of animals.[75]

In Shukin's analysis, Chicago slaughterhouses *rendered*—that is, trimmed off and recycled—the visual, olfactory, and aural by-products (yes, even the squeal) of animal slaughter, and sold them back to spectators in the form of guided tours that were simultaneously exciting and educational.[76] These tours sought to contain the stomach-turning excess of animals' screams and smells, and to foreground the strikingly mobile images of animal disassembly. In doing so they primed viewers for "new modes of visual consumption."[77] Here Shukin aligns her argument with Lynne Kirby's contention that the railroad, another nineteenth-century technology bound up with the invention of cinema, contributed heavily to the formation of "a subject invested in the consumption of images and motion—that is, physical displacement—for entertainment."[78] Drawing a compelling framework of formal analogies and historical connections, she asserts, "Animals hoisted onto moving overhead tracks and sped down the disassembly line constituted one of North America's first 'moving pictures.'"[79]

What exactly attracted tourists to these moving images of animal disassembly? What did they get out of traveling to the city's margins to view this gruesome spectacle? Temple Grandin's account of what led her to the doors of the Swift meatpacking plant, and in turn to a career that includes redesigning slaughterhouses, is instructive: "The slaughterhouse was real." Her explanation echoes Jane Giles's wager that the public's thirst for "images of *unfaked* visual horror" drives the more recent proliferation of documentary evidence of violent animal death in film.[80] Brantz's and Horowitz's accounts of slaughterhouse tourism locate this desire for indexical proof in important context. If Grandin poses the late twentieth and early twenty-first-century slaughterhouse as a window into death that surpasses the abstractions of religion, Brantz and Horowitz highlight how the nineteenth-century slaughterhouse offered this view specifically within emergent public spaces of leisurely consumption. Brantz asserts, "Before there were theme parks and movie theaters, people flocked to slaughterhouses in order to quench their thirst for thrills derived from horror."[81] Horowitz likewise remarks, "There's a little of that amusement park horror. It's the same impulse that pushes people to see scary movies. People would go, see their gore. And then they would go home and eat a steak."[82] Industrial slaughter works as a thrilling spectacle that is imbued with reality, these remarks suggest, precisely because it is divorced from quotidian reality.

As a commodified vehicle for "real" visual horror, slaughterhouse tourism served complex and at times ambivalent purposes. If visitors were

drawn to visit slaughterhouses by a taste for macabre spectacle, they left with more than that desire sated. The avowedly morbid tours also articulated pedagogic and consumerist functions that were in dialogue—and sometimes at odds—with one another and with the overarching aim of spectacle. Shukin points out, after all, that the goal of this auxiliary economy, from the industry's point of view, was "persuading a nation to desire meat as a regular part of its diet."[83] The sense of disconnect built into the spectacle enabled tourists to follow their entertainment with a steak dinner, and so too did the numerous ways in which the tours instructed them that cows are, to use Cora Diamond's words, "something to eat."[84] Through tours and other marketing measures, Horowitz elaborates, the industry aimed to train the public to consume meat on a daily basis (the wealthy among them already did) and to desire specific cuts, brands, and types of meat; it also sought to impress the public with its sanitary, efficient, and modern modes of production and packaging.[85]

Although slaughterhouse tours seemed to unspool "raw footage" at a "staggering pace," to recall Shukin's description, tour operators carefully framed and edited them, with specific attention to tourists' affective and sensorial experiences. Shukin explains that "the business of slaughterhouse touring promised significant returns," yet, as *The Jungle*'s incendiary effect proved, it was "a risky business, one that meatpackers needed to mimetically manage in order for the affective surplus of animal disassembly to be converted into capital rather than into political agitation of the sort inspired by Sinclair's novel."[86] To reframe this risk in the current context, Ag-Gag laws now criminalize the kinds of activity and speech that produced *The Jungle*.[87] The strategies of "mimetic management" that Shukin identifies express a preoccupation with managing spectatorial identification, and they articulate this concern through attention to the entwined issues of perspective and process. They also bear a striking resemblance to the filmic conventions of the slaughterhouse aesthetic.

Perspective and process coalesce in the tours' management of the syntax of slaughter. In short, slaughterhouse tours adhered to the sequential nature of slaughter (as do films that conform to the slaughterhouse aesthetic). Shukin intimates that this basic structuring principle—the decision to align tourists' trajectories with that of the animals being slaughtered—proved to be among the tours' most important means of mimetic management. Although this alignment seems only obvious (indeed, natural), Shukin points out that it was also risky: the tours' construction of a "parallel path of tour-goers and animals" invited the same sort of "mimetic identification of human and animal" that caused

such an outraged, affective outpouring to *The Jungle*.[88] Yet if the tourists' ambulatory tracking of the successive dismemberment of one animal (one individual in an endless succession of members of the same species) threatened an unsettling identification, the alternative she suggests returns us squarely to the bull's unslaughtering in *Kino-Eye*. Following Vialles, Shukin avers that witnessing the reconstitution of bits and pieces of meat into whole animals would be exponentially more disconcerting.[89]

The risk that tourists might identify with the animal(s) being slaughtered was offset by framing strategies that ensured that tourists' perspectives triangulated with that of the guide—not necessarily the flesh-and-blood guide, but the discursive character of the guide. Shukin's reading of Swift's 1903 *Visitors Reference Book*, a pamphlet given to tourists upon completion of the tour, spells out this move. Rendering the tour in the crisp, clean lines proper to grade-school textbooks, this textual supplement employs as its animated/animating narrator a cute white child clad in a chef's hat (fig. 3). Shukin contends that the pamphlet's "designers intuitively chose to recapitulate the tour through the eyes of a little white girl no older than six or seven years of age. . . . She models the proper response to slaughter, one that [they] may at some level have cannily understood becomes more difficult to recognize as pathological or sadistic when embodied by a little girl."[90] The modeling function of this supplementary guide resonates with theories of cinematic identification, particularly Christian Metz's concept of primary and secondary identification.[91] Against the threat of spectators' primary identification with the apparatus (here, the relentless dismembering machine of slaughter), tours could encourage spectators to identify with the tour itself, which, as in the paratext of Swift's *Visitors Reference Book*, was discursively organized as a character who expressed an idealized view of the process.

The racial politics inscribed in the Swift pamphlet's girl guide points to the myriad ways in which slaughterhouse tourism managed a complex web of racial, class, and gender relationships, and it bears considering another way that the tours framed race. According to Horowitz, sliced bacon partially owes its normalcy today to slaughterhouse tourism:

> Sliced-bacon departments were created in the 1910s . . . in part as a site for tourism. They would glass-in the walls and hire only white, native-born women for that department. There's no blood with bacon. It's cured and dried and cut already, so it looks really clean. It was a sign of the changing nature of the tours—this increasing idea that slaughterhouses should actually look clean and bloodless. . . . The

Fig. 3. Swift's *Visitors Reference Book* deploys a girl guide in slaughterhouse tour

subtext in how these slaughterhouses were presented on tours was "There are no black hands touching the meat." But of course there were all kinds of black hands touching the meat—that was just happening in other parts of the slaughterhouse.[92]

In other words, sliced bacon does not derive exclusively, as one might expect, from consumer demand for uniform pieces of cured pork (or from suppliers' creation of such a demand), but also follows from the industry's realization that it could profitably dovetail production and advertising needs in the "clean, well-lit rooms in which neatly dressed white women performed their tasks while seated comfortably at long tables."[93] Horowitz's story of sliced bacon is remarkable in that it identifies slaughterhouse tourism not merely as an auxiliary economy that (re) presented slaughter, but as a supplementary set of practices that exerted a substantial influence on the industry of slaughter by creating an enormously popular product category. It thus demonstrates that the tours' framing strategies not only trimmed off slaughter's affective surpluses, but also shaped its procedural means and ends. This influence carries over into the framing strategies that structure the retail of meat. To note just one connection, consider the importance of refrigerated glass display cases, which became indispensable soon after their introduction in the early twentieth century. Horowitz refers to an industry catalog's exhortation that meat retailers adopt the use of such cases: "Your cus-

tomers are the same people that buy from department stores. They like to window shop, and are influenced by what they see."[94]

In the twentieth century, film largely replaced the practice of slaughterhouse tourism and now offers the public an exclusive view of the meat industry. In the next chapter, I examine sponsored films such as Smithfield's "Taking the Mystery Out of Pork Production" (2011) and *This Is Hormel* (F. R. Furtney and the Hormel Co., US, 1965), which replicate the tours' reliance on secondary identification with cheerful, curious characters who promote a sanitized view of slaughter. *This Is Hormel* mimics Swift's framing of their tour with child guides by delegating two earnest, inquisitive brothers and their obliging Pa as surrogate tourists. As with slaughterhouse tours, these films' careful choice of guides demonstrates an awareness of the need to anchor the potentially overwhelming sight/site of slaughter in an identifiable, individualized gaze. Even as they conscientiously cue viewers' curiosity, these purportedly transparent windows into the industry exert a great degree of control over spectators' affective response to slaughter. My comparative analysis of *American Dream* shows this exercise of control in relief: in keeping with its observational stance, the documentary's introductory scene of slaughter does not invest in an on-screen gaze, and it thereby prevents spectators from aligning, much less modeling, their response with that of diegetic witnesses. The film's refusal of perspective, I argue, initiates its unnerving potential.

Glass Walls

Exposure as Shock

Contemporary critiques of factory farming are imbued with apocalyptic rhetoric. This is not so much to say that participants present the current arena of agribusiness as a doomsday scenario, but rather that they recognize the rhetorical value housed in the term's etymology (the Greek *apocalypse* means an "unveiling" or "revelation"). Critics ranging from Jonathan Safran Foer to abolitionist animal-rights groups are united in their assertion that correcting the food industry's ills entails, first and foremost, unveiling them to a mis- or uninformed public. Thus, although many films avail themselves of the graphic imagery and emphatic tenor associated with end-of-days tales, they do so with the aim of delineating a situation that is imminently reparable: according to their logic, the solution to the industry's horrors—horrors that rival, many critics aver, the limit cases of human-on-human atrocities (slavery, the Holocaust)—resides in their exposure.

The documentary exposé *Food Inc.* (Robert Kenner, US, 2009) lends itself as a ready example, as it foregrounds its reliance on the rhetoric of unveiling. Indeed, the film's opening sequence explicitly stages a revelation of the incommensurability of the idyllic *idea* of farming and the brutal *facts* of industrial food production. The camera roves an ordinary American supermarket, taking an inventory of the too-bright foodstuffs that neatly line the shelves. It lingers on the generic pastoral imagery that adorns the packaging, allowing viewers ample time to register the labels' pretense and to note the film's credits, which are styled as prod-

uct logos. The penultimate shot rests on a shrink-wrapped package of ground beef, printed with the cartoon silhouette of a cheery cow and Kenner's directorial credit. The shot dissolves into an image of a real cow—the shadow of its brand image—and a cut to a moving aerial shot places this animal not on a grassy knoll, but in the vast expanse of a factory feed lot. At this juncture, a voice-over intones forthrightly, "There's this deliberate veil, this curtain, that's dropped between us and where our food is coming from. The industry doesn't want you to know the truth about what you're eating, because if you knew, you might not want to eat it." The film proceeds to disclose this truth in exacting detail, pausing periodically to reiterate the value of revelation. A particularly apposite instance occurs toward the end of the film, when Joel Salatin, the owner of a successful small-scale farm and a well-known proponent of alternatives to mass-produced food, affirms, "If we put glass walls on all the mega-processing facilities, we would have a different food system in this country."

Salatin's hypothesis riffs on an unofficial slogan of sorts for vegetarian and vegan activism: "If slaughterhouses had glass walls, everyone would be vegetarian." People for the Ethical Treatment of Animals (PETA) solidified this saying's currency in 2009 with its release of "Glass Walls," a short video narrated by the aphorism's self-proclaimed originator, Sir Paul McCartney. The former Beatle in fact prefaces his commentary by asserting his authorship: "I've often said that if slaughterhouses had glass walls . . ."[1] His lead-in prepares the viewer for the video's realization of its titular logic (a logic its intertitles repeat seven times in thirteen minutes): PETA may not be able to replace the physical facades of slaughterhouses, but it can, through its use of the techniques of investigative journalism (most notably hidden cameras), render visible the horrifying interiors of these edifices in excruciating detail. "Glass Walls" thus enacts a particularly lurid performance of apocalyptic rhetoric, relentlessly cataloging one abomination after another. In doing so, the video points to an obvious but no less significant premise of what we may identify as the dominant strain of activist food rhetoric: the successful critique of the food—and particularly the meat—industry hinges on the provision of shocking visual evidence. Empirical knowledge in the form of facts and figures will not suffice; moving images—images that both index movement and move the viewer—are required to effect individual and social change.

The use of apocalyptic rhetoric in the critique of agribusiness and its effects on animals is so pervasive that it appears plausible that even Jacques Derrida, an orator unlikely to adopt this style, has done just that.

In his "Animal I Am" address, Derrida begins to differentiate between an atemporal and comparatively benign human-animal divide (we have sub-jugated animals "depuis le temps" or since time, he points out) and the historically specific entrenchment of this division in the modern regime of industrialized food production.[2] In order to forge this distinction, he begins to tally up "the *unprecedented* proportions of [modernity's] sub-jection of the animal."[3] According to his itemization, the magnitude of modernity's mastery over animals derives principally from its vast and comprehensive demographic expansion of farming; precipitated chiefly by the introduction of genetic manipulation and production for global consumption, this relatively recent radical transformation of how humans treat animals is tantamount, he makes clear, to "the worst cases of genocide."[4] Yet at the juncture when his discourse should, according to generic conventions, give way to the provision of gruesome eviden-tiary details, the philosopher draws back with an anaphoristic reminder:

> *Everybody knows* what terrifying and intolerable pictures a realist paint-ing could give to the industrial, mechanical, chemical, hormonal, and genetic violence to which man has been submitting animal life for the past two centuries. *Everybody knows* what the production, breeding, transport, and slaughter of these animals has become.[5]

Derrida's veer toward unveiling turns out to be a feint, a move that ultimately underscores the complicity of that rhetorical approach in humans' "organized disavowal" of their systemic torture of animals; to "thrust" on his audience pathetic imagery of humans' exaction of pain on animals "would be both too easy and endless."[6] It would be redun-dant. We already know.

What we know about the dominant means by which humans currently produce, breed, transport, and slaughter animals for meat of course exists in ever changing relationship to what we do not know about these practices and conditions. As Garrett M. Broad explains in his study of the interplay between Ag-Gag legislation and undercover videos of ani-mal exploitation, "The production of knowledge and non-knowledge . . . take[s] shape in large part through the interaction of storytelling prac-tices across the multi-modal forms of communication that are present in society, with media playing a vital role in this process."[7] In this chapter, I consider film's participation in shifting the balance of "knowledge and non-knowledge." The preceding synopsis positions the "realist paintings" of popular expository documentary and Derrida's discursive repudiation

of graphic revelation at two extremes. My aim here is to complicate the space in between—to populate or multiply its limits, as Derrida would say.

Central to my discussion, to be sure, is a critique of films that, phrased in apocalyptic rhetoric, place their faith in the politicizing power of shocking revelation. Here the provision of explicit imagery is meant to shock spectators out of their complacency about and complicity with the current conditions of the meat industry. These films act on spectators in a bid to make spectators act. Jason Middleton's insight that expository documentaries such as *Food Inc.* belong to what Linda Williams terms "body genres" is instructive. Observing that the two primary senses of moving—being in motion and the production of emotion—imbued *the movies* from their start, Williams urges reappraisal of "genres that focus on particular kinds of body movement and body spectacle—musicals, horror films, low comedies, 'weepies.'"[8] Middleton in turn argues for reappraisal of the outwardly sober (and prestigious) discourse of documentary by linking it with body genres associated with (lowbrow) viscerally embodied entertainments. In eliciting a physical response from spectators, expository documentaries move spectators is a specific way: as he puts it, their particular "mode of disciplining the spectator involves visceral moments of disgust whose reward is the production of knowledge."[9] Of course, this mode of shocking exposure is not at all specific to the subject of animal killing or the site of the slaughterhouse—indeed, documentary media regularly pull back the curtain to reveal all manner of reprehensible matters—and my analysis can be read metonymically as a critique of exuberant unveiling. My precise aim, though, is to demonstrate the stakes of applying this rhetorical strategy to representations of animal slaughter. I articulate these stakes by connecting this form of unveiling to what Burt terms a "slaughterhouse aesthetic." This mode of cinematic representation works to maximize the visibility of animal slaughter, yet it does so by relying on conventions that disconnect slaughter from daily life and disassociate the spectator from the slaughtered animal body; the use of these conventions is particularly problematic in animal-rights films, insofar as it obliges these films to reproduce the structures of fetishization and isolation that underwrite the very practices they aim to critique.

Separating Slaughter

"When I first tried to visit a slaughter plant, they wouldn't let me in. And I thought, 'What's so mysterious in this place they won't let anybody in?'"

So recounts Temple Grandin in an episode of Errol Morris's documentary TV series *First Person* (US, 2001), devoted to her life story. She continues, "I wanted to find out what happens when you die. Regular religion was way too abstract; it was just meaningless. But the slaughterhouse was *real.* I walked up to the front lobby [of the Swift slaughterhouse] and they said, 'No, we don't give tours of this plant.' '*What?*'" Grandin is autistic, and she identifies her need to align metaphysical ideas with concrete "pictures" as a product of her disability and the scientific outlook it has fostered. She is also persistent. Several years after she was turned away from Swift, she met the wife of the plant's insurance salesman at the grocery store: "Two days later I was in the Swift plant. The door to opportunity opened."

That door led to a career as a consultant to the livestock industry that complements her work as an animal scientist, author, and professor. The title of this episode, "Stairway to Heaven," refers to the name for the spiral ramp that she designed so that cattle proceed—in a manner she claims is soothing—toward the knocking box through opaque-walled, single-file chutes in a circular fashion, their faces pressed up to the rumps that precede them. Grandin has not only designed many of the largest livestock-handling facilities in the United States, but has also gained widespread recognition as a forthright spokesperson for the "humane" principles that govern her designs. In one of her many appearances across various media platforms, she provides the on-screen introduction for "Taking the Mystery Out of Pork Production" (US, 2011), a series of internet videos sponsored by Murphy-Brown, the livestock subsidiary of Smithfield Foods, the world's largest pork producer and a competitor of Swift:

> I was really pleased when Murphy-Brown came to me and said they wanted to make videos just showing how a modern pork farm works—showing sows, showing finishers, showing other parts of the farm—because a lot of the public has no idea what goes on inside a hog farm. And we just need to show it. You know, it shouldn't be a mystery. There's nothing mysterious that goes on inside a pork farm. You know, put a video camera inside and show it.[10]

It is an unsurprising irony that the footage that follows serves to obscure the processes of pork production: the video carefully details the "safe, comfortable, and healthy" conditions afforded the pigs at various life stages, primarily by repeatedly surveying the roomy pens in which they are confined, but it does not show the places or processes of slaugh-

ter that determine the end of their lives or the transformation of their bodies into meat. Grandin's prelude to Smithfield's bucolic rendering of pork production thus reproduces her own mystifying first attempt to see animal slaughter, thereby testifying to her transformation from a curious, frustrated spectator to an expert insider.

Read together, Grandin's remarks in "Stairway to Heaven" and "Taking the Mystery Out of Pork Production" shed important light on the modern meat industry's vexed relationship to its own visibility. Grandin's incredulity at her summary dismissal from Swift—a company that, a century earlier, had run a brisk business in tours—and her subsequent assertion of the value of transparency make a great deal of sense given the meat industry's oscillating apportionment of visual knowledge about itself. The industry's stance on public self-display has both shifted significantly over time and contained contradictory impulses within more narrowly defined historical periods. These diachronic and synchronic tensions in turn inform the means by which filmmakers endeavor to produce visual knowledge of the industry.

Swift provides an apposite case in point. Currently among the largest American meatpackers and a subsidiary of a Brazilian firm that is the world's largest producer of beef and pork, Swift has long relied on moving images as part of its branding strategy and produces online infomercials that are not unlike the one Grandin made for its competitor, Smithfield. In 1901, around the same time it was selling in-person tours framed by its *Visitors Reference Book*, Swift commissioned Selig Polyscope Co. to produce "The Stockyard Series," a set of sixty-odd films that includes titles such as *Arrival of Train of Cattle, Stunning Cattle, Dumping and Lifting Cattle, Sticking Cattle,* and *Koshering Cattle.* In the 1950s, Swift sponsored films such as *The Big Idea* (Edward M. Grabill, US, 1951), the plot of which Rick Prelinger describes as "a woman reporter from an iron curtain country and an American newspaperman . . . tour a Swift plant and . . . come to realize that capitalism is the system that provides the greatest degree of worker freedom." Prelinger also makes note of *Carving Magic* (1959), a home economist's hands-on demo of how to carve meat. Its director, Herschell Gordon Lewis, went on to a successful career directing low-budget gore films, and one wonders how his experience with Swift informed his later success in filming dramatic scenes of human butchery.[11]

Understanding the historical complexities of (in)visibility in the history of modern slaughter is crucial to developing a more nuanced appreciation of the formal and rhetorical strategies available for documenting the industry's innerworkings. Shukin explains these dynamics thus:

There seems to have been a historical "window" in which slaughter enjoyed and capitalized on its visibility rather than sought invisibility, a window in which tours of abattoirs were immensely popular and the industry played a large role in publicizing the modern nation's efficiencies. This window did not remain open for long, however; although tours of slaughterhouses have continued across the twentieth century and into the twenty-first (often with the pedagogical purpose of giving schoolchildren a glimpse of industrial economy), the space of slaughter has become increasingly identified with resistance to graphic exposure, so that films of slaughterhouses circulated by animal-rights organizations such as People for the Ethical Treatment of Animals in the second half of the twentieth century and the twenty-first have been seen as forced glimpses into a clandestine space barred from the public view.[12]

It is worth refining this timeline. Animal-rights activists' forays into using photographic technology to expose sites of animal exploitation date to the early 1980s: PETA formed in 1980 and in 1981 released its first undercover video expose, of the vivisection of rhesus monkeys in a medical research lab in Silver Springs, Maryland.[13] Efforts to use documentary image technologies to reveal the exploitation of animals for agricultural purposes developed after activists' initial focus on the abuse of animals in experimental research. The meat industry's ensuing "resistance to graphic exposure" has found its most concrete expression in the form of Ag-Gag laws, which criminalize activities aimed at producing visual evidence of animal abuse, namely taking photographs or video of animal agriculture operations, as well as the kinds of employment fraud required to gain access to facilities in order to produce these documentary images and the delayed reporting of abuses that is necessary to stage an exposé. The first Ag-Gag laws passed in the early 1990s in Kansas, Montana, and North Dakota, and variations have since been enacted in several additional states and introduced in dozens more—along with related but more broadly directed "agricultural disparagement" or "food libel" (also known as "veggie libel") laws, which place limitations on speech about agricultural products and practices.[14]

Although the meat industry increasingly relies on legislation to silence critics armed with damning documentary evidence, it maintains extensive marketing operations in order to promote its carefully crafted self-image. Indeed, these efforts often work in tandem: Smithfield Foods produced its "Taking the Mystery Out of Pork Production" video series

in response to the Humane Society's release, several months prior, of an undercover video that documented workers abusing pigs at a Virginia farm run by Smithfield's subsidiary, Murphy-Brown.[15] Drawing on the work of Glynn Tonsor and Nicole Olynk, Broad points out that the distribution of undercover videos and mainstream media's attention to them produces a documented impact on consumers' purchases of meat and, in response to "this image-oriented challenge from animal activists, the animal production industry has responded with efforts to maintain control of a mediated narrative that is central to its continued operations and growth."[16] In this context, the placement of Grandin at the helm of the video series demonstrates a concerted attempt to shore up the meatpacker's welfarist ethos.

Disparate film modes and genres make use of similar conventions to capture the routinized killing of animals. These shared conventions are characterized, according to Burt, by a "dispassionate camera." He argues that "imagery of mechanization and anonymity appears interchangeably whether in art film, documentary or animal-rights videos on the meat process. One might almost call it a slaughterhouse aesthetic."[17] This aesthetic is born of two mutually reinforcing techniques: mechanized tracking shots and rhythmic, linear editing. In their drive toward mimesis, the cinematographic and editing techniques of the slaughterhouse aesthetic reproduce the alienating effects of mechanized animal disassembly. Burt asserts:

> The fetishization of animal death as part of an industrial process renders visible that which we rarely, if ever, see. Few films, however, actually explore the relationship between this revelatory imagery and other aspects of culture, preferring instead to reinforce its sense of separateness. Magnetized as the eye might be to the act of animal killing, whether through fascination, repulsion or a combination of the two, the sense of isolation that the act has behind the walls of the abattoir is in fact reinforced.[18]

Films that adopt the slaughterhouse aesthetic succeed in exposing a site that, in Owain Jones's words, is "customarily closed off from [a] conventional ethical gaze," yet they do so at the expense of obscuring this space's connections to daily life.[19] To put it another way, they acknowledge the horrors of the meat industry, yet in doing so they disavow this institution's embeddedness in the fabric of the world. As Burt explains, the meat industry proliferates changes, connections, and conflicts in the

overlapping spheres of economics, ecology, politics, labor, transportation, and advertising, and it powers "particular configuration[s] of technology, the animal, and discourses of efficiency, breeding, health, and ethics."[20] Yet in its effort to show slaughter to the exclusion of all else, the slaughterhouse aesthetic renders these connections invisible.

Animal-rights films are marked—and marked perhaps more noticeably—by another set of conventions: techniques associated with undercover filmmaking, such as low-resolution, grainy footage; shaky camerawork; fuzzy digital time-stamps; and nighttime or infrared lighting. These techniques are outwardly at odds with the slaughterhouse aesthetic; in particular, cinematographic traces of the highly mobile responsiveness required by covert filmmaking (haphazard framing, swish pans) challenge the measured control expressed in the rhythmic tracking shots that typify the slaughterhouse aesthetic. Yet these outwardly oppositional techniques often work in tandem, suggesting that the slaughterhouse aesthetic allows, accommodates, and even at times invites techniques of clandestine filmmaking. Such techniques function emphatically not just to show the processes of meat production, but to expose or reveal the violence of animal killing and disassembly. As Jamie Lorimer puts it, the "illicit feel" produced by the "gritty (and often grainy) realism" of animal-rights films "is employed strategically to make us believe that these are shady practices happening in hidden places. Here the camera takes us where we would or could not go, revealing spaces, bodies and events generally obscured from contemporary visual horizons. Such images are primed to erupt spectacularly into public view, courting controversy and reaction."[21]

The limitations of the slaughterhouse aesthetic emerge most clearly through comparative analysis of two films that document the same corporate space of slaughter from (not altogether) antagonistic perspectives—yet both with decided disinterest in animals or animal rights: *This Is Hormel*, an educational film sponsored by the Hormel Corporation in the waning days of slaughterhouse tourism, and *American Dream*, an observational documentary that follows the local meatpacking union's fight for fair wages and benefits at Hormel's headquarters in Austin, Minnesota. Burt develops his working definition of the slaughterhouse aesthetic through comparisons of two films that are antagonistic in their own ways: Frederic Wiseman's observational documentary *Meat* (US, 1976), which claims impartiality on issues of animal welfare, and PETA's feature-length video *A Day in the Life of a Massachusetts Slaughterhouse* (US, 1998), which advocates vociferously on animals' behalf. He also lists Wiseman's *Primate* (US, 1974) as an exemplar:

its penultimate scene documents the dissection of a chimp, and is framed and edited with a rapid-fire nonchalance that replicates the unrelenting precision of the scientists' scalpels. Burt pithily sums up *Primate* and *Meat*: "In these films, little is explained and much is seen." In illustrating how the slaughterhouse aesthetic's effects of fragmentation and isolation hold "regardless of the sympathies of the filmmaker," Burt intimates a critique of the revelatory approach adopted by so many animal-rights films: insofar as these films reproduce the formal logic of fetishization that underwrites the industry of slaughter, they undermine one of their central messages—that animals are not simply pieces of flesh fated for human consumption.[22] I do not wish to belabor Burt's astute critique of the conventions of the slaughterhouse aesthetic, but rather to highlight the productive potential these conventions hold, simply by dint of their susceptibility to deviation. (Burt allows for this potential by qualifying his categorization: "One might almost call it a slaughterhouse aesthetic.")

Hormel's primary claim to fame is its development of the much-mocked mystery meat SPAM (Austin, Minnesota, consequently bears the unfortunate nickname Spamtown, USA), and, on the face of it, *This Is Hormel* and *American Dream* formally resonate with their shared thematic concern with the production of the canned meat, a low-grade pork that is ground down to a rubbery, uniform consistency and coated with a gelatinous aspic. Both films submit their documentary footage from inside the Hormel plant to an analogous process of homogenization and thereby present meat production as an easily digestible process; the SPAM analogy is perhaps stronger in the case of *American Dream*, as it repeatedly quotes *This Is Hormel*, seamlessly incorporating that film's footage into its own materiality. The provenance of Kopple's incorporated footage is unclear and goes uncited in the credits. At its outset, the film incorporates the introductory sequence of an educational film titled *Hormel*, then intermittently splices in sequences that are ostensibly taken from this film yet are identical to bits and pieces of Furtney's *This Is Hormel*; given the portability of industrial and educational film footage, my speculation is that *Hormel* and *This Is Hormel* are constructed of stock footage compiled by Hormel in the mid-1960s—that is, they are simply different iterations of the same material. To add to this mix, Kopple also intermittently cuts in her own documentary footage of the Hormel plant. Her reliance on stock footage of slaughter recalls other instances of recycled slaughter imagery, such as Fernando Solanas and Octavio Getino's incorporation of footage from *Faena* (*Slaughter*, Humberto Ríos, Argentina, 1960) in *La hora de los hornos* (*The Hour of the Furnaces*, Argentina, 1968).

The homogenizing conventions at work in *This Is Hormel* and *American Dream* do not grind all scenes of slaughter into homogenous sameness or entirely expunge the messiness of animal slaughter. To be sure, no film entirely escapes or adheres to the conventions in question. In a word, film fragments. The cinematic medium is built on the atomization of time and space—the disassembly and reassembly of the profilmic world. Filmmakers have long realized that certain spaces (or, more precisely, technologies of space) lend themselves to the atomized linearity of the filmstrip. In particular, the mobile, rectangular windows of speeding trains and the ceaseless lateral ebb of assembly lines constitute mise-en-scène wherein alignment with the cinematic apparatus can be mined for visually pleasing symmetries. *Baraka* (Ron Fricke, US, 1992), for example, attests to the *photogenie* of the convergence of mechanical assembly and animal disassembly: a sequence nestled in the interior of this nonnarrative, kaleidoscopic inventory of "civilization" splices together monolithic vistas of the industrial processing of both computer innards and fluffy chicks. More famously, *Modern Times* (Charlie Chaplin, US, 1936) exploits cinema's potential for formal and thematic alliances with the assembly lines of modern mass production—and it does so with an opening ovine metaphor that likens the denizens of modernity to innocent, unthinking sheep. Walter Benjamin reads Chaplin's movement through space as metonymic of cinematic movement: "Every one of his movements is composed of chopped up bits of motion. Whether you focus on his walk, or the way he handles his little cane or tips his hat—it is always the same jerky succession of tiny movements, which applies the law of filmic sequence to that of human motorics."[23] Chaplin's choreography of factory work shows up the ease with which the mindless, repetitive flow of mass production breaches the assembly line, subsuming everyday life into the stuff of monotonous labor: in one famous scene, Chaplin's tramp becomes so fixated on his assigned task that he extends it to the factory's surrounds and attempts to tighten the "bolts" of a woman's blouse. Yet this scene also highlights the precariousness of the assembly line's systematicity: the tramp's monomania causes a delay, and the line disastrously breaks down. In short, Chaplin exploits to critical and comic effect not only the assembly line's capacity to mesmerize but also its vulnerability to disruption. These competing ocular interests—the thrall of repetition and the shocking interruption of it—characterize the cinematic tracking of mechanical assembly, in general, and the slaughterhouse aesthetic, in particular. My reading of Kopple's *American Dream* attends specifically to this relationship between convention and deviation, and considers the

extent to which the cinematic representation of slaughter invites their copresence. In this regard, my analysis underscores, more generally, that if the cinematic medium is built on fragmentation, so too is perspective built into the apparatus. This latter, equally fundamental material condition disallows the exact duplication of the profilmic world, foreclosing the possibility of a perfect reproduction of the bits and pieces of animal slaughter.

The mimetic representation of slaughter produces fragmentation on two levels: the individual animal body and the systemic processes of slaughter. (To put it another way, it introduces ruptures on the levels of shot composition and of narrative.) Perhaps not surprisingly, the framing and editing choices in *This Is Hormel* typify this twofold segmentation. The film primarily consists of neatly matched series of static, straight-on medium shots, which track increasingly reduced and segmented corporeal forms as they advance through processes of progressive refinement. Medium close-ups of the nascent meat products punctuate the steady tempo of these sequences: a fifteen-second sequence of four shots presents an instantly smoked and packaged ham, inserts of advertising images display simmering stews and succulent cuts of beef. The film's insistent compositional segmentation reinforces what surely must have been among Hormel's aims in commissioning the film: to present slaughter as a mechanical marvel—and a remarkably hygienic and efficient one at that. The film's voice-over narrator persistently voices this message, as he emphasizes the highly specialized technology (automated bacon cure injectors, a Saran-wrapping machine) to the exclusion of the other entities present in the factory. In this regard, the constant on-screen presence of the diminishing animal bodies and the humans who facilitate the various processes seems almost perfunctory; these animals and humans are the requisite raw materials and expeditors, respectively, of the polished machines. That said, recurrent close-ups of the human hands required to strip fat and cut finished steaks provide constant reminders of the indispensability of human labor.

This Is Hormel's uniform framing and editing consistently enact what Carol J. Adams calls "body chopping," a term that evokes the violent fragmentation performed by the pornographic representational strategies with which she associates it. Adams demonstrates that mainstream outlets of visual culture, particularly North American advertising, regularly employ this technique to depict women and animals.[24] She argues that the resultant images of fragmented bodies serve as "cues of violability." That is, the visual representation of the body as a series of discrete,

Fig. 4. A series of close-ups of hands cutting meat punctuated by a spectacle of an assortment of meats in *This Is Hormel*'s montage of meat production

chopped-up parts invites the spectator to imagine her violation of the parts that appear within the frame, all the while forgetting that those parts constitute an unseen whole.[25] As a matter of course, the slaughter-house aesthetic compositionally cuts up a particular type of body: the living-then-dead animal body. And in doing so, it solicits violation in a specific form of consumption: eating. *This Is Hormel*, like "Taking the Mystery Out of Pork Production" and most films sponsored by the meat industry, excises the scene of slaughter—the exact moment of death—from its overview. According to the film's constructed geography, the kill floor is located in a separate, unseen space; the sequential overviews of pork and beef production each begin with carcasses, and thereby suggest that meat production begins with raw, inert material. By divorcing the act of killing from the production of meat, the film further sanitizes the routinized violation and consumption of the animal body.

This Is Hormel maintains its fragmented, mechanical style for its thirty-minute duration, as it seamlessly links one sequence of disassembly to another. The sequences are grouped according to the type or originating species of meat (pork, beef, and amalgamations of the two) and,

further, according to types of products: ham, bacon, pickled pigs' feet, gelatin, SPAM; ground beef, cowhides, prime beef cuts; wieners, chili, Dinty Moore stew. This sequential logic reaches a sort of apex a little over halfway through the film, in an overhead static shot, seventeen seconds long, that presents some dozen different cuts of meat arrayed on a blue surface that spins slowly like a Lazy Susan—or a carousel—as the narrator intones, "choice tenderloin steaks, boneless top sirloins, and New York–cut steaks—ah, there's plenty of good eating on this table." The decontextualized shot appears to exist in a future tense and a space outside the factory, the hastily arranged cuts of meat (some placed on doilies, while a plastic bag spills cubes of raw meat) signifying a future abundance; this temporal break is confirmed by the subsequent shot, a close-up of a businessman's neatly manicured and bejeweled hands cutting into a perfectly cooked steak. This momentary lapse into meat spectacle is neatly reabsorbed as the filmic tour moves on to the feed mill and then to the production of Hormel wieners. Altogether, the film's insistent movement from whole to parts constructs the various *processes* of meat production as an interminable *procession*: corpses are skinned, halved, quartered, cut, sliced, ground, emulsified. By aligning itself with the machinery's relentless reduction of the animals' bodies, the film affirms the inexorable logic of refinement, within which the animal body amounts to nothing more than raw material.

The connotations of this procession of raw meat emerge in light of Adams's discussion of the intersections of gender, meat, and pornography. She describes contemporary advertising's fondness for images of women adorned with raw meat as indicative of "the resurgence of the raw as real (with the raw, there's always more)."[26] Her aside indicates that *rawness* connotes plenitude. The mimetic representation of the circular technology of animal disassembly reinforces this suggestion: the bits and pieces of raw material glide along conveyor belts and across the screen, with no end in sight. Furthermore, the quality of rawness is also frozen in the future perfect: to be raw is to be not-yet-cooked or, perhaps more accurately, to-be-cooked.[27] In these entwined senses, *This Is Hormel*'s unremitting procession of raw material bespeaks an infinite supply of meat, at the ready for human consumption.

I pause here to note that *This Is Hormel*'s arrangement produces a familiar taxonomy of meat processing, one that in fact resembles the organization of numerous animal-rights videos and pro-animal films. Burt notes the "neat symmetry" with which his exemplars are organized: Wiseman's *Meat*, for example, extends its first hour to documenting the

course that cattle travel, from feedlot to transport truck; an "intermission" in the form of a black screen punctuates this footage, and the film then retraces this trajectory, but this time with sheep.[28] The inventory of industrial horror that comprises PETA's "Glass Walls" is organized according to species in a hierarchy of cognitive capacities: first pigs, then cows, chicken, and fish. Anat Pick finds a comparable organizing structure in *Earthlings* (Shaun Monson, US, 2005): familiar "pseudo-realist taxonomies of speciation" provide the film's substructure, and its broader arrangement unfolds as a survey of five categories of animal (ab)use—"pets," "food," "clothing," "entertainment," and "science." For Pick, the lengthy running time of *Earthlings* tests the limits of the list or litany arrangement, as the film's "collage of atrocities" can be too much to endure for ninety minutes.[29] Significantly, arrangement by species (often in a species hierarchy) is a conventional organizing structure that is deeply familiar from nature/wildlife films, where, as Nicole Seymour points out, it serves a "non- or anti-ecological" purpose.[30] If, as Pick suggests, cinema's power lays its "entanglement in the world it shoots, edits, and projects," this kind of categorical arrangement renders invisible not only connections between species and environments, but also connections that bind cinema with the world it represents.[31]

Although *This Is Hormel*'s sequences seamlessly connect in a coherent expository narrative, its narrative as a whole is presented as discrete. The film brackets its exposition of the inner workings of the Hormel plant within the timeworn frame of a tour: two young brothers, their gee-whiz curiosity piqued by a passing Hormel freight train, are granted a tour of a local plant. The tour, cheerfully conceived, is an orderly narrative that guides the uninitiated across a threshold, and asks them to observe what lies beyond. It is also a detour or diversion into a sphere detached from the tourist's lived reality. *This Is Hormel*'s flimsy excursive structure accommodates this dual mandate of instructional observation and self-contained entertainment. Indeed, the film's title deictically circumscribes its educational and spectacular value; like Roland Barthes's Photograph, it declares, "*That, there it is, lo!* but says nothing else."[32] The establishing shot that initiates the narrative proper echoes the title's declaration: tree branches, a narrow bridge, and a small swatch of water provide a bucolic frame for an anonymous industrial facility. The film's final sequence, meanwhile, itemizes the small army of on-site labor—administrative workers, lab technicians, electrical experts, machinists—required to sustain the plant as an autonomous, isolated unit. The film thus emphasizes an image of neat self-containment that extends beyond

the geographic isolation characteristic of modern American slaughterhouses. Although messy material relationships certainly constellate around the plant, they do not appear in *This Is Hormel*'s sanitized tour.

Hormel maintains this illusion of isolation today. An updated "establishing shot" of the Austin plant and its scenic environs appears in Ted Genoways's 2011 journalistic exposé:

> On one bank stands the Hormel plant, with its towering six-story hydrostatic Spam cooker and sprawling fenced compound, encompassing QPP [Quality Pork Processors, Inc., Hormel's current corporate identity] and shielded from view by a 15-foot-privacy wall. When I asked for a look inside, I got a chipper email from the spokeswoman: "They are state-of-the-art facilities (nothing to be squeamish about!) but media tours are not available." On the other bank is the Spam Museum, where former plant workers serve as Spambassadors, and the sanitized history of Hormel unfolds in more than 16,000 square feet of exhibits, artifacts, and tchotchkes.[33]

Following Genoways's account, it seems that the company has redoubled its efforts to contain its inner workings and sanitize its image, trading the potentially volatile medium of film for the comparatively stable marketing tool of the company museum and the trusted barrier of the fence.

Comparative analysis of *American Dream*, a cinema verité look at an embittered labor struggle in late-1980s Austin, Minnesota, highlights not only the pervasiveness of the conventions of the slaughterhouse aesthetic, but also the substantive impact that even slight deviations from them can produce. The film's establishing shot compositionally recalls that of *This Is Hormel*: a medium long shot frames the slaughterhouse in silhouette against a purple twilit sky. This shot recalls a haunting introductory image of Packingtown from *The Jungle*:

> The line of the buildings stood clear-cut and black against the sky; here and there out of the mass rose the great chimneys, with the river of smoke streaming away to the end of the world. It was a study in colors now, this smoke; in the sunset light it was black and brown and gray and purple. All the sordid suggestions of the place were gone—in the twilight it was a vision of power.[34]

As with *This Is Hormel* and Sinclair's novel, this opening shot situates the slaughterhouse as a space that will be revealed to the spectator—and

therefore as a space that is separate from her (to be sure, one could well rejoin that this is a mandate common to all documentary). In contrast to *This Is Hormel*, though, the shot is noticeably handheld, and thus embodies the perspective of the camera operator as a witness at the threshold. The muted din of animal squeals envelops the serene image, and the shot quickly folds into the introductory sequence, which reads, outwardly, as an abridged tour of the plant and its processes: shots follow the sequential movement of the line, tracking the reduction of live pigs into plastic-wrapped strips of bacon and softball-sized lumps of pork. The sequence lasts less than a minute, then cuts abruptly to a black screen, over which a stylized title shot stamps—indeed, brands—the patriotically rendered words *American Dream*. The film then enters a montage of television news footage and sound bites detailing Reagan-era labor politics before turning its full attention to documenting the labor struggle at Hormel.

American Dream's bracketing of the scene of slaughter within its introductory sequence initially works to support the film's prioritization of the human struggle for just working conditions. The film positions the sequence in a primary position (it comes first), yet even as it does so it establishes the animals as secondary—or even incidental. To put it quite cynically, the sequence's discrete survey of animal slaughter seems designed to establish at the outset that the human labor at the center of the ensuing dispute is highly proficient and valuable (i.e., alienated and worth rooting for). In its initial unfolding, the opening sequence detaches itself from the film's diegesis, serving as a succinct display of evidence for the spectator to keep in mind. As the film plays out, however, it reintroduces the stark evidence of slaughter. With no explicit motivation, bits and pieces of graphic footage from inside the plant flash up with irregular frequency. Eleven minutes into the film, an eight-second-long shot of the disassembly line interrupts a series of interviews with various representatives of the labor dispute; the shot frames an expressionless worker as he severs the necks of suspended pigs, and then pulls back to show an unending looped line of drawn bodies. Some thirty minutes in, an equally brief sequence connects a shot of the plant's parking lot to one of workers passing cuts of meat down a conveyor belt; these shots bleed into footage of a similar operation taken from *Hormel*, an educational film that, as mentioned, appears to be a contemporary of *This Is Hormel*; a lengthier citation of *Hormel* footage—more mesmerizing than the previous one, in my view—concludes the film. These flashes or fragments are diegetic yet only tenuously tethered to the narrative, and their insertion in the film intermittently reminds the spectator of the bloody

site from which the labor controversy emanates. Through them, the film initiates a potent critique of the conditions that prop up slaughter. One could even argue that it performs the sort of suppression so evident in films like *This Is Hormel*, precisely in order to lay bare the messy social, political, and economic relationships seething beneath the surface of slaughter.

Yet if *American Dream* introduces these connections, it refrains from rooting them in any substantive questioning of slaughter's place in the dreamwork of America. It is difficult to fault the film for falling short here—its central concern lies, after all, with human labor as it is implicated in slaughter. Curiously, though, the film's emphasis on the human actors is precisely what interrupts its outwardly dispassionate gaze. That is, the film's particular anthropocentrism obliges it to deviate from the aseptic, fetishizing conventions of the slaughterhouse aesthetic. Here it is necessary to loop back to the introductory sequence and look more closely at its attention to the human hands that animate the process of slaughter. Capturing the forceful, dexterous movements of these hands requires a fair amount of camera movement: the minute-long sequence contains slightly unstable handheld footage, several zooms, a vertical tracking shot that cuts against the conventional horizontal axis of slaughter, and a disorienting swish pan. The sequence's attention to the hands—and the rough movements such attention necessitates—shows up the sinister intimacy that the labor of slaughter requires; these hands do not impassively convey the raw material forward, but rather drive the bolt stunner into a pig's back, slice through flesh, and wrestle with meat that does not slide easily off the bone (fig. 5).

These shots underscore the obdurate, idiosyncratic fleshiness of the animals, the manipulation of which often requires the dexterity and responsiveness of human hands. In his otherwise triumphalist chronicle of the changing dynamics of modern meat production in America, Horowitz repeatedly falters on this singular quality. Indeed, his account establishes the intransigent materiality of the animal body as the lone factor that has frustrated the full mechanization of slaughter. "Animals' bodies resist becoming an expression of our will," he asserts. "To this day the meat industry remains tethered to a natural product, hemmed in and constrained by the special feature of its source. The dilemma of a meat-eating nation is that meat comes in irregular sizes and begins to deteriorate the instant its vessel, the animal, is killed."[35] Of course, this "dilemma" is precisely what sustains human labor in the industry of animal slaughter. In his history of Chicago's Packingtown, William

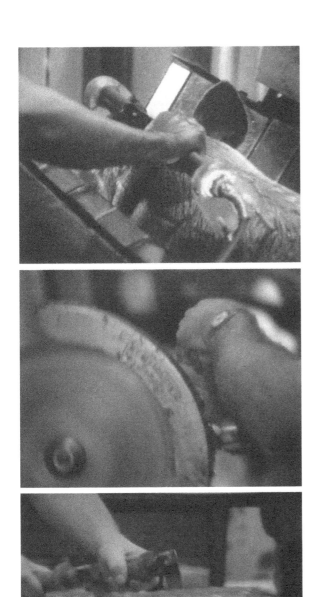

Fig. 5. A series of handheld shots of hands stunning, slicing, and cutting flesh in *American Dream*

Cronon explains that mechanization could only go so far because "ulti-mately the organic irregularities that make each animal unique also made human eyes and human hands indispensable for most of the pack-ing process."[36] Brantz adds that "the individuality of animal bodies pre-vented the standardization of slaughter, which up to this day—despite technological sophistication—still often requires the human hand and its flexibility with a knife."[37] In observing the ways in which meat gets in the way of making meat, these writers highlight the peculiar status of animals as raw material for mass production. The recurring distinc-tive shots of hands in *American Dream* likewise call attention to the ani-mals' particularity—they are irregular, unique, individual—and to the inextricability of human labor in their slaughter. The film's soundtrack amplifies this awareness: it adheres to the conventional sonic sequence of slaughter, but the rapid succession of noises creates an eerie superim-position—a kind of aural flattening as the pigs' squeals are muffled by the grinding wail of the chainsaw and the metallic whetting of a knife, and then by the crisp crease of wax wrapping paper. In these ways, the film accords with Belinda Smaill's observation that "films about the activ-ity of labor frequently fix on the gesture, movement, and energy of the worker, accentuating this dynamism through editing and music."[38] In the setting of a slaughter plant, this fixation discloses the supplemental rela-tionship between responsive human labor and automated mechanical production.

In sum, *American Dream*'s opening sequence participates in the slaughterhouse aesthetic, but in such a way that it disallows the spec-tator's adoption of a dispassionate gaze. Its distinctly unsettling quality derives from its disruption of procedure. The sequence's blunt depic-tion of the breaking down of animal bodies resists easy alignment with the filmstrip's systematic dismantling of space and time into ordered frames. The sequence follows the incremental logic of slaughter (whole to part), yet the violence of each discrete task overwhelms any potential sense of progression. Whereas *This Is Hormel*'s sequential presentation of animal disassembly slides across the screen as an uninterrupted proces-sion of fleshy material, *American Dream*'s stutters forth as an accretion of assaults on living-then-dead bodies. This accumulation underscores a perhaps obvious but no less significant distinction: slaughter differs from other modes of mechanized, mass production in its procedural trajectory (it *dis*assembles rather than assembles), and also in what it processes—living-then-dead bodies. To document slaughter, then, film-makers have at their disposal a range of techniques that can alternately

efface or emphasize the process's stark singularities. The introductory sequence of *American Dream* veers toward emphasis: its formal qualities brush against the smooth succession of mechanical disassembly, reminding the spectator of the material bodies from which meat derives.

The slaughterhouse aesthetic is so entrenched in contemporary visual culture that its conventions crop up in everything from earnest advertisements to knowing parodies. "Back to the Start" (Johnny Kelly, UK 2011), a stop-motion animated video produced for the American fast-food burrito chain Chipotle to promote its corporate philosophy of "Food with Integrity," presents an apt case in point.[39] The ad doubles as a music video for Willie Nelson's cover of the band Coldplay's song "The Scientist," the lyrics of which climb from plaintive to exultant. The video begins with an idyllic scene of a family on their small farm, complete with chirping birds and snorting pigs. An overhead tracking shot steadily charts the process by which the basic tools of their husbandry multiply into the convoluted infrastructure of intensive factory farming (silos, feedlots). The camera assumes a more rigid horizontal movement and tightened frame as it passes through the sprawling processing plant—a move that highlights the need for greater control when composing the scene of animal disassembly (fig. 6). It then opens slightly to follow the farmer-father as he contemplates the by-products of this intensive industrialization (caged animals, toxic sludge). To signal the farmer's—and Chipotle's—rejection of this new, brutal regime, Nelson belts out, "I'm going back to the start," and the camera trades its fixed horizontal track for a more mobile perspective. Adopting a fluid, zigzagging movement, the video concludes with the farmer dismantling the walls and fences of his industrialized farm, and returning to green, open pastures (fig. 6). The song fades out to the chirping of birds and the snuffle of a pig.

Long before Chipotle took up the conventions of the slaughterhouse aesthetic, the popular television cartoon *The Simpsons*—perhaps the one show in American television history that has consistently engaged with the ethics of eating meat—submitted them to parody. In "Lisa the Vegetarian" (season 7, episode 5), an episode that originally aired on Fox in 1995, Principal Skinner shows an educational film titled *Meat and You: Partners in Freedom* after Lisa asserts her newly adopted vegetarian politics in the classroom. Presented by "The Meat Council" and tagged "Number 3703 in the 'Resistance Is Futile' Series," this cartoon mockumentary cannily parodies the conventions of midcentury industrial/educational films like *This Is Hormel*. Troy McClure, a cowboy turned educational film narrator, guides an inquisitive boy named Jimmy through the pro-

Fig. 6. A mechanized tracking shot of industrialized slaughter gives way to an unencumbered mobile camera as Chipotle goes "Back to the Start"

cess of meat production. Their tour of a hypergeneric meat-processing facility conforms to the slaughterhouse aesthetic: shot in familiar tracking shots, it proceeds along the conventional trajectory, beginning in a high-density feedlot and ending with a delivery truck brimming with processed beef. Yet *Meat and You* outdoes the anesthetized educational films it parodies, glossing over the interior space of animal slaughter and disassembly entirely. When McClure guides Jimmy inside the facility to see the kill floor (which, he reassures the boy, "is more of a steel grating that allows material to sluice through so it can be collected and

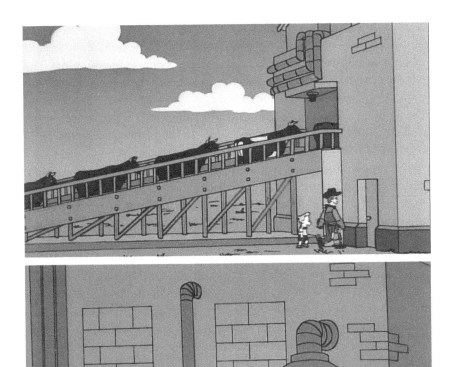

Fig. 7. An educational tour of meat production bypasses the sight of meat production in *The Simpsons' Meat and You*

exported"), the camera remains outside (fig. 7). An exterior tracking shot suggests that McClure and Jimmy are proceeding down the line but offers no visible proof of what the two see—a refusal underscored by the cinderblocks covering the plant's windows (fig. 7). The grisly nature of what occurs inside the plant is evidenced only by Jimmy's ashen face upon exiting and the sound that accompanies the exterior tracking shot. A fusion of panicked moos and wet squishy noises, this auditory confirmation of the unseen kill floor is at once comical and unsettling.

Meat and You expertly parodies the way in which films styled in the

slaughterhouse aesthetic proclaim to "show" everything but, in effect, tell us nothing—in this, it recalls the first slaughter film, *The Mechanical Butcher*, and the strange early subgenre of sausage-making films. The exterior tracking shot of the slaughter plant's facade falsely promises to grant visual access to the scene of slaughter, and it is synched to a mix of sounds that, within the diegetic world of this cartoon-within-a-cartoon, evoke the living-then-dead bodies inside. In the postmodern pastiche of *The Simpsons*, this bit of sound is but another darkly comedic effect. Yet even as it pokes fun at the hyper-efficiency of the modern meat industry, this condensed cacophony of frightened moos and "sluiced material" unnervingly insists on the unremitting material logic that grinds animals into meat. In this way, *Meat and You*'s brief treatment of the noises of the killing floor points to sound's status as a particularly unstable formal element in the tradition of slaughterhouse films.

In its marked elision of images and distortion of sounds from inside the slaughter plant, *Meat and You* corroborates Salomé Aguilera Skvirsky's insight that the process genre (defined in this book's introduction) finds distinct challenges—which is to say, critical potential—in the documentation of meat production. Corporations frequently turn to techniques of processual representation such as mesmerizing sequential arrangements to market their goods and modes of production, Skvirsky explains, because they "evince the spirit of craftsmanship" in their methodical movement through the steps of industrial production; by "track[ing] the production process from beginning to end (even when the steps are presented out of order)—from raw material to finished commodity—the spectator, unlike the factory worker, occupies a position analogous to the artisan who has knowledge of every step in the production process."[40] As films like "Taking the Mystery Out of Pork Production" attest, the marketing departments of industrial meat producers recognize the risk of adhering to the process genre because, when it comes to processing animals into meat, "The finished commodity seems less like a wonder than an abomination." Processual techniques such as an exacting focus on human labor, as my discussion of *American Dream* attests, cannot but disclose animals' idiosyncratic fleshiness and all the other striking "ways in which animals are *unlike* raw material such as cotton or wicker." Consonant with my reading of this sequence from Kopple's film, Skvirsky identifies *Meat, Blood of the Beasts, Faena,* and *Our Daily Bread* as examples of independent films that take up processual techniques "not as a stimulus to consumption but as its deterrent."[41] Ten years after *Meat and You*, MTV aired its own parody of an 1970s-era sponsored or educational film

focused on meat-making, *Wonder Showzen: The Hot Dog Factory* (John Lee and Vernon Chatman, US, 2005). Positioning this segment as a "spoof that proves the rule" of the process genre, Skvirsky notes that its use of very young child narrators provides a discomfiting "counterpoint" to its montage of archival images, as "the seemingly naive but visceral commentary of the children—which continually references animal nature, body excretions, waste, odors (e.g., poop, boogers, bad breath, dissected body parts)—makes plain the truth of the disgusting visual images, amplifying their noxious impression."[42] As TV parodies that call out the grossness of meat production more for the sake of humor than to advocate for its elimination or remediation on behalf of humans and animals, *Meat and You* and *The Hot Dog Factory* occupy a space of critique adjacent to the kind of independent films that, as Skvirsky puts it, "use the process genre against itself."[43] In the audio tracks that deliver this humor, these two short mockumentaries hit on sound's potential to unsettle what is typically apprehended as an overwhelming visual spectacle.

"The Effort Wasn't Just to Show the Slaughter": Capturing the Sounds of Slaughter

In her discussion of slaughterhouse tours as a proto-cinematic experience, Shukin suggests that the ostensibly "useless" sounds produced by animals being slaughtered (or by those awaiting slaughter) turned out to be potent ingredients in the thriving nineteenth-century trade in slaughter as spectacle. Continuing in this tradition of gory spectacle, horror films such as *The Exorcist* (William Friedkin, US, 1973) and *The Texas Chainsaw Massacre* (Tobe Hooper, US, 1974) mix sounds sourced from slaughterhouses to heighten thrilling scenes of carnage. These examples demonstrate a particular feature of the portability of sound: like "stock" images, recorded sounds can be made to circulate as generic signifiers in diverse contexts; "stock" sounds can, moreover, be aligned with images to which they bear no indexical relation.[44] If the squeals, cries, moans, shrieks, and bleats occasioned by slaughter promise to titillate spectators, they also threaten to appall, repulse, sicken, and sadden. It is not just that sound excites the spectator's affect in unpredictable ways, but also that the spectator often cannot modulate its length or intensity. As Susan Sontag points out, "Sight can be turned off (we have lids on our eyes, we do not have doors on our ears)."[45] To be sure, at-home viewing technology frees the spectator from the compulsion to listen that operates on spectators in movie theaters; speaking from my personal experi-

ence of viewing and reviewing the films discussed in this book, I hit the mute button far more frequently than I shut my eyes. The diffuse quality of sound is exacerbated by the sheer quantity or intensity of sounds in the industrial slaughterhouse: as the narrator of *The Jungle* remarks of his first aural experience of the killing floor, "One feared that there was too much sound for the room to hold."[46] It is more accurate to say, then, that the sounds of slaughter can indeed be put to "use," but they may not be as easily framed and instrumentalized as are images of slaughter.

Questions of verisimilitude and animals' particular physiognomy of suffering drive the instability or potency of the sounds made by animals facing or enduring slaughter. These factors crystallize when considered alongside Williams's discussion of the function of sound in hardcore pornography, a body genre frequently summoned in discussions of graphic images of animal exploitation and killing. Much like the cinematographic and editing strategies of the slaughterhouse aesthetic, this type of pornography is organized, according to Williams, around "the principle of maximum visibility."[47] She further defines this genre in contradistinction to its softcore counterpart: a hardcore pornographic film or video "tries *not* to play peekaboo with either its male or its female bodies. It obsessively seeks knowledge, through a voyeuristic record of confessional, involuntary paroxysm, of the 'thing' itself."[48] The correspondences between hardcore's pursuit of the "thing"—that is, of visual evidence of sexual pleasure—and the way in which cinema strives to index the exact moment of death are striking; most notably, these two efforts to document events that are always already elusive (if not invisible) are articulated according to a shared logic of supplementarity.[49]

According to the evolutionary history Williams elaborates, the object of hardcore's gaze is, increasingly, not just sexual pleasure but the precise moment of its climax—that is, of orgasm. The genre has developed conventions for fixing this revelatory moment: these include the "meat shot," a close-up shot of penetration that verifies that an unsimulated sexual act is ongoing; and the "money shot," industry jargon for a shot, usually a close-up, of a penis externally (i.e., visibly) ejaculating.[50] Williams points out that meat and money shots can only deliver so much visible proof or knowledge: the former confirms that sex is happening (but only suggests that pleasure is being had), whereas the latter evidences male pleasure. As she puts it, "Knowledge of the hydraulics of male ejaculation, . . . though certainly of interest, is a poor substitute for the knowledge of female wonders that the genre as a whole still seeks."[51] Compared to the external, visible transformations (erection, ejacula-

tion) that unmistakably index male pleasure, female pleasure remains elusive and even invisible. Williams thus conjectures that hardcore pornography charges the soundtrack with supplementing the proof of female pleasure: "In the sexual numbers a dubbed-over 'disembodied' female voice (saying 'oooh' and 'aaah') may stand as the most prominent signifier of female pleasure in the absence of other, more visual assurances." That is, the "articulate and inarticulate . . . cries of women" stand in as evidence of their otherwise unrepresentable pleasure.[52] Williams's argument resonates with a supplemental logic I have traced elsewhere: social and material conditions prevent cinema from documenting real human death, and the medium in turn relies on animal bodies to register visible evidence of death—or at least of the bodily transformation it enacts. This displacement from humans to animals does not yield the definitive knowledge of death that it promises; reviewing scenes of animal death, we acquire no real knowledge of the "fact" of death, but rather approach an understanding that humans share death—finitude, vulnerability, suffering—with animals.[53] Williams likewise argues that the hardcore film's displacement of its fact-finding mission from the image to the soundtrack never really turns up evidence of female pleasure.

The supplementary relationships Williams identifies in hardcore pornography resonate in sound's relation to the slaughterhouse aesthetic, a set of conventions that trim away the visually excessive features of slaughter—the actual sight of killing, as well as the animal body's material resistance and its unpleasant visceral residues. Burt does not mention sound in his discussion, and his silence on the matter may well indicate that the slaughterhouse aesthetic largely eliminates the aural evidence of industrialized animal killing. Yet although the framing and editing conventions of the slaughterhouse aesthetic may cut out the visual excess of slaughter, this mode of filmmaking cannot—short of muting—neatly contain the affectively potent aural evidence of slaughter.[54] Sound, in Williams's account, does not accede to easy analogy with the evidentiary frame of the image track, in hardcore pornography or in any other genre or mode. The discrete unity of the shot and the sequential linearity of the image track—cinematic properties central to the representation of animal death—possess no analogue in the realm of sound. As Williams points out, the production and experience of cinematic images and sounds are incommensurate: whereas images can be "framed" (isolated and scrutinized), sound cannot be sectioned off into discrete parts. Sound, as Mary Ann Doane observes, "*envelops* the spectator."[55] In the case of hardcore, the close microphones used in postdubbing intensify

the spectator's sense of envelopment and incite "a sense of connected-ness with the sounds they hear."[56]

Sound's capacity to bring the spectator into proximity with the images on-screen certainly holds the potential to disrupt the fetishizing frame of the slaughterhouse aesthetic and to unnerve the spectator. Thus, the inclusion or exclusion of the direct animal sounds of slaughter in films that treat the slaughterhouse has significant stakes. My preceding account of animated renderings of the slaughterhouse aesthetic suggests that the decision to include—and, moreover, to mute or to amplify—the sounds of slaughter have ideological implications. Chipotle's "Back to the Start" not only silences slaughter, but also brackets it with bucolic farmyard sounds; this aural whitewashing contributes to the advertise-ment's message that meat production can be made more pleasant. Meanwhile, *The Simpsons' Meat and You* condenses the before-and-after sounds of slaughter into a compact din that satirizes the meat industry's "sluicing" of animal bodies. Yet in its inclusion of this bit of sound, the mockumentary momentarily veers from the stable ground of cartoon parody and opens up to a more affectively charged response. The same can be said of *American Dream,* the opening sequence of which also dis-tills the aural effects of slaughter into a potent concentrate.

As with the gendered (in)visibility of sexual pleasure that Williams discusses, the affective potency of the sounds of animal slaughter derives, in large part, from the sense that we cannot really see animals' pain and suffering. To be sure, animal bodies visibly register, often in very demon-strative ways, the trauma of being killed and slaughtered: they shake, convulse, flail, thrash, and fall in pain. Yet whereas these movements are immediately recognizable as bodily signifiers of pain (and, indeed, of resistance to its infliction), animals' facial expressions of suffering may be perceived as unfamiliar and even illegible. The grimaces and facial contortions of animals in pain are typically viewed, at one extreme, as mere physical reactions to stimuli and, at the other, as possessing a depth and specificity that is always already inaccessible to humans. Yet if animals' physiognomy of suffering is easily dismissed as unimportant in its superficial physicality or illegible in its profound alterity, the sounds of animal pain and suffering—the "voices" of animals dying—are com-paratively difficult to ignore or to misconstrue. This is true of the actual spaces of slaughter. Reflecting on a series of ethnographic interviews he conducted with slaughterhouse workers, Smith writes that their com-ments attest to "how difficult it is, even for those inured by their daily experiences, to avoid hearing the call of the animals involved." He also

observes "the evolution of deliberate managerial and spatial techniques that seek to suppress the animals' room for self-expression (especially vocally)."[57] Although these techniques may be motivated by the sort of humane principles that Grandin champions on behalf of animals, shielding human workers from the disquieting cries of dying animals also serves industry interests. Such efforts to mute slaughter suggest that these sounds stand to supplement—that is, to add to and to supplant—the image track's evidence of animal disassembly.

To further illustrate this supplemental logic, I conclude by returning to *The Cove*, a film I discussed in chapter 1 and that, in performing the kind of pensive spectatorship that the category of slaughter cinema calls for, I have critiqued in different terms elsewhere.[58] To be sure, *The Cove* documents not a brick-and-mortar industrial slaughterhouse, but a murky cove in Taiji, Japan that serves as a sequestered space for the routine killing of dolphins. Yet to the extent that the "slaughter" (as the film's rhetoric puts it) in the titular cove is driven by visual politics and economic logics shared with the beef, pork, and poultry slaughter industries, it makes sense to fold comparative analysis of the film into this context. Indeed, as Janet Walker puts it, the Taiji fishermen are comparable to "workers at a Hormel plant or other slaughterhouses in the US meat and poultry industries whose livelihoods have been compromised by the consolidation of wealth among the executives and stockholders."[59]

Among the sleekest iterations of twenty-first-century documentaries aimed at revealing the deplorable impacts of late-capitalist industry on animals and the environment, *The Cove* harnesses its own act of exposure as the driving force of its narrative. An early bit of voice-over commentary aptly sums up the film's mission to infiltrate the titular cove, a "natural fortress" buttressed by tunnels, barbed-wire fences, keep-out signs, and a bellicose security detail (members of which are armed with their own video cameras): Ric O'Barry, the film's central activist, explains, "Nobody has actually seen what takes place back there. And so the way to stop it is to expose it. They've already told us that: 'Don't take pictures.' The sign says, 'Don't take pictures.' And so the way to stop it is keep exposing this to the world." In his on-screen narration, however, director Psihoyos explains that the success of his film's mission to expose and stop the slaughter of dolphins depends on the crew's ability to reveal more than the visual field:

I wanted to have a three-dimensional experience of what's going on in that lagoon. I wanted to hear everything that the dolphins were

doing, everything that the whalers were saying. The effort wasn't just to show the slaughter. You want to capture something that'll make people change.

This "something" is of course the aural experience of slaughter in the cove, which the film records using state-of-the-art, high-fidelity sound technology. In line with Williams's reasoning, Psihoyos's statement indicates that the film's recourse to the sonic registers of slaughter is intended to augment the reality of the gruesome visual scene of the cove. Yet this aural evidence comes to supplant the visual footage.

Psihoyos and his team invest so heavily in sound not only because the sounds of animal suffering and death are affectively powerful, but also because the sounds that live, healthy dolphins make are considered to be markers of their intelligence, self-awareness, and sociality—in short, of all the qualities that, according to *The Cove*, make killing dolphins an unpardonable offense. As with other cetaceans, dolphins are "acoustic creatures": their primary sensuous experience of the world is aural, and they communicate with one another in language that is audible at extreme distances. Psihoyos rhetorically aligns *The Cove*'s attention to dolphins' verbal language (i.e., to their intelligence) with biologist Roger Payne's 1967 discovery and dissemination of the singing of humpback whales. Following Psihoyos's declaration of his commitment to aural fidelity, a cut to archival footage presents protesters in Trafalgar Square in 1971, listening to a recording of humpback whales. Psihoyos explains, "In the 1960s when the IWC [International Whaling Commission] wasn't doing anything about the slaughter of large whales, there was one guy, Roger Payne, who helped start the whole save-the-whale movement by exposing to the world that these animals were singing. That was profound."

The film's reliance on sound as an index of dolphin's intelligence and sociality—in other words, of their consciousness and therefore their right to life—ups the affective intensity of the sounds it reproduces of their agonizing death. Psihoyos also stages, within the film itself, the unsettling experience of hearing dolphins about to die. In a scene midway through the film, Psihoyos, O'Barry, and several other crewmembers retire to a hotel room to "process" the footage they have lifted from the cove. The film shows them in a circle around a laptop, out of which streams the recorded sound of the dolphins fearfully communicating with one another in the moments leading up to their slaughter. The viewer hears these cries, and hears and sees the crew's disturbed response to listening to them. O'Barry remarks to his colleagues, "That's

an eerie sound, isn't it? The dolphins we're hearing now are all dead. Tomorrow there will be another group replacing them." Speaking from my own experience, viewing and listening to this scene—which takes place in a generic, white-walled hotel room—proves far more unnerving than watching the subsequent footage of carnage in the blood-soaked lagoon. The sounds of the dolphins' panicked chirrups evoke an immediacy and proximity that the later, visually oriented scenes lack. To be sure, this immediacy is driven by the film's anthropomorphic treatment of dolphin communication; knowing what the film has told me about the language of cetaceans, I hear these sounds not as inarticulate cries of fear but as the dolphins' desperate attempt to collectively formulate an escape plan from their abruptly altered habitat. The enveloping quality of these haunting sounds is amplified by the diver's comment that the dolphins' verbal response to death stands to be unceasingly reiterated. For the diver, the possibility that these sounds could resonate in perpetuity—that the same sounds of terror could be produced by different animals again and again—is intolerable. Given sound's unsettling supplemental logic, it may prove unbearable for the spectator, too.

CHAPTER 3

Cabinets of Curiosity

"From Hunter to Huntee," the first episode in season 3 of *Queer Eye: More Than a Makeover* (Netflix, US, 2019), begins, according to formula, with the Fab Five touring their newest not-just-a-makeover subject's home, taking note of items that indicate something troublesome about their lifestyle. They crowd around Jody Castellucci, a white woman in her forties who works as a guard at an all-male prison and lives with her husband on a farm in Amazonia, Missouri. As they murmur about her strictly camouflage wardrobe and inspect the compound bow that she uses to hunt deer, Karamo Brown separates from the group and steps from the kitchen into the dining room, its wood-paneled walls cluttered with bric-a-brac (a unicorn figurine, a lamp shaped like a fish). "Oh . . . my . . . God," he intones as a series of eyeline matches of taxidermy mounts—a buck, a duck, a boar—reveal the objects of his alarm. Exaggerated Foley of the cries associated with these animals—a grunt, a string of quacks, several snorts—accompanies the sequence of inserts, the eerie effect preparing Karamo's subsequent declaration: "This is a horror movie. Jesus, take the wheel." Shot-reverse shots of the mounts and his face show him cycling through expressions of surprise and disgust with varying degrees of sincerity, and a medium long shot frames him walking through the gallery and reaching out to pet the deer (fig. 8). The scene doesn't linger in Karamo's sense of unease, but quickly rights itself in humor as the camera turns to the reactions of other members of the Fab Five (Jonathan Van Ness lithely clomps like a deer, Bobby Berk likens the mounts to "all of Snow White's little friends") and to familiar activities such as inventorying the subject's medicine cabinet.

Fig. 8. Karamo Brown reaches out to pet a deer mount in *Queer Eye*'s "From Hunter to Huntee"

Karamo's assertion of genre occurs in footage from an interview that took place separately from the tour of Jody's house (he is wearing different clothes in this bit of inserted commentary), and the inclusion of this asynchronous material suggests that someone decided that this bit of narration was sufficiently important to edit into the initial tour of Jody's home. It is also worth noting that Karamo, who is Black and the appointed expert on "culture" (within the rebooted series, this domain of expertise emerges as an amalgam of self-acceptance, self-confidence, and interpersonal ease that is loosely informed by popular intersectional politics), identifies the mounts as signature genre decor, rather than Bobby, a white Midwesterner who is the resident expert on "design" and the person typically tasked with sizing up and remaking participants' domestic spaces. Karamo's declaration summons the iconography of horror films, in general, and contemporary Black horror, in particular. Taxidermy is an effective if unsurprising element of the mise-en-scène of horror films, not merely because it is morbid, but because morbid fascination with killing, preserving, and displaying animal bodies always already threatens to extend to humans—Norman Bates's stuffed birds and mother in *Psycho* (Alfred Hitchcock, US, 1960) offer the paradigmatic example of this slippage. Several recent Black horror films—including two particularly successful ones, *Get Out* (Jordan Peele, US/Japan, 2017) and the horror-adjacent sci-fi-fantasy-comedy *Sorry to Bother You* (Boots Riley, US,

2018)—mobilize this metaphor in a critique of white America's unrelenting predation of African Americans, and particularly Black men. I return to the entanglement of taxidermy (and animals more broadly) and Black masculinity in these latter two films, along with the TV series *Atlanta* (Donald Glover, FX, 2016–) in chapter 4.

Much like their cinematic counterparts, dramatic TV series tinged with horror sometimes deploy taxidermic mounts as grim symbolic decor. In police procedurals and crime dramas, they may be associatively linked with perpetrators or the investigators tracking them down—see, for example, the trophy-studded offices of the investigators in the first seasons of *Top of the Lake* (Jane Campion and Gerard Lee, BBC, Australia/New Zealand/UK/US, 2013) and *True Detective* (Nic Pizzolatto, HBO, US, 2014), or the myriad mounts and skins tucked into various homes in *Fargo* (Noah Hawley, FX, 2014). Like *Fargo*, *Bates Motel* (Netflix, 2013–17), a prequel to *Psycho*, recognizes the indispensability of taxidermy in its televisual adaptation of an iconic cinematic world; it not only features copious mounts but also stages young Norman's taxidermic apprenticeship with his dead dog ("A Boy and His Dog," season 1, episode 8). As it did with so many tropes of the detective genre, *Twin Peaks* (Mark Frost and David Lynch, ABC, US, 1990–91) subverted the association between taxidermy and homicide detection even as it established it: toward the end of the season 1 pilot, a deer trophy inexplicably rests on a table in an interrogation room at the sheriff's department (fig. 20), recalling the opening sequence's final shot, a slow zoom-in that captures murder victim Laura Palmer's photograph in the high school's trophy case. The pilot thus trades in the metaphor of the slain white beauty queen as trophy, yet simultaneously upends the equally cliched association between hunting and detective mastery. In seeming seriousness, *The Crown* (Peter Morgan, Netflix, UK/US, 2016–) associates blond beauty with trophies in "The Balmoral Test" (season 4, episode 2), in a plot that entwines the royal family's weekend-long "stalking" of a wandering stag with its acquisition of Lady Diana Spencer as a suitable marriage prospect for Prince Charles. *Trial & Error* (Jeff Astrof and Matt Miller, NBC, US, 2017–18), meanwhile, plays on the cliché using a mockumentary format to follow a legal team as they mount their defenses of oddball accused murderers in a taxidermy shop in a small town in South Carolina.

If the morbid iconography of taxidermy taps into the spectacle of horror and ties neatly into narratives of tracking down criminals, the centrality of process and the potency of class-based taste associations make it a fitting subject and decor element in the outwardly more banal

genre of reality television.[1] A number of series (albeit short-lived ones) are devoted to documenting the taxidermic process, forming a subgenre that Christina Colvin calls "televised taxidermy": *Mounted in Alaska* (History Channel, US, 2011); *American Stuffers* (Animal Planet, US, 2012); and *Immortalized* (AMC, US, 2013).[2] More frequently and perhaps less noticed, mounts crop up in the background of home-renovation reality series. Aside from *Queer Eye*, my sample here is limited to HGTV series, which, as Mimi White points out, "set the standard for property TV and . . . housing aspirations," and are imbued with "a lingering sense of domestic unease" thanks to their endless repetition of domestic conflicts that are only ever superficially resolved in the final "reveal" (*House Hunters* [1999–] and *Love It or List It* [2008–] are her primary focus).[3] Paying attention to taxidermy in these series discloses enduring sources and structures of domestic unease that extend far beyond the inevitable deferral of a fully realized "dream house" complete with harmonious nuclear family.

The most apparent of these sources lies in taxidermy's class-based associations with taste. Like television, taxidermy enlaces the high and low, at turns signifying cultivation and vulgar popularity. This duality has been embedded in taxidermy at least since its popularization in the nineteenth century, when industrial purveyors such as Rowland Ward and Ward's Natural Science Establishment began to market it as a way of "purchasing class mobility" and made "traditional game trophies . . . available to the armchair explorer along with incarnations of 'grotesque wildness' in the form of monkey, eagle and leopard 'zoological lamps' and other fusions of wilderness chic and modern appliance."[4] This history (discussed more presently) explains why taxidermic mounts are among a select class of decor objects that appear alternately in the "before" and "after" of makeover series, where they can serve as indicators of backward bad taste or as markers of distinction that imbue the newly remade home with a sense of a sturdy familial history and proximity to the "natural world." In "From Hunter to Huntee," Bobby remakes Jody's ghastly gallery of mounts simply by culling all but a select few, demonstrating the value of restraint in tasteful decor. A 2013 episode of *The Most Embarrassing Rooms in America*, "Too Much Taxidermy," affirms this principle by reducing the motley crew of specimens in a mountain lodge to six birds carefully arrayed over the mantle.[5] "Dega Don't," the third episode of the first season of the *Queer Eye* reboot (2018), likewise demonstrates that thoughtful placement can transform a lowly taxidermic form into a curated family heirloom: in the "before" segment, a

Fig. 9. A deer mount is elevated from the detritus of Cory's basement man cave to prominent living room display in *Queer Eye*'s "Dega Don't"

buck mount surfaces amid a raft of party costumes and NASCAR memorabilia in the cluttered basement mancave of white police officer Cory Waldrop, who lives in Winder, Georgia; in the "after" reveal, the same mount is moved upstairs to serve as the focal point of the newly redone family room, and Cory's wife Jennifer says approvingly of its elevation, "[The Fab Five] did it, so it's okay" (fig. 9). As in Jody's dining room, reconfiguring taxidermy in the social space of the Waldrop family's living room involves replacing most of the mounts with elegantly framed family photographs. The effect in both *Queer Eye* episodes remains disturbing: far from being assimilated into the family fold, the three-dimensional

disembodied animal heads loom out from the gallery-wall collages of cherished family moments.

Jennifer's endorsement of Bobby's restyling of the deer mount confirms that if taxidermy was deemed unfashionably old-fashioned by the 1950s, in the first decades of the 2000s it has achieved an increasingly mainstream status as fashionably old-fashioned.[6] The rise of taxidermy as emblematic of a rustic yet refined style in early twenty-first-century American decor is perhaps best evidenced by a fan's creation of a dollhouse that displays the "farmhouse chic" style popularized by *Fixer Upper* (HGTV, US, 2013–17), one of HGTV's most popular series in the 2010s: along with the series' signature shiplap walls and exposed beams, the replica features a miniature deer mount over the bed in the master bedroom and an antler-strung chandelier in the dining room.[7] Although taxidermy at times continues to signify a peculiar brand of macabre decadence (see, for example, the kitchen counters clad in alligator skins in "Rustic Luxe Redux," season 2, episode 11 of *The Kitchen Cousins* [HGTV, US, 2011–12]), in contemporary home-renovation series such as *Fixer Upper*, it more commonly expresses a popular style that embraces both upper-middle-class aspirations and nostalgia for "frontier" values—a simpler time in which Americans lived closer to the land (botanical prints, carefully placed plants, and a mock tepee in a bold stripe round out this vision in the *Fixer Upper* dollhouse).[8] Current trends in taxidermic decor find their apotheosis in the current fad for faux taxidermy: mounts of iconic quarry such as elephants and giraffes, made of materials ranging from somewhat realistic resin to cardboard undisguised as cardboard, frequently bedeck the walls of made-over rooms on reality series, and crowd the market for baby nursery decor at stores ranging from Walmart to Pottery Barn to online repositories of millennial artisanship like Etsy.com.[9] The increasing ubiquity of these patent imitations attests to their infinite reproducibility and thereby inverts the function of the hunting trophies they replicate: to preserve a singular kill.

The placement of stuffed and stretched animal skins in the mise-en-scène of television series raises questions about taxidermy's place alongside TV sets in the home. If taxidermied animals on television typically serve as shorthand (as mere "props" that signal genre and convey taste), this chapter argues that taxidermy as a craft and art form, scientific practice, globalized industry, and especially as a domestic technology/medium informs how and why we watch TV in substantive ways. As technologies of visual display that are typically mounted or otherwise prominently placed in household spaces, television and taxidermy are

historically entwined in important ways—namely, in the project of imperialism and its attendant vicarious visual pleasures, the legacies of which persist today in a racialized, acquisitive gaze that is seldom recognized as such. Foundational to the popularization of both television and taxidermy as domestic media is their facilitation of "armchair travel," allowing viewers to effortlessly experience—to collect and consume—exotic lands, peoples, and fauna without incurring the expense or discomfort of leaving home.[10]

To be sure, television and taxidermy "bring the world into the home"[11] in outwardly oppositional forms: the former is moving, multifarious; the latter, still and singular (it is dead). Yet an investment in "liveness"—in the provision of "living color"—binds the two. Beginning with the first broadcast transmissions, television's ontology has been understood in terms of liveness, primarily in the sense that television events are broadcast at the time of their occurrence, but also in the related sense that what television broadcasts is vital, lively, alive. This view of television has long been contested, even before time-shifting technologies became ubiquitous and transformed the temporal dimensions of TV spectatorship. As Jane Feuer put it in 1983, "As television in fact becomes less and less a 'live' medium in the sense of an equivalence between time of event and time of transmission, the medium in its own practices seems to insist more and more upon an ideology of the live, the immediate, the direct, the spontaneous, the real."[12] Taxidermy of course insists on liveness in the sense of being alive. It attempts to (re)present the dead animal as if it were alive, yet the very ability to manipulate the animal body into a state of frozen animation is predicated on its deadness; as Rachel Poliquin points out, "Its realism is deadly."[13] The taxidermic display of liveness/liveliness not only requires that the animal be killed, Jane Desmond adds, but also that "all marks of killing must be erased."[14]

In terms of audience and distribution, television and taxidermy likewise immediately present as antimonies: the former has traditionally been understood as a mass medium (one that has more recently bifurcated into niche markets), while the latter persists in the popular imaginary, if not in actual practice, as an eccentric hobby and unconventional choice of home decor. The image of late nineteenth-century taxidermy as a quaint practice shared by small-town artisans and Victorian homemakers must be reconciled with the reality of a burgeoning globalized trade in reconstructed animal bodies. Coote et al. capture the scale of the modern taxidermy industry in their account of "the growth of an extensive international commercial trade in zoological products [that]

manifested in a vast geographical web of sales and exchanges, which involved field collectors, freight forwarders, natural history retailers, private collectors, and museum personnel, and was supplemented by auctions, exhibitions, and expeditions."[15] In this light, taxidermy's trajectory recalls the shift from animal slaughter as a highly localized artisanal trade to a vast globalized industry that stocks homes with a steady supply of animal materials.

This chapter considers these antimonies yet focuses on the historical and representational continuities between television and taxidermy. Understanding the material and cultural entanglement of television and taxidermy makes it clear that the weighty symbolic meanings of taxidermy inhere even (or especially) in instances when taxidermy is supposed to be just that—Karamo's uneasy reaction to Jody's trophy collection attests as much. With a focus on materiality, I bring together cultural histories of television and taxidermy in order to develop a more nuanced media history of *wilding* the interiors of American homes. In this chapter, I primarily use this verb as a cross between its intransitive use, "Of an animal or plant: To be or become wild; to run wild, grow wild," and its transitive use, "To make wild, in various senses."[16] This is the sense of wilding that Karen Jones employs to describe how, in the nineteenth century, "animals drawn from the British empire animated the domestic interior in abundance: trophy heads of exotic game, cases of brightly plumaged songbirds, zoomorphic furniture and bespoke diorama displays 'wilding' the great indoors with powerful messages of captivation, consumption and conquest."[17] Television, I argue, joins taxidermy in maintaining and extending the presence of animals (and other forms of digestible difference) in the home in the twentieth and twenty-first centuries—in wilding modern American domestic space. As Jones intimates, this transformation of the home proclaims itself to be an embrace of "untamed" nature, yet it in fact enacts the opposite: bringing bits and pieces of flora and fauna into the home entails not just careful control, but "captivation, consumption, and conquest." Yi-Fu Tuan's reminder of the etymological affinity between *domesticate* and *dominate* reminds us as much: "Domestication means domination: the two words have the same root sense of mastery over another being—of bringing it into one's house or domain."[18]

In chapter 4, my use of *wilding* shifts to invoke the context it more likely conjures for many readers today: the sensationalized, racialized media coverage of New York City youths of color *wilding* in the sense "of a gang or its members: to go on a protracted and violent rampage," which

no doubt contributed to the wrongful convictions of Antron McCray, Kevin Richardson, Yusef Salaam, Raymond Santana, and Korey Wise for the rape of Trisha Meili, a white woman who was jogging in Central Park on the evening of April 19, 1989.[19] Of the branding of the accused youths' behavior with this more recent usage of wilding, Stephen Mexal summarizes: "It served to further distance the crime and the accused from the standards of white civilization. It took words like 'savage' or 'uncontrollable' and turned them into a single verb, pregnant with race anxiety." Yet as Mexal unearths in his genealogy of wilding's "complex racial and cultural history," the term can also be understood as participating in "a strategic performance of wilderness"; here Mexal refers to writers (namely, Charles W. Chesnutt and Richard Wright) and hip-hop artists who have "made strategic use of the language of wilderness in order to contest its role in sustaining racist discourse."[20] Certainly *Get Out* and *Sorry to Bother You* work in consonant ways to destabilize the racist trope of the Black-man-as-trophy, and I return, in chapter 4, to consider how they and *Atlanta* invite wilderness and "wild" animals into their diegeses in ways that likewise disrupt reductive equivalencies of Black lives and animal lives, while simultaneously challenging a long-standing (and largely well-founded) discomfort with talking about African Americans and animals together. I am drawn to the sense in both usages that wilding is an act of using or evoking animal bodies, in a jarring and almost always violent way, to transform private and public space; I establish the first usage here so that I may call on the subversive potential of the second meaning in chapter 4.

Looking at television and taxidermy together demonstrates that the displacement of animals in modernity does not proceed as a neat substitution—the replacement of "real" animals with their clean and convenient simulations or simulacra—but rather that the two commingle. My comparative approach thus opens an exploration of how taxidermic and televisual modes of bringing animals into the home change our conceptions of our relation to the world and its human and nonhuman inhabitants; that is, it illuminates the ways in which these media reorient how we view the world from within the outwardly contained space of the home. In a study of twentieth-century American television culture that is foundational to my work here, Cecelia Tichi asserts that "technologies can be bearers of ideological values carried forward from the past into the present."[21] Tichi is particularly interested in how the television environment—the domestic space surrounding the TV set and representations thereof—absorbs and reproduces values long associated

with the "hearth," namely family "togetherness" and American patriotism. Directing my attention to the adjacent focal point of the taxidermic mount, a medium that precedes the television set and at times retains (or regains) its place alongside it (and sometimes within it), I explore the ideological associations that taxidermy introduces into the home—chiefly, its value as a medium that makes otherwise unknowable animals instantly accessible, viewable, and possessable.

My project here participates in a small but strong scholarly conversation that historicizes and critically interrogates the intersection of long-established practices of animal display with what I call, following Walter Benjamin, *technically reproduced media*. This term encompasses the kinds of mechanically reproduced media Benjamin focuses on (photography and especially film), as well as subsequent forms of electronically reproduced media (television) and digitally reproduced media. I do so not to flatten the differences between photography, film, television, and digital media, but rather to distinguish them as separate from yet adjacent to the medium of taxidermy. Benjamin points out that "in principle a work of art has always been reproducible," but he identifies the turn of the twentieth century as marking a "profound change" in the widespread standardization and transmission of technically reproduced works. For Benjamin, "technical reproduction" refers to modern forms of reproduction processes that are characterized by speed, quantity, and some degree of automation—as he puts it, "the hand [freed] of the most important artistic functions." Although taxidermy in principle eschews these qualities (especially automation), in practice it increasingly adopts them (especially quantity). Taxidermy and later forms of technically reproduced media are also fundamentally connected in their provision of armchair travel. As Benjamin explains, "Technical reproduction can put the copy of the original into situations which would be out of reach for the original itself. Above all, it enables the original to meet the beholder halfway."[22]

The history of taxidermy that I carve out aligns with television insofar as both are domestic media that couple the banal and exotic—that impose order and celebrate miscellaneity. This connection emerges from the history of cabinets of curiosity, which in their bifurcated aim to showcase both order and the accumulation of heterogeneous matter, took after wild animal menageries, an earlier form of spectacular animal display, and which in turn set the stage for more modern ones, namely zoological shows. In some cases, these forms of public spectacle commingled, with the key difference being that whereas wonder cabinets

assembled fragments of dead animal bodies and inert organic material, menageries and zoological shows gathered living animals (to be sure, due to the conditions of their imprisonment, their lives were almost always short-lived).

My discussion of the inheritances of curiosity cabinets extends Jody Berland's argument that the ongoing proliferation of animal imagery in digital communication platforms summons the colonialist ethos (among other potent values and affects) of early modern European menageries. Referencing a history of displaying wild animals plucked from distant lands that stretches from Roman, Incan, and Asian empires to early modern European aristocratic estates, Berland observes that menageries invited "observers to expand their own horizons imaginatively into rich but unknown geographies without fear of injury or harm. These exotic animals bridged distant worlds and at the same time reinforced the differences between them."[23] Posing this historical context alongside advertising campaigns from the early days of computing (including Honeywell's "Morrie's Menagerie" [1964–72], a run of print ads featuring animals sculpted from computer parts, and O'Reilly Media's software guides, which, beginning in the 1970s, were styled as eighteenth-century engravings of menageries), she argues that the branding of digital-communication tools and platforms "with images drawn from menageries calls to mind the wonder and acquisitiveness of early colonial exploration."[24] Building on her analysis of these digital menageries and more recent mascots for brands like Geico, Firefox, and Twitter, my project highlights how animal images in popular television discourse in the twentieth century not only maintained colonialist values of "wonder and acquisitiveness," but reframed them as specifically consumerist desires to bring nonthreatening forms of difference into the home. In developing this argument, I expand on insights from Berland and scholars such as Cynthia Chris into the shared heterotopic functions of sites of animal display and technically reproduced media.

My attention to television nuances Berland's media history of animal imagery and complicates accepted histories of animals in modern media, which typically commence with cinema in the form of Eadweard Muybridge's freeze-framed horses and fast-forward to the riot of animal curiosities on the internet. Berland contends that prior to the 1960s, far fewer animals circulated in American advertising, and that "when an animal was part of a picture, its relationship to the story or product was comparatively direct: a cow advertising milk, a monkey or giraffe signaling the countries to which American Airlines could take you, a mustang

evoking the speed of the eponymous car."[25] My discussion of television centers on advertisements for television sets in home-decorating magazines from the mid-twentieth century (namely, *Better Homes and Gardens* from 1948 to 1960), and my research demonstrates that, beginning in the 1940s, advertising for TVs and other domestic goods and appliances in fact heavily enlisted animal imagery, sometimes in direct or literal ways, but often in more oblique forms. My analysis considers the variety of animal types that populated these advertisements and thus attests to a multiplicity of meanings circulating in discourse around television that carries over into the medium's embrace of heterogeneous content.

In developing an understanding of taxidermy's relationships with other media, this chapter engages in generative dialogue with Judith Hamera's study of how another "domestic leisure box," the home aquarium, intersects with related technologies and sites of display.[26] Although aquariums outwardly appear to have much in common with menageries and zoos, Hamera points out that the "radical otherness of the inhabitants" (an alterity that, unlike that of the charismatic species that tend to attract the most attention in zoos, remains impervious to identification), as well as the domestic labor of management and maintenance that they require, make them more like gardens.[27] The initial strangeness of bringing bits and pieces of aquatic life into the home was softened, she contends, by experiences with "overlapping and mutually reinforcing technologies that already acclimated viewers to highly mediated visual consumption in commerce and in leisure."[28] Key among these nineteenth-century technologies and media were "the shop window, the theater, the panorama, and literal and fictive travels," which in many of their iterations "linked seeing to owning."[29] Television, and particularly nature documentaries such as *The Undersea World of Jacques Cousteau* (BBC/ABC, 1968–76), contributed to the popularity of home aquariums. Television shares, moreover, in many of the "perceptual logics" that Hamera finds in the tank and related technologies.[30] The museum diorama, designed expressly to display taxidermy, serves as a crucial link between the television and the aquarium, in that it integrates "the perceptual dynamics of the window (the sense of transparent, unmediated access) and the theater (a proscenium orientation and identifiable characters) with the two-dimensional landscape painting of the panorama."[31] I look to Hamera's media archaeology of the aquarium to find structures of influence in taxidermy and television that likewise combine to solicit a possessive, consumerist gaze.

Any exploration of technically reproduced media's complicity with

taxidermy is indebted to Fatimah Tobing Rony's critique, in *The Third Eye: Race and Cinema,* of the taxidermic impulses coursing through early ethnographic cinema; this book is no exception. The cruel paradox motivating the "salvage ethnography" of early twentieth-century anthropology replicates the destructive reproductive logic of taxidermy: to capture the image of a vanishing culture requires, at minimum, acquiescing to its death, if not actively contributing to it, just as creating a lifelike mount of an animal necessitates allowing it first to die, if not killing it. Further, just as the taxidermist effaces the traces of killing, the ethnographic filmmaker erases all marks of their participation in this drama of disappearance.[32] For Rony, Robert Flaherty's *Nanook of the North* (France/US, 1922) exemplifies this deadly affinity, and nowhere more sharply than in the concluding close-up (akin to a trophy shot) of Nanook's (Allakariallak's) face:

> The head of Nanook at the end of the film is shot in a similar fashion to the head of the walrus that we see at the end of the hunt: the walrus is hunted by Nanook, but Nanook is hunted by the explorer Flaherty. The film begins with a close-up of Nanook's face; throughout the film the camera surveys Nanook's face and it becomes a landscape; at the end of the film it is this landscape which is also penetrated. The sleeping body of Nanook, like a corpse, represents the triumph of salvage ethnography: he is captured forever on film, both alive and dead, his death and life to be replayed every time the film is screened."[33]

In connecting cinema with taxidermy, Rony evokes André Bazin's observation of the medium specificity of film's "ontological obscenity": its singular capacity to replay moments "indefinitely" and in particular to repeat death, which "for all creatures . . . is the unique moment par excellence." Because it is not a "temporal art," taxidermy cannot violate our sense of "lived time" in the same unsettling way that a filmic replay of death can.[34] Yet when taken in hand with Bazin's words, taxidermy's stilled representation of creatures' deaths—a reproduction of death that it produces so that it may be looked at—is also obscene. Taxidermy and taxidermic ethnography are all the more powerful and awful because they exclusively train this repetition on marginalized others.

Rony models an appreciation of medium specificity that remains open to the generative potential of comparative media approaches—a kind of attention that I strive to adhere to throughout *Bits and Pieces.* Much as she observes of film, television bears an analogical likeness to

the medium of taxidermy. If ethnographic film is the cinematic mode that most readily adopts taxidermy's destructive reproductive logic, then reality TV is the televisual genre that poses the most striking resemblance to it today. The opening moment from *Queer Eye* offers an apt example, as it splices together dozens of shots (some filmed in one time and place, some in another) to recreate the moment of Karamo's spontaneous reaction to Jody's taxidermy gallery. Yet my goal is not so much to pursue this likeness between the cutting up and putting back together of "reality" in the form of televisual images and the material bodies of animals—fascinating though it promises to be, and indeed perversely intriguing when compounded by the laser-focused image-crafting industries of plastic surgery and social media in reality TV series like *Keeping Up with the Kardashians* (Bravo, 2007–) or by the presence of moribund animals in documentary series such as *Tiger King: Murder, Mayhem, and Madness* (Netflix, 2020). Rather, in what follows, I move back and forth between the historical developments of taxidermy and television, identifying lines of material, representational, and cultural influence.

Reading academic and popular histories of taxidermy together, in the following section I think through taxidermy as a material process and sketch out its semiotic resemblances to and historical relationships with photography, film, and television. This work connects my project to Pauline Wakeham's proposal, itself an extension of Rony's insights, that taxidermy "may be conceptualized as a sign system inclusive of but not restricted to the literal stuffing of skins that reproduces a continually re-articulating network of signs that manipulate the categories of humans and animals, culture and nature, and life and death in the service of white supremacy." In an argument that parallels Tichi's observation that technologies convey past ideologies into the present, Wakeham contends that "the semiotics of taxidermy . . . travel and transmogrify across a range of cultural texts such as museum installations, ethnographic cinema, and technoscientific discourses," and, as they transform over time, they "revivify colonial and racist discourses through malleable semiotic codes that find fresh ways to reinforce fantasies of colonial mastery in the current era."[35] Curiosity cabinets were foundational to taxidermy's development as a popular form of domestic decor and scientific museum practice in modernity, and I demonstrate how the meanings born of this material practice of collecting exotic bits and pieces of the outside world—along with congruent tropes of media acting as windows to the world and vehicles for armchair travel—have come to imbue tele-

vision with the power to instantaneously access, travel to, and consume heterogeneous material. Understanding the intersections of taxidermy and television as a rearticulation of colonial and racist discourses helps to explain the horror that Karamo (as well as Chris and Cash, the protagonists of *Get Out* and *Sorry to Bother You*, respectively) recognize in the glassy stares of the mounts they encounter in predominately white domestic spaces marked by television/as televisual. It also contextualizes now long-standing media forms of bringing animals into the home, and thereby provides a sense of how much change is needed to reorient the ways we look at and live with/alongside animals in domestic space.

Paradoxical Definitions and Defining Paradoxes

Taxidermy is a "preservative media," yet what it preserves is not exactly the animal as such but rather a human's idea of what the animal looked like when alive.[36] Historians of taxidermy take great pains to distinguish the practice from mummification on procedural and functional grounds. Mummification, which began to be practiced intentionally in Egypt around 2600 BC, relies on chemical processes to preserve human and nonhuman bodies—skin and internal organs—intact. Taxidermy, in contrast, is first and foremost a process of disassembly: removing skin, breaking down bodies, and taking out flesh and viscera. (In procedural terms, it resembles slaughter's undoing and remaking of animal bodies, with the difference being that one produces decor and scientific objects, the other meat.) The taxidermist then stitches the skins together in an attempt to approximate an idea of what the animal looked like.[37] Mummification and taxidermy also serve different ends. Made to ease the passage into the afterlife, mummies are typically interred; in rare cases when they are displayed, it is in a supine pose that approximates sleep and invites a reverent gaze. Taxidermy, in contrast, is made to be looked at—it "has always striven, simply and rather mundanely, to perpetuate the ability to look at animals."[38] Susan Leigh Star provides an important clarification for scientific taxidermy, noting that its primary function in the United States up until to 1880 was "to preserve *numbers* of specimens, not necessarily for display." As preservation techniques advanced in the late nineteenth century, so too did techniques of display, resulting in "the conversion of the museum from storehouse to showcase."[39] In this "golden era" of natural history museums (1880–1920) and continuing into the present, taxidermy becomes, in its to-be-looked-at-ness, as close to the converging forms of technically reproduced media that

surround us today as it is to the eccentric relics with which it is more frequently associated. As Mark Alvey observes, "The mounted animals of 'natural history' displays (and hunting trophies) are fashioned explicitly to be viewed, studied, admired, wondered at—like photographs and motion pictures."[40]

To be sure, taxidermy is and is not the animal; it is an indexical (re) presentation of the animal. Modern taxidermy achieves this paradoxical status—at once a "human-made *representation* of a species and a *presentation* of a particular animal's skin"[41]—through its development as a scientific and artistic enterprise, with the most definitive change occurring in the treatment of animals' interiority and attendant changes in the language to describe the practice. The term *taxidermy* first appeared in print in 1803, yet the creation of the first taxidermic specimens predates this usage—by precisely how long is up for debate.[42] Taxidermy emerged out of seventeenth-century curiosity collections in Europe that combined pickled whole specimens (mostly marine animals) and pieces of animal bodies that are less prone to decay (horns, teeth). Preserving and displaying dead animals became "taxidermy" (from the Greek *taxis*, "order," and *derma*, "skin"—literally the arrangement of skin) when practitioners began removing animals' innards, preserving the skins, and reworking them into a likeness of the animal.[43] Stuffing long served as the primary method for shaping animal bodies: in the eighteenth century, hunters often turned to furniture upholsterers to skin and stuff their trophies, and the lumpy shapes they produced were called "stuffed animals"—this phrase was soon extended to that most beloved class of children's toys, which few today associate with the display of dead animal bodies, although the current profusion of "cute" stuffed mounts sold for baby nurseries shows the connection coming full circle.[44] By the nineteenth century, it was possible to find a more specialized tradesperson in a metropolis like London by consulting the listings for "Bird and Beast Stuffers" in the city's trade directory.[45] More than a hundred years after "taxidermy" came into use, "taxidermist" became the preferred trade designation; this change registers the earlier shift, beginning in the nineteenth century, from stuffing skins with inert vegetable matter to "modeling" them on specially cast forms or models, which were either created by the taxidermist or purchased from a company. Along with "modeling," "mounting" became the term practitioners prefer to refer not just to affixing a finished specimen to a wall (as one would a flat-screen TV), but to the overall process of recreating a lifelike semblance of an animal without the use of stuffing—"a mount."[46] Both "modeling" and "mount-

ing" connote an artist's or craftsperson's deft manipulative hand and eye for spectacular display, while "stuffing" decidedly does not.[47]

This evolving terminology captures the primacy of reworking animals' skins in the processes of creating and exhibiting taxidermy. In his *History of Taxidermy: Science, Art, Bad Taste*, Patrick Morris, a renowned authority on taxidermy in the UK, recounts his travels to Europe's most storied natural history collections to uncover early examples of what he calls "true taxidermy"—that is, specimens that have been "fully skinned," their inner flesh and organs eliminated.[48] To authenticate exemplars, Morris X-rays specimens, discounting from his genealogy those that retain any interior biological material.[49] Jane Desmond's identification of the "'dermis' of taxidermy [as] its authenticating ingredient" provides the flip side to Morris's rejection of inner matter: "Throughout this taxidermic process of dismemberment and reassembly, the presence of the animal's skin, and sometimes appendages such as claws, hooves, and tails, is absolutely essential. This outer covering is what meets our eye and it must never be fake. Soft tissues—eyes, nostrils, tongues—can be glass, wax, or plastic, but only the actual skin of the animal will do."[50] Desmond's description sheds light on the peculiar "purity" of taxidermy's procedural and material composition: it is at once an additive art that requires the creative incorporation of all manner of disparate materials, and a subtractive process that purports to clear away all but the authentic surface—the mount's indexical connection to the animal.

The primacy of skin aligns taxidermy, on semiotic grounds, with photography, film, and even television. Revising Roland Barthes's likening of photography to embalming, Michelle Henning asserts that attending to resemblances between photography and taxidermy is in fact more generative: taxidermy, after all, "is all about surface appearance and is made of the skin of the thing itself. Likewise, photography is concerned with surface appearance, and takes only the skin, the outward appearance, of the real."[51] As Helen Gregory and Anthony Purdy explain, this surface appearance is etched by light onto light-sensitive paper, producing a "skin" of photographic film—a residue that is embedded in some romance language's words for film (the French *pellicule*, the Italian *pellicola*, the Spanish *película*). Here they note Laura Marks's proposal of the metaphor of skin as a way to understand how the material basis of analog film solicits modes of viewing that shift between optical and haptic— between the kind of conventional "looking at" that is predicated on distance between the viewing subject and viewed object, and a kind of sight that merges with touch, so that looking becomes, to some extent, feel-

ing in a tactile sense.[52] That taxidermy, like photography and cinema, invites optical and haptic viewing is bound up with these media's related semiotic status as both indexes and icons. "Like the photograph," Gregory and Purdy write, "a mounted specimen is an indexical trace of a real animal *before* it becomes an iconic representation of that animal." More importantly, for taxidermic mounts as with analog photographs and films, "[Indexicality] also carries more weight in its reception [than iconicity]; in Barthes's words, 'the power of authentication exceeds the power of representation.'"[53] That said, the authenticity of taxidermy derives not just from the causal relationship between referent and sign, but also from the specimen's outward fidelity to established knowledge of biological appearance—in Jones's words, its "patina of biological authenticity."[54] Television, too, can be both index and icon, though any claim to televisual images (particularly those in video or digital form) being causally or physically produced by their referents is far more contested.[55] Putting aside a convoluted proof of this bond, suffice it to say that the medium of television shares with the sign systems of taxidermy (and photography and film) a sense that authenticity is fundamental to its meaning. This perceived authenticity rests on the surface of televisual images, be they vistas of untouched nature on *The Blue Planet* (BBC, UK, 2001) or close-ups of beloved stars and trusted news anchors.

Over and above these semiotic affinities, this chapter explores the significant material, representational, and historical connections that bind taxidermy with technically reproduced media, especially television. Placed in rough chronology, it would seem that first photography, then cinema and television, simply replace taxidermy as media that make animal bodies more visible and accessible to humans who otherwise would not encounter them in person; the histories of these media unfold, however, not as tidy narratives of succession but rather as stories of complicated, ongoing inheritances. Narratives of replacement are prevalent in accounts of the changing conventions of natural history museums. "The development of taxidermic techniques reads," as Desmond summarizes it, "as a technological history of increased 'realism,' and in that way joins a historical/aesthetic trajectory that moves from painting to photography to moving pictures, or from wax recording cylinders to records to CDs."[56] Poliquin writes, for example, that "in an era before animal documentaries and color photography, museums were a primary venue for the general public to learn about nature, and taxidermy was a primary technology for making creaturely life visible."[57] Melissa Milgrom makes the more pointed claim that, in the second half of the twentieth century,

"taxidermy displays gave way to IMAX theatres and robotic dinosaurs."[58] Yet this was no wholesale replacement. Milgrom also describes the most ambitious permanent taxidermy collection yet undertaken in the twenty-first century, the Kenneth E. Behring Family Hall of Mammals in the Smithsonian's National Museum of Natural History, which is at once remarkably regressive in its collection approach (it contains trophies of endangered animals, shot by the Hall's namesake) and modern in its design approach: the African Hall, the exhibition's signature space, features "television screens embedded in the floor like rocks in a stream."[59] The hall also includes an "Evolution Theatre" that screens a film on loop and numerous interactive computer displays.[60] This example suggests that if technically reproduced media pushed taxidermy from its central position in natural history museums in the twentieth century, they now work to update a medium wary of being perceived as "old-fashioned."

Taxidermy's sustained involvement with technically reproduced media extends beyond the institutional public space of the museum and is particularly apparent in the labor of its practitioners. For example, Gregory and Purdy point out that although taxidermy is often thought of as a pre-photographic practice, the two media in fact "grew up" together and share "intertwined histories."[61] In practical terms, the camera and gun work hand in hand as tools for "capturing" animals and their images.[62] This is as true now as it was in the 1880s, when Étienne-Jules Marey invented a chronophotographic gun (*un fusil photographique*) to "shoot" birds in flight and produced some of the first moving images of animals. In her *Complete Handbook of Taxidermy*, Nadine H. Roberts counsels aspiring taxidermists to purchase a camera and learn how to use it, because cameras come into play at every stage in the taxidermic process, including taking "trophy shots" in the field of the dead animal bodies they will transform into mounts, studying magazine photographs as instructive models, and creating and circulating a photographic record of their craft.[63] Garry Marvin writes evocatively about the inseparability of the trophy mount (the taxidermied animal) and the photographic trophy, observing that the latter, which almost always hangs alongside the former in the home collections of hunter-taxidermists, documents the instant at which the hunter turns, triumphantly, away from the felled prey and adopts an outward gaze and pose more akin to that of a tourist displaying their occupation of "a site/sight of interest."[64] Taxidermy is also entwined with the film industry. Having honed their modeling skills over years of intricate work with resistant materials, taxidermists can find relatively lucrative work creating decor and special effects on

film and television sets.[65] Taxidermy serves not only as suggestive decor but also as a replacement for animal actors on sets. Although filmmakers today increasingly turn to CGI in order to avoid using live animal actors (and thus avoid the allegations of animal cruelty that frequently accompany such use), renting taxidermic specimens offers a more budget-friendly alternative, and in some cases it may be aesthetically preferable given that computer-generated images of animals risk falling into the "uncanny valley" of disquieting resemblance.[66] Although live animal actors and computer-generated facsimiles predominate, industry demand for taxidermic specimens is evident in the ACME Film and Television Directory, which currently lists six rental houses that specialize in renting taxidermy and other "lifelike" animal forms to film and television productions.[67]

The complementary—indeed, supplementary—relationship between taxidermic, photographic, and filmic processes is nowhere more evident than in the inventive output of Carl Akeley, perhaps the most influential taxidermist of all time. Remembered primarily for the innovative dioramas populated by magisterial taxidermic specimens that he created for the Field Museum of Natural History and the American Museum of Natural History, Akeley's invention of a lightweight and easily handled movie camera is less often discussed but no less important (indeed, it stands to reason that more people have viewed films shot with his camera than have seen the many mounts and dioramas he painstakingly created). Mark Alvey recounts that Akeley began developing the camera after being disappointed with the limitations of existent cameras during a 1909 expedition, patented it as the Akeley Motion Picture Camera in 1915, and sold it for exclusive use to the US Signal Corps during World War I.[68] Just as the War Department valued the camera's dexterity for aerial reconnaissance, filmmakers in varied arenas would come to appreciate its unique mobility and ease of use, among other features: numerous explorers and scientists, Akeley among them, recorded their expeditions with Akeleys; the same appeal held for documentary filmmakers, including Robert Flaherty, who used two Akeleys to shoot *Nanook of the North*; Pathé and Fox Movietone made the Akeley the de facto camera for shooting newsreels; and into the 1940s Hollywood studios used them on both backlot productions and on location.[69]

Akeley developed his film camera precisely to facilitate the creation of moving-image records that, along with an array of other media (stereoscopic photographs, drawings, clay molds, death masks, written notes dense with exactly detailed data), would serve as instructive transcrip-

tions from the field once he returned to his workshop and faced the task of sculpting inert skins—the only animal material he brought back—into realistic specimens. In relying on cameras to produce more realistic taxidermic specimens, Akeley participated in a larger trend: in the early twentieth century, as Desmond explains, the new medium of plaster-of-paris modeling "combined with that of early film as taxidermists turned from sketching to cameras to more accurately capture movement and muscle."[70] Focusing on reception rather than production, Morris likewise argues of this same time period that "the development of photography, then television, provided better access to wildlife than stuffed specimens, so public expectations were raised and the appraisal of bad taxidermy become more critical."[71] In other words, technically reproduced media do not replace taxidermy, but rather create a consumer market that impels practitioners to create more realistic taxidermy.

Taxidermy is not a medium that easily accedes to technical reproduction (as are television, photography, and film), yet it is a highly "reproducible" medium. Citing Donna Haraway's claim that "taxidermy fulfils the fatal desire to represent, to be whole; it is a politics of reproduction," Wakeham elaborates that taxidermy "is also a technology that is particularly *reproducible*—a technology that has been repeatedly reproduced for politically charged uses since the early 1900s."[72] In the popular imaginary, the human labor of creating taxidermy is considered to be, if not solitary artistic practice, then an idiosyncratic artisanal one; perhaps more importantly, the sense that taxidermy (especially the taxidermic genre of hunting trophies) derives its auratic authenticity from the singularity of the mount is fundamental to its ontology. These associations are at odds with the historical reality in which taxidermy becomes, if not ubiquitous, a common fixture both in everyday domestic spaces and in institutional spaces of science, education, and entertainment. To be sure, taxidermy will never reach the level of abundance of more easily standardized items of mass production because the idiosyncrasies of its material inputs prohibit full automation. Every animal, Star points out, "differs in size, texture, and its vicissitudes of decay," and transforming animal bodies into realistic mounts thus requires a great many different kinds of tools and highly skilled practitioners.[73] As with even the most industrialized forms of animal slaughter, taxidermy requires the involvement—and indeed intimacy—of human labor. Yet although these processes of animal dis- and reassembly may always necessitate some skilled intervention by the human hand, many aspects of taxidermy were (like slaughter) standardized and scaled up in tremendous proportions in the late nineteenth

and twentieth centuries. More than any other development, the ready availability of inexpensive premade animal forms from mail-order catalogs (and now online sites) has made it much easier to produce taxidermy, particularly for non-expert hobbyists. Many other facets of the process have been streamlined: for example, all taxidermists source their glass eyes in standardized sizes from a few firms that specialize in their production.[74]

A brief account of the leading taxidermy houses of the United Kingdom and the United States (both confusingly bearing the name Ward) illustrates modern taxidermy's immense scale. Ward's Natural Science Establishment, founded in Rochester, New York, in 1873, was the largest American dealer—by the end of the nineteenth century, at least one hundred American museums displayed specimens from Ward's.[75] Akeley cut his teeth working at Ward's as a teenager and nearly became disillusioned of taxidermy because the company prioritized speed over craft; after quitting and moving on in his career, he referred to Ward's approach as "upholstery."[76] But the pace and quantity of production at Rowland Ward in the UK far surpassed that of Ward's. Jones recounts the process of unpacking shipped animal carcasses in the company's London workshop, which in a metaphor that precedes Upton Sinclair's novel, was called The Jungle: "Following disinterment from crates and barrels, biotic material was cleaned and cataloged in a process that could only be described as industrial. Speed was of the essence; as Rowland Ward noted to Powell-Cotton, every second the animal was in the workshop it was 'spoiling all the time.'"[77] Yet if Rowland Ward's nineteenth-century operations ran at breakneck speeds and produced prodigious amounts of taxidermy, they "scarcely rivalled the 'factory system' of the Van Ingen brothers in Mysore (which produced some 43,000 leopard and tiger mounts between 1900 and 1998)."[78] Although the mass production of taxidermy may sound like a thing of the past—an unfortunate blip in colonial history—it remains alive and well. Milgrom describes the Smithsonian's fifty-thousand-square-foot taxidermy lab in Newington, Virginia, where the majority of the specimens for the Behring Family Hall of Mammals were produced in the early 2000s, as like "IKEA if IKEA sold only stuffed animals."[79]

The image of an IKEA store overflowing with taxidermy speaks to how taxidermy, in its growth as a global industry, both democratized and diversified the trade. Whereas the industrialization of slaughter in Europe around the same time manifested as the swift absorption of dozens of specialized, site-specific jobs into one sequestered space of slaugh-

ter, the industrialization of taxidermy entailed audience fragmentation and dispersal into divergent genres. Taxidermy began to spill over from the exclusive domain of the wealthy elite in the beginning of the nineteenth century, as members of the industrial middle classes found themselves in possession of more money and spare time, some of which they spent on taxidermy.[80] As Poliquin puts it, "Taxidermied creatures were democratized as gorgeously ennobling for everyone."[81] Taxidermists set up shops in cities and towns across the United States and Europe, with some towns in England supporting upward of a dozen taxidermists at a time. In order to distinguish themselves, many individual taxidermists and all large taxidermy firms began to specialize in working with certain kinds of animals (birds, for example) or producing certain kinds of mounts (hunting trophies).[82] "This burgeoning industry," Jones explains, "catered for all tastes and budgets, from traditional sporting masks and memorialized pets to cases of game birds and tea-supping kittens in anthropocentric pose."[83] Taxidermy's fragmentation into specialized markets resonates with television's trajectory as a mass medium that has more recently bifurcated into niche markets. As I demonstrate in the next section, taxidermy and television likewise both come into being—and into the home—in the form of collections that secure enduring audience appeal and symbolic value from their assemblage of animals.

TV and Taxidermy as Heterotopia

The paradoxical (re)presentational nature and material composition of modern taxidermy make sense within the historical context of the medium's development in two overlapping spheres of spectacular consumption: the natural history museum and the home. "Perhaps uniquely," Morris wagers, "taxidermy support[s] both scientific enquiry and household ornamentation."[84] Or, as Colvin puts it, "Two forms of taxidermy predominate in the popular imagination: the type specimen in the natural history museum and the severed-head-style hunting trophy."[85] Although I am more interested in the latter and its relation to other domestic media, both kinds of taxidermy are best understood within the larger shared historical contexts out of which they developed. The origins of both scientific and decorative traditions of taxidermy lie in early modern *Wunderkammern*, or "cabinets of curiosity." Cultural histories of taxidermy consistently identify sixteenth- and seventeenth-century wonder cabinets as the starting point for the crisscrossing tracks of the "taxidermic project"—a project that, in Jones's words, amounts to

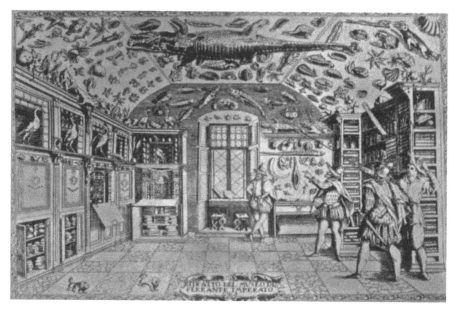

Fig. 10. First known published image of a natural history display, Ferrante Imperato's curiosity cabinet in Naples

a centuries-long "compulsive culture of hunting and collecting" and, in Steven Asma's, speaks to a long-standing impulse "to hoard dead things and display them in groups."[86] The domestic precursors of museums, curiosity cabinets assembled the organic spoils of empire. A prized feature in the homes of European royalty, aristocrats, and members of the merchant class, they sometimes began as small collections in cupboards or boxes, but frequently their contents multiplied until they filled entire rooms, and these rooms were in turn bedecked with shelves and the kind of furniture display cases that we now refer to as cabinets. An engraving of the Italian noble and apothecary Ferrante Imperato's curiosity cabinet, published in his 1599 *Dell'historia naturale di Ferrante Imperato napolitano Libri XXVIII* and renowned to be the first image of a natural history collection, suggests a set of representational strategies translated from individual boxes to entire rooms: the ideal view, arranged along a linear Renaissance perspective, takes in the full array of objects (fig. 10).[87]

The items arrayed in these early collections were resolutely curious both in and of themselves, and as a collection. Given the limitations of preservative techniques and the challenges of overseas transportation, animals were rarely preserved whole, and "no attempt was made to achieve life-like form."[88] Poliquin explains, "If naturalists and collectors

did not travel to see exotic nature for themselves, what arrived from distant lands invariably arrived as enigmatic bits and pieces."[89] This sense of fragmentation persists in suggestive lists in accounts of curiosity cabinets: Poliquin refers to "snippets of fish, leg bones, horns, and loose feathers," and, in a more exhaustive summary, to "horns, bones, beaks, antlers, teeth, claws, feathers, eggs, tufts and balls of hair, and calcitic deposits expelled or found inside human and animal bodies."[90] She suggests that competing presentational logics drove these early collections. Typically, "collectors mingled artifacts indiscriminately in chaotic displays of visual delight. Strange fish and mummified reptiles hung from the ceiling, stuffed birds and mammals lined the walls, shells and dried reptiles were arranged in drawers, and pickled sea creatures stood in glass jars in open cabinets."[91] An indiscriminate approach can amount to an inclusive one: as Wakeham explains, early curiosity cabinets "constituted a more idiosyncratic form of collection that often aspired to the impossible ideal of universality, of collecting and representing everything."[92] Yet an ascendant order—founded on form rather than species—emerged in some collections. Poliquin notes, for example, that Sir Hans Sloane's vertebrate collection (itself part of a vast collection that provided the foundation of the British Museum, British Library, and Natural History Museum in London) "was divided into smaller assemblies of parts from divers animals: a collection of teeth, a collection of feathers, one of beaks, another of skins, and an assortment of horns." Yet whether they were haphazardly assembled or grouped by type, these collections' most striking quality was their extravagant heterogeneity. These "cornucopia" or "smorgasbord[s] of exotic specimens" appealed to the desire for knowledge that gives these cabinets their name.[93]

Televisions were the curiosity cabinets of the twentieth century—a role that persists into the twenty-first century, albeit in convergence with new media, especially streaming platforms. In the first decades of their diffusion, televisions were encased in heavy wooden cabinets, and the television schedule has long been understood as assembling heterogeneous material, much of it from disparate sources—Raymond Williams's characterization, in 1974, of broadcast television programming as "miscellaneity" remains the most enduring summation of the medium's "content."[94] I turn to animals' place in the planned sequencing or "flow" of varied TV content in the final chapter, and here maintain my focus on television's material presence in the domestic environment and the ways in which that presence has, like taxidermy, been variously imagined (and imaged) as a curiosity cabinet, window to the world, and vehicle

for armchair travel—all of which are material practices and figures of speech that often trade in animals, and that are indeed founded in part on the activity of looking at animals.

John David Rhodes proposes that the curiosity cabinet, as forerunner to the museum, in turn informed the "cultural practice of cinemagoing," which he demonstrates is imbued with the "pleasure we take in immersing ourselves in the visual and sensual pleasure of other people's property."[95] Owners of curiosity cabinets displayed their extravagant collections only to their invited social peers (that is, to other wealthy elites), and the rise of country house tours in England in the early modern period opened the practice of entering and admiring others' homes to the public. Here Rhodes cites Adrian Tinniswood's observation that "the cabinet's and the country houses' contingencies were bound together by a powerfully attractive force—that of ownership, of the simple fact that the house and its objects belong to someone else and not to the interested observer."[96] Rhodes's contention that cinema too shares this force easily extends to television, a medium that may in fact surpass the others in the flagrancy of its exhibition of property—what is HGTV if not an endless tour of homes that the viewer does not and cannot own? In what follows, I argue that mid-twentieth-century television discourse positions animals as key props (or property) in its efforts to acclimate viewers to the strange new set, and in doing so it affirms animals' status as consumable property.

The spark of inspiration as well as the analytical foundation for my examination of the animals circulating in this discourse come from Tichi's study of TV's consolidation of American values and Lynn Spigel's rethinking of the medium's effects on public and private space. Picking up on their attention to texts that surround the TV set in the domestic environment and shape the viewing experience, I return to some of Spigel's central paratexts—specifically, advertisements that appeared in *Better Homes and Gardens*—with a new focus on the beings that animate them. For Tichi and Spigel, these beings remain elusive, sketched out only as generic categories. Referencing the Whittle Communications Corporation's claim that "our TVs are active family members," Tichi writes that "the television set of the late 1980s appears in anthropomorphic terms as live-in lover and family member."[97] In *Make Room for TV*, Spigel avers that magazine advertisements and other forms of popular discourse around television called on "anthropomorphism" as a strategy to naturalize the set within the home:

The magazines described television as a "newborn baby," a "family friend," a "nurse," a "teacher," and a "family pet" (a symbol that . . . had previously proven its success when the Victor phonograph company adopted the image of a fox terrier for its corporate logo). As the domesticated animal, television obeyed its master and became a benevolent playmate for children as well as a faithful companion for adults.[98]

Struck by the claim that early television discourse explicitly linked the medium with animals, I set off to find this TV-as-pet advertisement. Although my search for this specific reference came up empty-handed, it led me to dozens of other advertisements that explicitly figure animals as natural accessories and ready companions for the television and its human viewers.[99]

Many of these ads echo the example that Spigel gives to illustrate the above claim: a 1952 advertisement for an Emerson set in which "the immanent pet-like quality of the television set emanates from the screen where a child and her poodle are pictured."[100] This screen image of the girl and her poodle served as a stock image that cycled through various of Emerson's advertisements in the 1950s, sometimes appearing as the dominant image and at other times as a smaller image on a satellite set; it thus recalls the recirculation of slaughterhouse footage in films such as *Hormel* and *This Is Hormel*, and conforms with the larger sense of animal imagery's generic "portability." In an Admiral advertisement that is a close relative of Emerson's girl-with-poodle ad, a spaniel gazes at a set displaying two happy children in birthday hats (fig. 11). A human viewer has recently vacated the scene: his leather loafer is lodged in the dog's mouth and his plaid bathrobe puddles in a nearby armchair.[101] The advertisement thus asserts television's power to instantly transport spectators to new worlds, yet by coupling the set with "man's best friend," it reassures viewers that they can readily return to the cozy security of the domestic viewing environment. In this and similar advertisements, the use of conventional pets (dogs, cats) packages the medium as a timeless, limitless font of escapist entertainment and companionship, qualities summed up in a Motorola ad, published in 1948, that pictures a family and their cat delighting over their new set—"the gift that sings, talks, and lives for years."[102]

The use of pet imagery to anchor television in a secure and enduring home-viewing environment accords with Erica Fudge's exploration of the coupling of pets with ideals of domestic stability.[103] Fudge refers to Tuan's

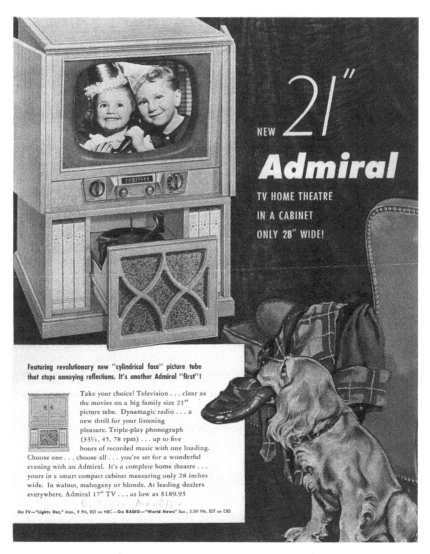

Fig. 11. A dog awaits the return of his owner, who has been transported by television, in Admiral advertisement

argument that human-pet relationships began to assume increasing intimacy in western Europe and North America in the nineteenth century because, given the seismic shifts toward industrialization and urbanization, "humans needed an outlet for their gestures of affection [as] this was becoming more difficult to find in modern society as it began to segment and isolate people into their private spheres."[104] Tuan's expla-

nation, she points out, builds on John Berger's argument that the exponential increase in the number of pets in the last two centuries "is part of the withdrawal into the private small family unit, decorated or furnished with mementos from the outside world, which is such a distinguishing feature of consumer societies."[105] Although I do not share Tuan's view of human-pet relationships as merely sentimental or Berger's suggestion that pets today are reducible to "mementos" or decorative objects, I do find their observations about the movement in modernity of nuclear families and pets into the sequestered space of the single-family home to be a suggestive explanation of how and why animals, in the forms of taxidermy and television, take up residence inside the home. Their claims persuasively suggest that a desire for animal company motivates the wilding of modern homes.

Pets and televisions are, after all, among the most affectively potent coinhabitants of the home. As the preceding advertisements foreground, they live inside our homes, at our hearths, waiting for our return, ready to entertain and provide us with company. Pets and TV sets—or, more commonly today, various devices and cable/streaming subscriptions—are often acquired by humans expressly to alleviate loneliness, and to provide a routine that fills time and a schedule that demands a satisfying (at least to humans) daily cycle of dependence. Televisual liveness conveys a sense of "co-presence" that, as Spigel puts it, supplies the feeling of "being alone, together"[106]—a feeling that some might ascribe to the experience of living with pets. And if the aforementioned advertisements appeal to the stability of the homebound pet and TV set, it is also true that animals and television harbor heterogeneity and contingency. The alluring possibility of the unexpected persists in the most docile of pets and mundane of programming—a potential demonstrated by the preponderance of videos featuring pets in *America's Funniest Home Videos* (US, ABC, 1989–).

The family pet was but one of a multitude of animals called on to sell television. Although pets predominate among animal figures in TV marketing of the era, numerous advertisements enlist other kinds of animals: working species (horses), charismatic megafauna (elephants, giraffes), amorphous cartoon beings, and, yes, even taxidermy.[107] Domestic taxidermy had begun falling out of mainstream fashion in the decades before the wholesale embrace of televisions in the home, which may explain why television sets and taxidermic mounts seldom appear together in advertisements for televisions. In the magazines and archives that I surveyed, I located just one instance: an advertisement

featuring a bird mount (a pheasant, or perhaps an uncharacteristically drab peacock?) poised above an Emerson set, published in *Better Homes and Gardens* in June 1951 (fig. 12).[108] This ad carefully arranges the essential iconography of the genre: the bird's wing tips down to meet the upward swing of the on-screen tennis player, while a metal urn on the console and a lush garden of palm fronds glimpsed through the window complete the union of TV technology, fauna, flora, and worldly cultural artifact. Additionally, the language of the "crash test" evokes the heft of automobile technology, embodying it in the masculine expertise of the man tuning the dial. Emerson's mascot in the bottom-right corner reiterates the advertisement's play on the dual senses of life: trumpeting the slogan "Better Performance . . . Longer Life," the elephant promises a television that delivers both vivid liveness and long-lasting durability.

While the avian mount in the Emerson ad is a rare instance of taxidermy appearing alongside a TV set, the prevalent display of varied kinds of animals in popular TV discourse (decorative animal figurines, on-screen animal spectacles, pets as companion or surrogate viewers) presents the domestic television environment of the 1950s as a sort of suburban wonder cabinet—a space to display heterogeneous animal and plant forms, along with worldly artifacts. The display of animal variety served as a marker of television's production of miscellany and anchored the new medium in a familiar past. Strategies for naturalizing the TV set within the home situated the console in continuity with both earlier styles in home decor, and older media and technologies. They aligned, first of all, with the late nineteenth-century "Indian craze," Elizabeth Hutchinson's term for the "widespread passion for collecting Native American art, often in dense, dazzling domestic displays called 'Indian corners.'" Long before they instructed consumers in how to arrange their TV sets, homemaking magazines such as *American Homes* modeled how to adorn middle-class domestic space with Native American art, a commodity that was readily available for purchase not just at "Indian stores" but at department stores like Macy's.[109] These magazines' advice to dress the TV set with tokens of nature and culture also took up techniques for outfitting middle-class homes with taxidermic specimens. In *Practical Taxidermy, and Home Decoration* (1880), Joseph H. Batty recommends that "a fungus bracket over the piano, or group of stuffed birds under the statue in the corner, or an arch of ferns and berries over the folding-door, give an air of culture and refinement to a home, however humble it may be."[110] Batty's assertion that bits of nature will evoke cultured refinement synchs with Hamera's explanation of the appeal of

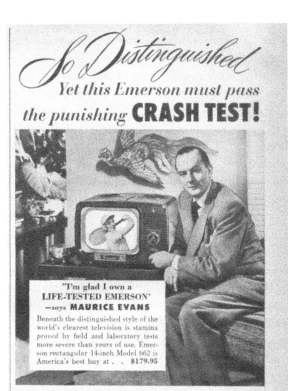

So Distinguished
Yet this Emerson must pass the punishing CRASH TEST!

"I'm glad I own a
LIFE-TESTED EMERSON'
—*says* **MAURICE EVANS**

Beneath the distinguished style of the world's clearest television is stamina *proved* by field and laboratory tests more severe than *years* of use. Emerson rectangular 14-inch Model 662 is America's best buy at . . **$179.95**

LIFE-TESTED for LONGER LIFE, Better Performance

3-Way
Pan American
Portable
Model 646
$29.95
(less batteries)

20-inch
Rectangular
Model 694
$499.95

17-inch
Rectangular
Model 687
$379.95

Home Radios are
Priced from $16.95

Trap-Door Crash Test! Releasing the trap sends this Emerson crashing with its full weight to the hard floor. Despite this punishment, *far* more brutal than normal shipping, Emerson *must* perform perfectly when tuned in!

Emerson
LIFE-TESTED
Television and Radio

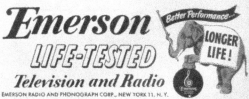

Better Performance...
LONGER LIFE!

EMERSON RADIO AND PHONOGRAPH CORP., NEW YORK 11, N. Y.

Prices slightly higher in South and West • Prices Include Excise Tax and Warranty

129

Fig. 12. A taxidermic
mount complements
a television set
in Emerson
advertisement

aquariums several decades later, as suburbanization began to take root and produced an "increasing demand for a portable and manageable 'nature' to compensate for the increasing absence of 'the country' from 'the city.'"[111] What is most notable about these strategies of display is that they evince an aptitude for cultivating and curating collections of heterogeneous materials so that they introduce a pleasing, unthreatening sense of difference into the home.

The confluence of nature and culture is apparent in advertisements that associated television specifically with animals and preceding forms of technology. For example, a full-page DuMont advertisement (fig. 13) published in 1950 marketed three snootily named sets (the Westminster Series II, the Burlingame, and the Andover) as "The Future with a Present." Featured in the November issue, as so many advertisements for the big-ticket item of television were in this era, the ad's slogan puns on the dual meaning of "present": a gift and the temporal now. Yet the ad relied more heavily on the past in its imagery: charmingly stylized drawings feature each set (cabinet closed to conceal the futuristic screen) perched atop a horse-drawn carriage operated by a nattily uniformed coachman, while in the upper foreground a larger image of an open console, clad with a red Christmas bow, displays an image of Santa Claus.[112] The ad's equine imagery recalls Akira Mizuta Lippit's observation that "when horse-drawn carriages gave way to steam engines, plaster horses were mounted on tramcar fronts in an effort to simulate continuity with the older, animal-driven vehicles. . . . Animals appeared to merge with the new technological bodies replacing them."[113] The ad's antiquated horse-drawn carriages thus rein the present-tense and fast-forward march of television into a reassuring past.

Second only to dogs and cats, horses are the nonhuman species that appear most frequently in midcentury advertisements for televisions. They typically feature as the screen image, their leaping profiles evoking Muybridge's equine motion studies and reaffirming the foundational allure of animal movement in the development of moving images. Pairing one such image with the tagline "most powerful ever built," an Admiral advertisement that ran in the March 1949 issue of *Better Homes and Gardens* evokes horsepower to associate television with the kind of unimpeded (auto)mobility prized in postwar America (fig. 14).[114] A two-page spread for RCA Victor that appeared in the July 1953 issue of the magazine does away with the television screen itself (a move common in advertisements of the era, as they sought to foreground the concealability of the TV set), presenting five closed cabinets, the most prominent

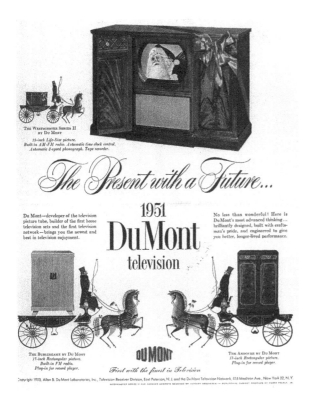

Fig. 13. Horse-drawn
chariots display
closed television
consoles in DuMont
advertisement

topped by a bronzed sculpture of a horse in full gallop.[115] An earlier
Motorola advertisement presents a less ostentatious version of the same
design: five cabinets, the central one ornamented by a stylized drawing of
an equine sculpture.[116] In another Motorola ad, four men watch football,
the glare-free screen lit by a lamp with a metal horsehead base.[117] This
small assortment of ads shows up the symbolic versatility of horses.[118]
They are, first and foremost, status symbols, yet depending on breed and
function, they can signify working-class prosperity or upper-class pedi-
gree. Horses are also working animals, and, as Lippit's observation about
horseheads affixed to trams indicates, their labor is primarily associated
with transportation and movement. This combination of status and
mobility makes them an apt figure to escort television into the home.

Delving further into the varied zoomorphic packaging of the medium
entails unpacking the television as "box." Descriptions of early TV sets
frame them as an organic container—indeed, a crustaceous one—in
language that contrasts the sleek flat screens of today. Tichi refers to
the technology's veneered casing as the "receiver carapace," while Paul

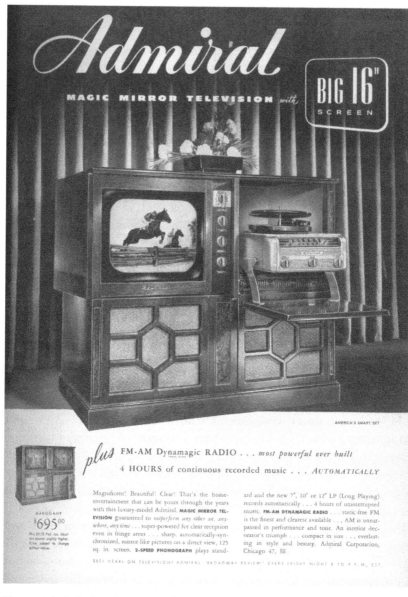

Fig. 14. Admiral advertisement evokes horsepower

Frosh, noting the television set's "self-sufficiency," describes it as "packed within a shell."[119] In the postwar context in which television emerged, this metaphor of a protective casing conjures a defensive retreat into isolated bunkers that conforms with the medium's associations with domestic containment and privacy. Withdrawal into the shell or container of television can also be understood as taking refuge in dreams, to call on Gaston Bachelard's phenomenology of the intimate spaces offered by shells, nests, and other homespun lairs.[120] Most relevant to my focus on technically reproduced media, the encasement of television calls to mind Benjamin's reflections on the profound shifts in perception of and access to art that were occasioned by the rise of mechanical reproduction:

> Every day the urge grows stronger to get hold of an object at very close range by way of its likeness, its reproduction. Unmistakably, reproduction as offered by picture magazines and newsreels differs from the image seen by the unarmed eye. Uniqueness and permanence are as closely linked in the latter as are transitoriness and reproducibility in the former. To pry an object from its shell, to destroy its aura, is the mark of a perception whose "sense of the universal equality of things" has increased to such a degree that it extracts it even from a unique object by means of reproduction.[121]

In light of Benjamin's critique, the ornate console—almost invariably described as "hand-rubbed" and pictured laden with carefully curated curios—disassociates the physical set from the mass media it broadcasts, framing television's ephemeral flow of generic content as "unique and permanent."

Curiosity cabinets afforded both "view and enclosure," Rhodes points out, and so too did TV cabinets.[122] As an enclosure, the wood casing of the box served several complementary purposes. Practically speaking, it contained the technology, messy wires and all, giving it, as Frosh explains, a sense of self-enclosed autonomy within the room.[123] It also frequently housed complementary (or competing) technologies, such as phonographs and radios. In addition to this pragmatic functionality, wooden TV consoles played a significant role in naturalizing the technology within the space of the home and in acculturating viewers to the practice of daily viewership. Tichi points out that "television, during wartime connected with precision radar and explosives, enters the postwar American household not as technology but as elegant furniture suit-

able for the 'country home.'"[124] Wooden cabinets that could be closed when the "tube" was not in use were particularly effective in concealing the reflective screen of cathode-ray tube (CRT) sets, which was sometimes cast as an "eye." Competing anxieties imbued the ocular qualities of the TV screen. In her analysis of television's recalibration of public and private space in postwar America, Spigel highlights concerns—quite prescient ones in light of the routine collection of user data by various media devices and platforms today—that the "new TV eye threatens to turn back on itself" and "becomes an instrument of surveillance."[125] Historicizing these changes in London in roughly the same period, Paul Cook characterizes the screen as "an opaque unseeing eye [that] immediately draws attention to itself as a kind of modern Cyclops."[126] Whether it was conceived of as hypervigilant or monstrously impervious to its environment, it was best to keep the screen veiled inside the cabinet.

Advertisements in home decor magazines played up the cabinet's function as a display piece, frequently by foregrounding the effect that the natural wood of the console would have on softening the TV's severe surface appearance and integrating the bulky technology within the streamlined space of the midcentury living room. These magazines also recommended placing a sprig of foliage, piece of coral, or other bits and pieces of organic matter on top of the TV set as additional camouflage, as well as arranging "classic" books and "objets d'art suggesting good taste and the leisure time in which to pursue collecting as avocation."[127] Straddling the nature-culture divide, animal figurines served as decorative objects in ads for televisions, often appearing in harmonious formations of two: a pair of zebras atop a Zenith console; twin Siamese cats, so lifelike they could be real, playing on an Admiral "Magic Mirror."[128] Many of these figurines were TV lamps, an inexpensive form of lighting decor that reconciled concerns that watching TV in the dark would harm viewers' eyesight with the fact that watching early television sets in dim lighting offered better image quality; these shadeless lamps frequently took the form of animals, and they remain collector's items today.[129] In short, an important strategy for negotiating the television's rapid assumption of the focal point of family living space was to treat the console in part as a display mantel for collections that integrated traces of flora and fauna with artful, worldly bric-a-brac. The success of this strategy of display was such that, when televisions began to shed their wooden husks in the late 1950s, a Sony Corporation advertisement instructed consumers to place their new "portable" set on top of their original console—after all, "It's a beautiful piece of furniture."[130]

If the wooden exoskeletons of early television consoles framed these objects as closer to nature, the names bestowed on them signaled connections with highbrow culture and, more significant to my discussion here, access to distant lands. "The nomenclature," Tichi remarks in her inventory of the names of the highest-end floor-model sets, "is strikingly Anglo-British (The Devonshire) and Continental-European (The Cherbourg), and American Colonial and Revolutionary (The Plymouth). All of these names invited associations with high social status and cosmopolitanism." Yet names derived from the Caribbean (The Nassau, The Honduras) also circulated among the Jeffersons and Westminsters.[131] Likewise, the cabinets' favoring of "classical" European furniture styles extended to decidedly orientalist ones: Magnavox boasted a "Chinese Chippendale Television Receiver," while an advertisement for Stromberg-Carlson's Empire model promised a console that was "handprinted with an authentic Chinese legend design on ivory, red, or ebony lacquer."[132] Altogether, these model names and styles cast television as a vessel for global travel and were consonant with the recurrent refrain that television's greatest service to the at-home viewer was to provide a "window to the world."

This adage established currency as the title of Thomas Hutchinson's 1946 book, *Here Is Television, Your Window on the World.*[133] A scene in Douglas Sirk's *All That Heaven Allows* (US, 1955) illustrates—and brilliantly deflates—popular television discourse's founding promise of transparency, immediacy, and instantaneous global connection: a TV salesman wheels a handsome table model into the living room of the widowed protagonist, Cary Scott (Jane Wyman), proclaiming, "All you have to do is turn that dial and you'll have all the company you want, right there on the screen. Drama, comedy—life's parade at your fingertips."[134] A dolly into a close-up of Cary's crestfallen reflection on the screen confirms her disillusionment: the set, purchased by her self-absorbed children, is a sad substitute for the world she is desperate to experience and the Thoreau-reading arborist she longs to be with (Ron Kirby, played by Rock Hudson). Her children's and her upper-middle-class peers' insistence on her adherence to the suburban status quo, exemplified by the commodity of television, is enough to send her running from her heavily curtained and Christmas-tinseled living room to Ron's cabin in the woods. But Ron is shooting fowl, and they miss each other by seconds; he falls off a cliff running after her, dead bird in hand. The film's final scene promises a happy ending: while Ron recovers on his couch, Cary looks through a grand picture window at a deer, only inches away in the snowy out-

Fig. 15 (*above*) & Fig. 16 (*facing page*). Three wintry scenes display the aesthetic affinities of television, dioramas, and cinema

side (figs. 15 and 16). She has traded the stultifying mediation of television for the authenticity of human connection and communion with nature. Or so the surface-level message of the film asserts. Attention to "the fissures lurking under the [film's] glossy surfaces,"[135] coupled with my discussion of the congruencies of taxidermic and televisual display, suggests that Cary in fact turns away from her children's gift of televi-

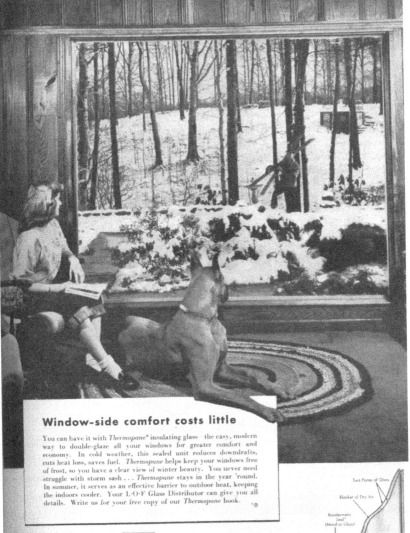

Window-side comfort costs little

You can have it with *Thermopane** insulating glass—the easy, modern way to double-glaze all your windows for greater comfort and economy. In cold weather, this sealed unit reduces downdrafts, cuts heat loss, saves fuel. *Thermopane* helps keep your windows free of frost, so you have a clear view of winter beauty. You never need struggle with storm sash... *Thermopane* stays in the year 'round. In summer, it serves as an effective barrier to outdoor heat, keeping the indoors cooler. Your L·O·F Glass Distributor can give you all details. Write us for your free copy of our *Thermopane* book. ®

FOR WISE VISION SPECIFY THERMOPANE
MADE WITH POLISHED PLATE GLASS

L·O·F Thermopane

MADE ONLY BY LIBBEY·OWENS·FORD GLASS COMPANY
1119 Nicholas Building, Toledo 3, Ohio

Two Panes of Glass
Blanket of Dry Air
Bondermetic Seal (Metal-to-Glass)

Cutaway view of Thermopane

BETTER HOMES & GARDENS, NOVEMBER, 1949

sion, only to embrace a domestic environment that is exquisitely styled *as* television—with all of its attendant ideological values of containing "wild" difference.

The windows in Sirk's film, so central to his signature staging and saturated images, synch with Spigel's and Tichi's observations about the material and figurative alliances between the TV screen and the window frame, two integral elements of the midcentury American home that were frequently displayed in spatial harmony. For Spigel, the coupling of televisions and panoramic picture windows (along with globes, maps, and all of the aforementioned curios) "created the illusion of spatial conquest."[136] In this light, actual and televisual windows to the world extend the function of the nineteenth-century taxidermic practices of wilding the indoors that Jones describes in terms of "captivation, consumption and conquest." Although not nearly as numerous as those for television sets, advertisements for windows and window treatments appear in *Better Homes and Gardens*, several of them featuring animals and the outdoors.[137] An ad for Thermopane bears a striking resemblance to the final shot of *All That Heaven Allows*, only human and animal occupy different sides of the window: a woman and her Great Dane gaze out of a vast picture window at a hunky man carrying skis in the snow (fig. 16).[138] Despite the absence of television sets in both images, I cannot but view the Thermopane advertisement and the concluding shots of *All That Heaven Allows* as refracted through the visual aesthetics of postwar television, which themselves take up after earlier practices of looking at carefully contained animal collections.

These images recall, specifically, the winter season of Carl Akeley's "Four Seasons of Virginia Deer," an incredibly intricate and innovative group of four habitat dioramas that he sold to Chicago's Field Museum in 1902, almost a decade after starting the project (fig. 15). The installation caused "a sensation in the museum world," Alvey explains, because "it was the first large-scale realization of Akeley's vision of taxidermy: animal *groups*, not only presented in natural pose, but set in a detailed lifelike representation of their native habitat."[139] To be sure, numerous elements distinguish the 1902 museum diorama from the 1949 print advertisement from the 1955 Technicolor film, the most significant being that Akeley's diorama represents an animal group as a cohesive unit, whereas the ad and film depict individual animals (human and nonhuman) in viewing relationships with one another. Yet the appeal of the lavish, immersive spaces in all three is remarkable: they all position the viewer in rapt regard of a natural world that, frozen (both in tempera-

ture and in time) behind a sheet of glass that stretches to the edges of the images' frame, appears entirely accessible.

The affinities between these three images affirm Hamera's insight into the shared "visual logics" of the aquarium, diorama, panorama, and television, which "continually remind viewers of their own privileged positions as viewers: seeing without being contained, apart from yet a part of and even vicariously immersed in the scene."[140] Hamera contends that the window, a key technological link between these media, provides essential "perceptual training" in forms of spectatorship that elicit this sense of being apart from yet a part of—in Spigel's phrase, of "being alone, together."[141] Of course, different windows afford different views: "apartment windows opening onto the increasingly diverse populations on crowded urban streets, department store windows framing manufactured clothing modeled by blank-eyed mannequins, and workers laboring in the cubes of glass-sided skyscrapers" are among those that Hamera highlights.[142] This tripartite view provides an apt categorical summary of the miscellanea of television programming, which prioritizes representations of social diversity (primarily in cities), consumer goods, and postindustrial labor. I return to the circulation of animals in such representations (*what* we watch) in the following chapter, and here pursue the window's influence on *how* we watch. In relation to the department store window, Hamera calls on Anne Friedberg's insight that the display frame of the nineteenth-century shop window strongly shaped a "consumptive mode of 'just looking,'" a phrase that summons the almost constant "desire for purchase" that pervades our experience of modernity.[143] Commercial television is explicit in its invitation of a consumptive mode of looking, literally displaying items for purchase in advertisements and shopping channels, and presenting them in only slightly more veiled (and, arguably, all the more desirable) fashion in dramas, sitcoms, and reality series. Explicit or not, television's constant exhibition of goods fosters a sense of always-on desiring.

I pause here to note that television must be understood in relation to the primary technology that brings animals into the home—the refrigerator. In a study of postwar discourse around this appliance that complements Tichi's and Spigel's work on television sets, Paul Gansky explains that while television was touted as "a window to the world," refrigerators—most of which were manufactured by companies that also produced televisions—were marketed as "an immersive window that brought foods from around the world into a single, controllable place within the house." He elaborates:

Refrigerators were constructed in explicit relation to television, an emergent medium sold in this era as collapsing time and distance, turning viewers into globetrotters. Print advertisements, the General Motors promotional film *Out of This World* (1964), and Disney's film *A Tour of the West* (1995) similarly framed refrigerators as televisual vessels to distant and unexplored geographies. . . . Harnessing the exterior world for private domestic benefit, and visually streaming discrete units of food in advertisements, the appliance became a screen, and its users became viewers.[144]

In concrete terms, home refrigerators worked in concert with refrigerated train cars to make many foods, but especially meat, available across large distances; as Gansky argues, they also converged with television to produce worldly consumers in the cultural imaginary.

Television's window to the world aspires to a vast, all-encompassing view of the world. To this end, it extends and expands what Hutchinson, drawing on Tony Bennett, calls "exhibitionary culture": "the nineteenth-century idea of putting the world on display as an expression of the desire to collect and organize knowledge." Exhibitionary culture took form and flourished in the nineteenth century, in public spaces associated with the acquisition of knowledge (natural history museums and world's fairs) and goods (arcades and department stores).[145] From its inception, discourse around television celebrated the medium's capacity to exhibit and in turn possess the world in all its infinite variety, and advertisements for TV sets emphasized its global reach. As World War II was drawing to a close, DuMont declared that "as soon as peace permits," its television sets would become "the biggest window in the world."[146] The ad pictures a diminutive family gazing at a TV screen that simultaneously binds together images of entertainment (a baseball vignette, a quartet of singers and starlets, a kicky chorus line) and frames a quickly spinning globe. The globe fits into Ella Shohat and Robert Stam's compendium of Western film's and television's assertions of "imperial mobility," which for them begins with the Lumière brothers dispatching cameramen to all corners of the world; is emblematized in the spinning-globe logos of major Hollywood studios such as RKO and Universal; and reaches an apotheosis, almost a century later, with Peter Jennings walking on a giant map of the Middle East in an ABC Gulf War special and, as they put it, "literally step[ping] on, sit[ting] on, and look[ing] down on the map, bestriding the narrow world like a colossus." Shohat and Stam conclude that, "in both cinema and TV, such overarching global points-of-view

suture the spectator into the omniscient cosmic perspective of the European master-subject."[147]

The all-seeing perspective of this spectator is, as they suggest, imbued with limitless mobility. Curiously, DuMont's television screen (in this and in many of the company's advertisements in the 1940s) more readily resembles a picture frame than the bulky CRT sets that the advertisement heralds. Alluding perhaps to Spigel, Tichi observes that "the coincident postwar fashion of the suburban picture window and the TV screen has been often remarked, with emphasis on the outward gaze through the vitreous medium into other environments beyond the household walls." She in turn connects the "slightly bulging rectangle with softly rounded corners" of early television sets to the quadrilateral frames of other modern technologies, namely the windows of trains, trolleys, and airplanes, as well as the photographic frames of still images (specifically, snapshots in family albums) and moving pictures. Asserting that the shape of television "meant motion, travel, and entertainment," she argues that "advertisers exploited this connection to persuade sedentary viewers that they were really traveling activists."[148]

The television is but one element among many (an especially compelling one) that lends the inhabitant of the modern living room a sense of limitless mobility and access to the world. In this environment, even the act of sitting and watching can be made mobile, as a 1950 advertorial in *Better Homes and Gardens* promised of a "turn-and-travel chair" that glides effortlessly between the television set, fireplace, and picture window.[149] Hamera observes that the aquarium—a rarer decorative object that is currently found in less than 15 percent of American households—is likewise frequently envisioned as a vehicle for armchair travel: "From the late 1850s to the present," she explains, "the pleasures of the aquarium are often described in terms of travel and tourism in a radically foreign place, the better to consume and appreciate it at home as a kind of living souvenir or to examine its inhabitants for details of their lives as one would the natives of exotic cultures."[150] Prominent forms of print media common to the living room circulate consonant promises of unfettered movement and transparent access to distant lands, peoples, fauna, and flora. Just think of all the copies of *National Geographic* that have joined TVs in American living rooms. Among the "most widely available purveyors of images of the non-Western world," according to Stephanie L. Hawkins, this magazine's "distinctive yellow-bordered cover denotes [its] all-encompassing 'window on the world' theme of global exploration and human cultural

variety."[151] The magazine is famous for displaying, within this window, images of indigenous peoples in lush color photography that, Hamera contends, conveys their "tactility and availability."[152] The yellow frame of *National Geographic* of course also exists within the frame of television, appearing as landmark documentary specials in the 1960s and 1970s before it became a flagship channel in 2001, thus redoubling the power of this window on the world.

In touting the medium's expansion of vision and travel, advertisements for television summon the primary allure of the early modern curiosity cabinet. "Curiosities were collected," Poliquin asserts, "because they acted as portals through which Europeans could experience and, in a sense, possess exotic lands, different societies, and outlandish creatures without traveling."[153] In midcentury America, television's affordance of this very sort of armchair travel was among its chief selling points. A 1944 DuMont advertisement that Tichi cites celebrates this power explicitly in terms of conquest, proclaiming, "You'll be an armchair Columbus! You'll sail with television through vanishing horizons into exciting new worlds." Much like curiosity cabinets, television (specifically in the form of news) is here presented as delivering "everything odd, unusual and wonderful, just as though you were on the spot."[154] And as with its seventeenth-century predecessors, exotic bits and pieces—suggested in the ad's closing promise of "ten-thousand-and-one thrilling voyages of delight"—were certainly among the most vaunted elements in television's endless provision of oddities and wonders.

Curiosity cabinets, windows to the world, vehicles for armchair travel: these material contexts and metaphorical figures that bind taxidermy with television offer variations on Michel Foucault's concept of heterotopia. Frosh's summation of the television as box is instructive: "Television acts as the container of the multiple locales, individuals, homes, and communities that it depicts: the container, in effect, of the multifarious spaces and social relations that make up our sense of the social whole—on an increasingly global scale. Television is a small, self-contained box that nevertheless brings forth multitudes."[155] Heterotopias, according to Foucault, are boxlike (or, as he would have it, "rectangular") institutions, spaces in which "all the other real sites that can be found within the culture, are simultaneously represented, contested, and inverted." Yet the processes of assemblage—of selecting, editing, reordering—by which heterotopias are constituted mean that "these places are absolutely different from all the sites that they reflect and speak about." Foucault's

exemplars include theaters, cinemas, and gardens—and by extension, zoological gardens, which in their collocation of ecologically discordant habitats starkly "juxtapose in a single real place several spaces, several sites that are in themselves incompatible."[156] Curiosity cabinets, museums, and libraries are heterotopias; so too, Berland observes, are menageries, and even homes.[157]

If heterotopias present worlds within worlds, then television, as a window to the world, puts into the abyss the heterotopia of the home. Focusing on the genre of nature/wildlife television, Chris argues that "television, if we can conceive of it as a 'real place' or network of places, encompasses within its spectrum at any given moment a range of images heterotopic in scope. . . . On any given day, one might flit from views of sharks off the coast of southern Africa to polar bears in Manitoba, rattlesnakes in Florida, crocodiles in Queensland, and pandas, real and replicas, in Sichuan Province." The proliferation of channels and platforms in the post-network era, she adds, only augments the sense that television is at once all places and no place. As Chris explains, "The images of animals and their habitats, natural or artificial, found through television, are presentations of real places and the creatures that live there, but they are 'absolutely different' from those real sites and their inhabitants."[158] Although she notes that representational conventions, industry economics, and geopolitical conditions contribute to this inevitable gap, she zeroes in on editing as the force that fundamentally differentiates heterotopias from the spaces they collect when she shifts her focus from television to film. Discussing a review of Carl Hagenbeck's short film *Menagerie at Hamburg*, she notes the reviewer's admiration of the "efficiency" of the film's narrative, which is structured as

> a tour taken by film rather than on foot . . . , excising the tiresome bits of any real visit to a menagerie or zoo: animals that have hidden themselves out of view, sleeping or otherwise inactive animals, long walks between displays. Thus, animals on film are even better than animals in zoo enclosures, and surely better than animals in the wild: they are not only captive and visible at our whim, not their own, but they are at their very best."[159]

Editing's power to make animals appear "at their very best" derives from its dual capacity to frame what is vivid and lively, and to elide what is uninteresting or dull. This two-pronged strategy is also at work in slaugh-

terhouse tours and the films that replaced them, as they foreground cleanliness and efficiency while excising the more gruesome bits of animal killing. It points, moreover, to the final chapter's examination of how animals—as icons that are at once spectacular and banal—circulate in the perhaps more unexpected niches of Black horror and prestige TV dramedy.

CHAPTER 4

TV Trophies

The National Broadcasting Corporation's (NBC) avian icon was expressly designed and debuted in 1956 to announce color programming on the network.[1] Topped off by a crest that resembles an exclamation point, this still-image version of "the Bird," as the network refers to it, features a plume of eleven feathers in six colors. Almost immediately, the Bird began to mutate. In 1957, it became animated. Five years later, the "Laramie peacock," thus named because it premiered before the Western series *Laramie* (NBC, 1959–63), took over and became the classic version: through a series of dissolves, its plume kaleidoscopes over a woodwind trill as a male voice-over intones, "the following program is brought to you in living color by NBC." At the height of its run, the peacock appeared on air twenty times per day. Other animals sometimes accompanied it: through the 1960s, color programming on NBC was bookended by the Laramie peacock and an animated snake logo, in which the letters *N-B-C* slithered into formation; in 1967, NBC dispatched a top-hatted cartoon penguin to announce that it would bring the Beatles' *A Hard Day's Night* to viewers "in lively black and white." By the end of the 1960s, the peacock's heraldry of color programming was deemed superfluous as all three networks were by then broadcasting in full color, and the logo was retired and replaced by a trapezoidal *N* logo. In the 1980s, executives rediscovered the bird's appeal and it reemerged as the streamlined six-feathered outline we know today—its gaze turned from screen right to left so that it looks ahead rather than back, among other minor variations. In the postnetwork era, the peacock remains one of the most recognizable logos not just in television, but across consumer goods. In

the summer of 2020, the icon was recast yet again, as the mascot of the Peacock streaming service, an over-the-top streaming service owned by NBCUniversal (the familiar peacock remains the NBC network logo). In this incarnation, the Bird is reduced to the symbolic word "peacock" (and, for smaller formats like online thumbnails, abbreviated further to the letter p) in a lowercase sans serif font, the bowl of the p tipped up like plume. A stack of six rainbow-hued dots buttresses the letters, evoking both the vertical ellipsis that signifies "more options" on computer interfaces and the column of blinking lights that indicate a working modem. This supplemental version of the Bird signals the expansion of choice ("Fun for the whole flock," according to a slogan on Peacock's landing page) and access to vibrant content in the digital era, while also pointing to the ongoing effacement of animals as they are increasingly abstracted into communicative symbols.

As so much work at the intersection of animal studies and visual culture does, *Bits and Pieces* wrestles with John Berger's thesis that, in modernity, "everywhere animals disappear"—and simultaneously reappear as "perhaps compensatory" images.[2] An animal figure that points back to the origins of animals' containment and spectacularization in menageries and gardens, yet also looks forward to emergent technological change, the NBC peacock articulates this displacement in a specifically televisual form. Scholars such as Akira Mizuta Lippit and Jody Berland have noted the ways in which disappeared animals reemerge both in images and as *the* image of various brands, particularly of transportation and telecommunications technologies, from plaster horseheads affixed to trains to Twitter's tweeting bird silhouette.[3] Berland's inventory of the "attachment of iconic animals to new communication practices and technologies" includes "the emperor's giraffe, the trader's beaver, the lions and deer that figure in so many coats of arms, the dog searching for the source of His Master's Voice, MGM's roaring lion, and the penguin logo familiar from Penguin paperback editions of classic fiction."[4] These emblems of curious, communicative liveliness circulate amid other systems that produce animals for consumption such as the meat industry and networks of captive display—and indeed their pleasing presence masks these imbricated systems of violence and containment. Lippit underscores this movement in his rewriting of Berger's thesis: "Animals appeared to merge with the new technological bodies replacing them. . . . Cinema, communication, transportation, and electricity drew from the actual and fantasmatic resources of dead animals."[5] Although scholars in film studies have thoroughly

interrogated these dynamics, televisual animals have yet to receive commensurate attention.

This chapter responds to this gap by reflecting on animals' presence as TV icons and in televisual texts. I begin by considering the place of animals in the production of color and flow, qualities that are central to the experience of watching television and to television history. I then zero in on a figure that is emblematic of television's taxidermic inheritances: the trope of the Black man as trophy. Returning to audiovisual texts mentioned in my earlier tracing of television's taxidermic inheritances, I examine how taxidermic mounts are mobilized in proximity to Black male bodies in *Queer Eye: More Than a Makeover* (Netflix, US, 2018–21), *Get Out* (Jordan Peele, US/Japan, 2017), *Sorry to Bother You* (henceforth *STBY*, Boots Riley, US, 2018), and *Atlanta* (Donald Glover, FX, 2016–). My close analysis of this last text positions it as an ongoing series that, in playing host to numerous enigmatic animals that call attention to televisual seriality and filmic-televisual intertextuality, refracts a satirical critique of the coupling of African Americans and animals—and does so perhaps most compellingly in an episode in which the character Alfred "Al" Miles (Brian Tyree Henry) negotiates his trophy status as a Black rapper. If chapter 3 demonstrated that the very act of watching TV is informed by historical practices of looking at (frequently dead) animals, this chapter considers instances in which trophies on television are taken up to challenge overlapping legacies of violent visual objectification.

Color and Flow

I open with the NBC peacock because it illustrates television's reliance on animals (both figural and material) to produce elements that are fundamental to the medium's ontology and form. Specifically, the bird emblematizes television's recourse to animals to provide color, an "actual and fantasmatic resource" that is construed as hue, race, and/ or as a figurative quality associated with diversity and vitality—and frequently as all three at once.[6] "What made the peacock such a wonderful logo," Lawrence K. Grossman, head of NBC in the late 1980s, avers, "was the fact that it worked to define color, whether seen on black and white TV sets, which everyone had then, or on color sets which almost nobody had. . . . [It was] very clear and stood for what it was meant for."[7] Pragmatically speaking, the peacock was meant to entice audiences to buy color television sets (at the time, NBC was owned by RCA, a leading manufacturer of color sets), and its plume, whether it was perceived as

mono- or polychromatic, stood for the spectrum of color TV technology. Yet, as herald for the network leader in color programming in the 1960s, the peacock came to metonymize NBC's use of animals to provide much of the "living color" that it brought into homes, principally in the nature/wildlife programming that it was known for broadcasting, such as *Wild Kingdom* (Mutual of Omaha, Marlin Perkins, 1963–71) and Disney's *True-Life Adventures* (1961–65).[8] As Susan Murray explains in her history of color TV, nature/wildlife programming of the 1960s and 1970s held out "the promise of color television to extend the eye through technology to places around the globe, under water, into bodies, through a microscope, and eventually into space, reveling in views that had been previously hidden or out of reach."[9] In fact, much of the nature/wildlife programming of the era was conceived and produced expressly to "show off color," Murray contends.[10] As a mascot that evokes color's possibilities even in its absence, the peacock affirms that animals excel at showing off the affordances of color technology, so much so that, at least on TV, they exist in order do so.

Yet as is so often the case with audio accompaniment, the NBC voice-over introduced a movement away from the avian icon's strict denotation of a colorful bird and close connotation of color TV programming. For many readers, the phrase "in living color" just as readily summons the sketch-comedy show *In Living Color* (Keenen Ivory Wayans, Fox, 1990–94), which broke ground with its almost exclusively Black cast and satire of racial stereotypes. For some, it also conjures the Black American hard rock group Living Colour, which formed in 1984 and also took its name from the NBC voice-over (the band sued Fox in 1990, claiming that the TV show had stolen its name and logo; the show subsequently changed its logo but kept its name).[11] *In Living Color* was conceived of as a challenge to the dominance of white comedic performers on *Saturday Night Live* and other comedy outlets, and one origin story holds that it was explicitly envisioned as a "black *Laugh-in*." Yet, as David Peisner explains, "there had already been a black version of *Laugh-In*." In 1968, George Schlatter, the producer of *Laugh-In*, created a pilot for *Soul*, a variety show featuring some of the most famous Black comics and musical performers of the day, including Nipsy Russell, Redd Fox, and Martha Reeves and the Vandellas. The show never made it to a second episode. The pilot, Peisner recounts, "opens with a shot of the iconic NBC peacock, followed by one actress promising, 'You never saw such *living*,' and another following her, 'and you never saw such *color*.'" In Peisner's account, Schlatter sent a copy of the *Soul* pilot to Keenen Wayans when

his series was in development, the suggestion being that *In Living Color* owes its title more to *Soul*'s play on its network host's tagline than to the tagline itself.[12] In this lineage, "in living color" evokes not just the presence of African Americans on television, but a reclamation of African Americans' belonging in the field of televisual representation.

Soul's introductory voice-over—intoned by two Black women on-screen rather than the off-screen voice-over of a lone white male—casts a knowing glance at television's dominant white gaze, particularly as it is exerted on the bodies of Black entertainment performers and enunciated by a detached male voice of authority. By the late 1960s, "colored" was well on its way to being replaced by "black" as the preferred self-designation in the United States.[13] Peisner describes *Soul* as "almost shockingly progressive for the era" in its commentary on racial violence and white ignorance, and the intro sequence's play with "living color" to refer primarily to the raced bodies of the show's performers sounded a satirical critique of status quo racialized television discourse. The continued remixing of "living color" in subsequent decades—first as the name of the rock group and then the sketch-comedy show, and, later, as the title of the influential scholarly collection *Living Color: Race and Television in the United States* (ed. Sasha Torres, Duke University Press, 1998)—attests to the sustained potency of this critical move. This act of self-naming acknowledges that, since the beginning of the network era, Black Americans and animals have been entwined in television's quest to usher images saturated with vitality, mobility, and diversity into domestic spaces. In claiming as their title a phrase that is indelibly associated with an animal icon, these TV creators, musicians, and scholars court a human-animal connection rather than renounce it. I understand this move as one among many that challenge the long-standing racist traditions and tropes of dehumanizing-by-way-of-animalizing Black people, and my reading of *Atlanta* and adjacent audiovisual texts in this chapter calls attention to consonant gestures of reappropriating "living color" that recast relationships between animals and African Americans in the terms of knowing, if tentative, alliances.

The complex denotative and connotative range of "living color" unfolds in the context of television "flow." Raymond Williams identified flow as the medium's defining condition in his 1974 *Television: Technology and Cultural Form*, and it has persisted for almost fifty years as the explanatory metaphor for how television is experienced: not as a discrete text but rather as a calculated assemblage of miscellaneous items that, by dint of TV's fundamentally sequential structure, generate mean-

ing intra- and intertextually. In his "medium-range analysis of flow or sequence" in what he notes is a distinctively American evening newscast, Williams observes:

> What seems to me interesting in this characteristic evening news is that while a number of important matters are included, the connections between them are as it were deliberately not made. The apparently disjointed "sequence" of items is in effect guided by a remarkably consistent set of cultural relationships: a flow of consumable reports and products, in which the elements of speed, variety and miscellaneity can be seen as organizing: the real bearers of value.[14]

Although instantaneity and simultaneity are chief among the values conveyed by this "hurried blur," other resemblances and connections emerge between the items that Williams carefully notes in a week's programming on both sides of the Atlantic.[15] What he calls "mutual transfer" is particularly conspicuous across items featuring nonhuman animals: he notes, for example, how a Little Whiskas commercial arrays different breeds of cats much as an "animal interest film" would unfold through sequential categorizations of species (a categorical arrangement prominent in animal rights films).[16] The most striking transfers in this sequence involve human and nonhuman animals: the unremarked movement from the identification of a murder victim (presumably human) to reports of vicious dogs attacking livestock, and the description of disabled men being released from "tiger-cages" matched with film of these men in a hospital, "one crawling on the floor." Of the latter, Williams notes the "apparent unconsciousness of contrast" between the news of the tortured men's release and the subsequent item: "Family camping in wood; children running under trees: the wife has brought margarine instead of butter; it is fresh and healthy."[17] The unmarked movement from the brutal to the bucolic in this sequence exemplifies how animals—or, more precisely, human viewers' practiced "unconsciousness" of animals—conduct flow.

If Williams's data indicates that animals shape flow in significant yet frequently unremarked ways, a look at more recent scholarship about animals on television begins to explain their appeal across genres and to suggest the need to consider animals that inhabit more unlikely recesses of TV's "miscellaneity." In the introduction to his 2018 book *Animals on Television*, Brett Mills presents a notation of "a random day of [British terrestrial] broadcasting" in 2016 that recalls Williams's long-range tally

of programming in 1973. Mills splits his inventory between "programmes specifically about animals" and those that more obliquely suggest "the multifarious ways in which beings are enmeshed within television's representations."[18] Of this listing of some thirty programs, many of which he poses as representative of others, Mills remarks:

> It is harder to *avoid* seeing animals represented on television on this day than it is to see them. Encountering animal representations is not something that requires effort or motivation; it is a normal—and normalized—part of the experience of consuming television. And this is true . . . across genres, across channels, across series for different age groups, and in both factual and fictional programming. Animals are part of the representational strategy of television as a whole, their depictions employed for a variety of symbolic, aesthetic, narrative and sociopolitical purposes. And yet if you were to look at the academic analysis of television you would be forgiven for thinking that the medium never depicts animals, so scant is the analytical attention paid to them. It is time we started to notice animals.[19]

Indeed it is, not least because attention to animals—beings especially susceptible to human viewers' practiced disregard or "unconsciousness"—promises to disrupt patterns of flow that facilitate unthinking acceptance of dominant, and predominantly violent, human-animal relationships. "The connections between them," to borrow Williams's words, "are as it were deliberately not made." Mills focuses his analytical attention on children's programming, cooking shows, and nature/wildlife documentary—this last being the genre that has received the lion's share of attention in the small body of extant scholarly work on animals in television. He observes that television in general and cooking shows in particular reinforce the visual politics of the meat industry, as "television rarely depicts industrial-scale meat production, and it thus renders invisible the daily experiences of a large number of living creatures. But television depicts cooking endlessly, almost obsessively." Cooking shows make visible the activities of processing animals in the home (preparing, cooking) while disregarding the less appetizing activities of processing (feeding, slaughtering, butchering) that occur outside of it—in, for example, factory farms—and they thereby "help to police the distinction between the home and the outside."[20] What does not appear on television tells us as much, if not more, than what does.

I turn to a TV series (and adjacent films) that, in taking up the par-

adigmatic genre of the domestic everyday, the sitcom, destabilizes the boundaries between the home and the outside world, particularly as they concern animals. My analysis understands these audiovisual texts as subverting key tropes and experiential qualities of viewing the nature/wildlife genre, and some contextualization is thus in order. The wave of scholarship on animals and audiovisual media that took off at the turn of the twenty-first century and continues to swell today gathered much of its momentum from three books on nature/wildlife documentary: Gregg Mitman's *Reel Nature* (1999), Derek Bousé's *Wildlife Films* (2000), and Cynthia Chris's *Watching Wildlife* (2006).[21] Mitman, Bousé, and Chris couple film and television in their analyses, yet focus on film. Chris comes closer to achieving a balance, demonstrating how in both its cinematic and its televisual incarnations, the nature/wildlife genre expresses "allegiances to both science and showmanship, to education and entertainment."[22] If documentary as a mode is known for accommodating both the discursive sobriety required to educate and politicize viewers, and the embodied thrills and visual shocks that entertain and delight them, then nature/wildlife documentary is especially deft at negotiating associations with prestigious, edifying institutional quality alongside brash commercialism. On TV, this flexibility means the ability to flip between the hushed tones of the latest David Attenborough special to the lurid thrills of Shark Week. The emphasis on spectacle in nature/wildlife documentary, in both its "high" and "low" expressions, presents as regular or common moments that are in fact exceptional (thrilling chases, gruesome kills), and it does so, Bousé explains, because the "expressive 'vocabularies'" of film and television excel at capturing "movement, action, and dynamism"—the very sort of elemental drama that "nature is generally not." Given the "vastness . . . and slow unfolding of time in the natural world," Bousé wagers that it "may actually be better suited to a television aesthetic of the C-SPAN sort."[23]

Spectacular nature/wildlife programming not only produces skewed images of the rhythms of animal life, but also reproduces divisions and distance between human and nonhuman animals—much as the apocalyptic rhetoric of slaughter cinema presents the meat industry as separate and isolated. As Mitman explains, the genre's "blend[ing of] scientific research and vernacular knowledge, education and entertainment, authenticity and artifice" ultimately works to create images of "unspoiled nature." The power of these images of "pristine wilderness" rests in the ability of spectacular imagery to trade in distance and proximity, which frequently reads as intimacy.[24] Mitman writes that the

nature/wildlife genre, along with its manifestations in theme parks and naturalistic displays in zoos and museums, "capitalize[s] on our desire to be close to nature, yet curiously removed from it."[25] In conversation with Helen Wheatley's work on spectacular television, Mills points out that as a domestic medium, television is particularly adept at capitalizing on the nature/wildlife genre's relay of humans' intimate separation from nonhumans and nature, given that "television's intimacy [lies] with images and figures which are simultaneously domesticated (brought into the intimate sphere) and absent (broadcast from another place, and often from another time)."[26] In this light, the spectacular display of wild animals in television documentary finds a generative double in what Lauren Burton and Francis Collins identify as the "banal production . . . of nonhuman subjects in everyday life" in more prosaic genres such as commercials, cartoons, and cooking shows.[27] My interest in *Atlanta* and adjacent texts lies in their subversive play with these tensions bound up in animals' largely unremarked ubiquity on television.

Trophy

If the NBC peacock points cheerfully toward technological progress, another animal emblem pervasive on TV—the hunting trophy— reminds us of television's historical and representational connections with visual displays of animal death, and particularly of television and taxidermy's shared propensity for collecting heterogeneous elements. Within this miscellaneity, the hunting trophy must be understood as one genre among many taxidermic genres—and one that circulates in varied televisual genres. "The reasons for preserving animals are as diverse as the fauna put on view," Rachel Poliquin explains as she taxonomizes taxidermy into "eight distinct styles or genres."[28] "Hunting trophies, preserved extinct species, and stuffed pets," she points out, "are not the same sort of objects, and each reveals diverse (dis)connections with the natural world and arouses vastly different responses."[29] Although other taxidermic genres certainly crop up on American television, the hunting trophy dominates, which makes sense given the significance of hunting in both actual practice and in the cultural imaginary of the United States. Contrasting taxidermy's development in different arenas on either side of the Atlantic, Melissa Milgrom notes that in England, for example, taxidermy "is a cottage industry with long ties to modern zoology," while in the United States it is tied to the nation's "predominant hunting culture," although here too it is connected to natural history

museums.[30] This lineage is important because it grounds American associations with taxidermy firmly in the space of the home. This connection with domestic space is coupled, Garry Marvin observes, with the sense that hunting trophies index "a deeply personal [relationship] between the hunter and the hunted"—that is, they are imbued with a sense of violent intimacy.[31] As a domestic genre with a distinctly sinister side, the hunting trophy bears striking affinities with the conventions of televisual representation, and, as my discussion here of a cluster of recent films and television episodes demonstrates, the culturally specific meanings of violent visual objectification and ownership it has accrued in an American context prime it to be recast as an icon of resistance.

In visual terms, the hunting trophy mirrors a staple convention of televisual representation—the close-up, and specifically the "headshot." That the headshot prioritizes faciality is an obvious but no less significant feature of it, Paul Frosh points out, noting that this framing typically includes the head, neck, and shoulders, and that it "focuses on the face of the subject (i.e., an image of the back of someone's head is not a head shot). This face frequently looks directly out of the image at the camera/viewer, but its gaze may also be directed off-center."[32] Frosh situates the "primacy of the human face as a televisual image" in the context of technological change: headshots were a staple of early television, particularly as they anchored network newscasts' direct mode of address; became less common as large, widescreen-enabling LCD and plasma TVs came into vogue at the turn of the twentieth century; and have entered a new era of ascendence thanks to television's expansion on mobile devices that are more "face-friendly in their aspect ratio."[33] Throughout this waxing and waning, Frosh argues, the headshot and the general "pervasiveness of faces on television normalizes and domesticates a paradoxical communicative structure: nonreciprocal face-to-face communication." Where theorists of urban space such as George Simmel and Erving Goffman find the city conducive to fostering "nonattentive visual encounters" (e.g., the customary behavior of apprehending without engaging fellow passengers on public transit), Frosh credits television with instilling "nonattentive mechanisms for apprehending unknown others into the home."[34] To summon Williams's scrutiny of the nightly news, headshots collaborate with flow in solicitating our nonattentive attention.

Headshots and hunting trophies are arresting yet ignorable figures because they are simultaneously specific and generic. In this duality they are akin to processual representation, which derives much of its power, Salomé Aguilera Skvirsky avers, "from its double register as both

a representation of a particular, specific instance of a process (e.g., *this* bath, *this* burglary) and as a representation of a general kind of action (e.g., bathing, burgling)."[35] By isolating the human face in close-up and circulating it amid other televisual conventions, Frosh argues, the headshot trades the face's status "as an index, a singular manifestation of a nameable, unique person" for a "universalized expressivity," effectively transforming it into a "substitutable emblem."[36] For regular viewers, the "face" of the news is at once a fixture in the home so familiar as to be familial, and an interchangeable stranger who can be instantly, unceremoniously dismissed. So too with hunting trophies. Reflecting on the "personal" relationships indexed by hunting trophies, Marvin insists that "no hunter I have spoken with would have a trophy in his or her home that she/he had not hunted and killed," for the simple reason that "a trophy shot by someone else would have no significance for another hunter."[37] Yet plenty of nonhunters display trophies of animals with whom they have a more transactional relationship. As Karen Jones explains, the late nineteenth-century industrialization of taxidermy at dealers such as the British Rowland Ward and the American Ward's Natural Science Establishment appealed precisely to a growing market of "armchair explorers" who were eager to "purchas[e] class mobility via the display of elite hunting paraphernalia."[38] For these consumers, trophies are "understood to be a 'generalization' of the animal," as Milgrom puts it.[39] For them, a deer mount represents not so much *this* deer but the category of deer and its attendant associations. In this context, a trophy's indexicality has less to do with signifying a close or causal relationship between the animal trophy and its human possessor than with conveying realist authenticity. Here it is worth recalling that as taxidermy expanded as an industrially produced consumer good, it also increasingly conformed to a realist or "naturalistic" style. Numerous scholars have noted that the advent of cinematic technology, itself founded on studies of animal motion by Eadweard Muybridge and others, spurred taxidermy to become more realist, as opportunities to view "live" animals on the big and small screens meant that consumers of taxidermy brought a more discriminating eye to the display of dead animals.[40] In the dominant realist style or mode of taxidermy, then, a painstakingly crafted mount depicts not a distinctive individual animal but an exquisite example of one.

Although headshots and hunting trophies share a visual composition (an intimate view of a fragmented body that renders individuals into generic, transposable figures), hunting trophies accomplish something

specific that headshots do not: they signify triumph. Triumph can take different forms in the imagination—for hunters, it may be envisioned as a conquest of "wild nature"; for consumers, as the acquisition of a class-signaling marker of wealth—yet it is fundamentally a display of victory or dominance. This much is given in the hunting trophy's origins in the Roman tradition of triumphal display. The first trophies were neither human nor animal, but the weapons and armor of defeated armies. These displays of the "spoils" of war were typically hung from tree branches or, in city spaces, on walls (modern trophies merely move this convention indoors), and, importantly, they "were erected to mark the place where a turning point occurred, usually in a battle."[41] *Trophy*,[42] as it happens, intersects with *trope*[43] at the etymon of the ancient Greek τρόπος, meaning "turning" or "change." This chapter, and indeed this book's turn to taxidermy and TV, began when my attention was caught—out of the flow, as it were—by a cluster of televisual moments in the late 2010s that turn on hunting trophies, and in doing so call out and critique the material and symbolic violence that they assert over animals and certain humans. I offer the following descriptive analysis of three of these moments—from *Queer Eye, Get Out,* and *STBY*—to set up my more sustained inquiry into *Atlanta*'s reclamation of the trope/trophy of the Black buck. As my carefully sequenced reading of these moments suggests, in their invocation of the Black-man-as-hunted-animal, these audiovisual texts introduce a change or turn in that figure's orientation, from a pronouncement of dominance to a gesture of alliance.

In a connection that Williams might mark as "deliberately not made," the scene from the *Queer Eye* reboot that opens chapter 3—the moment when "culture" stylist Karamo startles upon seeing their makeover subject Jody's trophy collection and reacts with horror (figure 8 in chapter 3)—recalls an earlier moment from what is perhaps the series' most memorable and discussed episode, "Dega Don't" (season 1, episode 3, 2018). This episode illustrates taxidermy's flexibility as a marker of class-based taste distinctions, as the Fab Five's makeover of police officer Cory's house includes elevating his deer mount from the discard heap of his basement to the point of pride in his formal living room (figure 9 in chapter 3). It further demonstrates the flexibility of trophies in that Cory may well be both hunter and consumer, and thus may be signaling his prowess as both an outdoorsperson and a member of the middle class (this is certainly the case for Jody). Yet this episode's overt interest in class mobility is eclipsed by anxieties about race, as it includes one of the more awkward examples of the many attempts made across television

genres in the late 2010s to talk about white police violence against Black men. Moments before the Fab Five arrive at Cory's house and peruse the deer mount and other detritus in his basement, Cory's friend Henry, a fellow white police officer, pulls over the stylists' car, in what they do not yet realize is a coordinated prank. Karamo happens to be driving, and his fear is palpable as he navigates being questioned by a white police office on the side of a highway in suburban Georgia while Black and queer— circumstances made worse by the fact that he does not have his identification with him. The situation only becomes more uncomfortable when it is revealed to be a prank and, in keeping with the lighthearted conventions of a makeover series, Karamo and the others must ultimately laugh it off. This prank sets up a conversation about race relations between Karamo and Cory that is as direct and genuine as one could expect of reality television, and, more importantly, it lends credence to the sense that Karamo's horrified reaction, two seasons later, to a wall of taxidermy in a white woman's dining room is about more than questionable decor decisions—it is on some level a recognition of the deep histories of racial violence that inhere in these mounts.

The Fab Five's run-in with Henry echoes an early scene in *Get Out* when protagonist Chris Washington (Daniel Kaluuya), a Black photographer, accompanies his white girlfriend to visit her wealthy parents in upstate New York. Rose Armitage (Allison Williams), who is driving, hits a doe, and the white police officer who responds to their call reporting the accident insists on seeing Chris's identification, even though he was not driving—as Black men, Chris and Karamo must be able to verify their legitimacy and indeed personhood on a moment's notice or face dire consequences. It's a succinct bit of foreshadowing, making a momentary encounter between a white police officer and a young Black man sufficient to raise hairs and bring the film into the realm of horror. *Get Out* uses the bodysnatching genre to narrate practices by which white people, under the cloak of patronizing admiration, seize African Americans' intellectual, aesthetic, and physical prowess, extracting what they can for their own purposes and leaving Black people in "the Sunken Place." The film's allegory of human appropriation is built on animal imagery, specifically deer in the form of roadkill and a taxidermic mount. Chris's first conversations with Rose's parents, Dean and Missy Armitage (Bradley Whitford and Catherine Keener) involve Dean celebrating the dead deer as an exterminated "pest" and Chris recounting how his mother was killed in a hit-and-run car accident when he was a child. Chris begins to realize the extent of the Armitages' malevolence

(Rose included) and is on the brink of escaping the house when he is cornered by the family and knocked out by the hypnotic taps of Missy's teaspoon. He comes to in the basement, strapped into an armchair in front of a vintage TV and a lithe buck mount (fig. 17). A grainy infomercial that looks like it was produced in the early 1990s flickers on the screen, and Roman Armitage, Rose's grandfather, explains the vampiric plot in which the Armitages have ensnared Chris: in a procedure they have perfected and trademarked as the "Coagula" (complete with deer mount emblem), they extract the "natural talents" of Black people and implant them into white people who desire to be "perfect." Hudson, a famous blind photographer, next explains in a televised pre-op tête-à-tête that they will take Chris's sight (his photographic eye) and implant it in Hudson; Chris will become Hudson's "passenger" or, more eerily, his "audience." Cognizant that he must protect not only "those things [he] sees with," Chris stuffs his ears with cotton from the armchair to tamp out the mesmerizing intervals of teacup taps. Having broken the spell, he bludgeons Rose's loutish brother with a bocce ball, impales Dean with the antlers of the buck mount, and takes on the remaining members of the Armitage family. His weapon in the final act is, significantly, neither the hunting rifle that Rose brandishes nor the bloodied rack of antlers, but rather his cell phone camera. From its start in the wooded highway, the film's association of Black men with hunted animals has been laced with a critique of white police abuse, and Chris rightly recognizes mediated exposure as the way to definitively defeat his captors.

STBY, a film frequently viewed in conversation with *Get Out*, takes the association of Black men with hunting trophies into more surreal yet equally acerbic territory, likewise using taxidermy to underscore how common tropes of Black masculinity, and especially Black male voices, are made into spectacular commodities (generically hybrid, *STBY* fits more into dark comedy than horror, though it certainly contains elements of horror). The film's protagonist, Cassius "Cash" Green (Lakeith Stanfield), a Black telemarketer who vaults to the top of company sales at RegalView when he learns how to deploy a "white voice" to sell to customers, discovers that he is enmeshed in a vast corporate conspiracy that involves turning humans into "equisapiens," or hybrid horse-humans, among other dystopian horrors. Cash's creeping realization begins as he wanders through a hedonistic party hosted by Steve Lift (Armie Hammer), the evil CEO of RegalView's parent company, WorryFree. After regaling his guests with the overblown story behind the heavily stitched rhinoceros mount in his lux drawing room, Lift insists that Cash take the

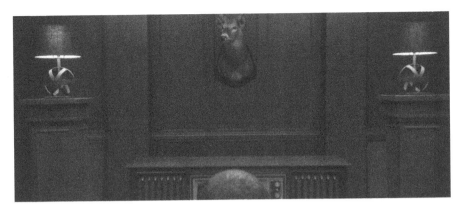

Fig. 17. Chris is held captive with television and deer mount in *Get Out*

Fig. 18. Cash is compelled to rap in *Sorry to Bother You*

stage and "bust a rap" for an audience of white revelers (fig. 18). Cash is visibly reluctant but sees that he has little choice; he has been cornered. Responding with an impromptu two-word rap that enthralls the crowd ("nigger shit" on repeat), he assumes the position of spectacle akin to the lifeless rhino's, a comparison brought home by the circular font of blood seeping through the bandage on his forehead, where a horn would be. The crowd blithely eats up the performance, unaware or uncaring that the lyrics work satirically by bouncing their reductive view of rap music against them. The scene thereby conveys both Cash's humiliation and his vocal subversion of it. Later, in a basement styled in the same hunting-lodge chic as the Armitages' subterranean space of experimentation, Lift attempts to hire Cash as a double agent for WorryFree. As with the Coagula, the television infomercial proves to be an apt genre for

his proposition, only WorryFree's production quality is more cinematic and postmodern: directed by "Michel Dongry" and cast with Claymation cavemen, the commercial situates the corporation's visionary development of equisapiens in a long history of using tools to modify humans and expand their capacities for work. In a narrative that jumps from rocks in "prehistoric times" to hand weights, pencils, and TV remote controls today, these hybrid human-animal bodies appear as but another extension of human labor. Although Cash outwardly acquiesces to Lift's demand that he take the offer, the remainder of the film centers on his efforts to expose WorryFree and rejoin his former coworkers and friends in a strike against RegalView. The first signs of his resistance emerge, in retrospect, in his performance in front of the rhino mount: Cash has learned to ventriloquize stereotypical expectations of Black men (along with the company message), precisely in order to resist being made into a tool of the capitalist status quo.

Get Out and *STBY* are of course films, yet their invocation of that most quotidian of TV elements, commercials and specifically infomercials, mark them as invested not just in the intertextual play between movies and TV shows, but also in the interstitial materials—the paratextual and largely commercial bits and pieces—that bind TV together. It also connects them to *Atlanta*, which, through its satirical take on the genre of the sitcom and its parodic commercials for psychic phone lines and sugary cereal, appeals to an audience versed in the conventions of 1990s American television. These three audiovisual texts connect in multiple ways, with the most apparent throughline being the presence of actor Lakeith Stanfield, as harbinger (*Get Out*), protagonist (*STBY*), and stoner sidekick (*Atlanta*). Sarah Juliet Lauro and Caroline Hovanec read the three as "case-studies from recent black cinema that make use of animals not merely to reflect upon the devaluation of black life in American culture (although this is a central aspect) but also to raise up animals as icons of resistance in a manner similar to Br'er Rabbit." Noting that, in *Get Out*, the buck in the basement remains prominent in the shot as Chris overtakes Jeremy, they read the mount as a reminder of Chris's mother and "more generally his ancestors" that spurs his resistance.[44] I would add that while the buck summons the doe that Rose killed earlier and echoes the way in which Chris's mother died, the vintage television and its hypnotic programming recall how Chris, as a child, reacted to his mother's unexplained absence by watching television for hours, and consequently harbors a lingering sense of complicity in her death on the side of the road. Now, however, Chris can break free of the televi-

Fig. 19. Alfred encounters deer guts in *Atlanta*'s "Woods"

sion's spell: by stuffing his ears—a strategic act of self-preservation or even self-taxidermy that redeploys slavery's most symbolically laden cash crop as a tool of resistance—he avoids being reduced to an "audience." In "Woods" (season 2, episode 8), the focal episode of my discussion of *Atlanta*, the character Alfred (Henry) encounters a dead deer and offers himself up as a trophy in an act of self-preservation not unlike Chris's (fig. 19). These echoes-with-a-difference, taken alongside these texts' uncannily similar metatextual reflections on the medium of television, insinuate a complex set of historically bound relationships between racial violence, taxidermy, and television in America.

Animals in Atlanta

Atlanta presents a striking example of a post-network-era TV series that recognizes animals as signifiers (if not material beings) uniquely poised to disrupt television's seamless relay of color as hue, race, and alluring figure of diversity and vitality. The series premiered on FX in 2016 and streams on Hulu; its second season aired soon after its first, in 2017; after delays induced by the pandemic and other production issues, its third season came out in the spring of 2022, and its fourth in late 2022. My discussion focuses on the first two seasons. I understand *Atlanta* as exemplary of US television's movement—still far from being fully realized—

from an incurious insistence on "stigmatic blackness" to an investment in "kaleidoscopic blackness." Ann DuCille uses the former term to characterize the kinds of Black characters she was regularly confronted with when she turned on network television as a child in the 1960s. She writes,

> By way of mass media in general and television in particular, the dominant culture secures and protects its possessive investment in whiteness and the privileges thereof through an equally possessive investment in stigmatic blackness—that is, in characters and caricatures historically demeaned and popularly represented as lazy, inept, ineffectual (except at sports, music, and dance), colorful, comical, criminal, crack-addicted; as Sambos, Sapphires, Mammies, Toms, Tricksters, Cons, Coons, and Jezebels; as servants, singers, and dancers; saints on the one hand or sinners on the other.[45]

At the risk of asserting a simplistic progress narrative, these reductive stereotypes have continued to circulate on television for over half a century, yet they have been joined by characters who introduce different kinds of Black experience into a field of representation that remains resolutely invested in reproducing and valorizing whiteness. Danielle Fuentes Morgan identifies a vein of recent African American satire—one of the primary televisual examples of which she posits is *Atlanta*—that "through a clear focus on questions of racial essentialism, either by disavowing or ironically embracing racial performativity," she argues, "creates a tension that opens up a hidden interior into kaleidoscopic Blackness."[46] Through Al's ironic performance of the Buck—a figure absent from DuCille's list, but one that gained substantial purchase on the small screen as the embodiment of "colorful, comical, criminal" Blackness after its cinematic heyday in the blaxploitation films of the 1970s—*Atlanta* insinuates a nuanced understanding of the interiority of this character and the actor who embodies him.

To develop this reading of *Atlanta*, I position the series as being about traffic and as being structured by traffic—an arrangement that offers an alternative to the mode of touristic media that, with its insistence on processual techniques and faith in transparency, I have critiqued throughout *Bits and Pieces*. Through idiosyncratic choices of composition, temporal tricks of editing that Glenda Carpio refers to as "condensations" and "dilations," and subversive play with tired stereotypes, *Atlanta* disrupts patterns and practices of nonattentive flow.[47] In its carefully framed title sequences, establishing shots, and other interstitial images that visualize

mobility and stasis, *Atlanta* considers how bodies, goods, and services move—or don't move, as it were—through the city, the music industry, and especially through domestic spaces. The slow-moving story stages the characters' spiritual and economic strivings in the streets, sites of commerce, institutional spaces, and residential interiors of Atlanta, the capital of the New South and a city that rarely receives its due in television or film. Much of the first season follows Earn (Donald Glover), backpack on, as he travels between his dead-end job (he's initially stuck selling credit cards at Hartsfield-Jackson, one of the world's busiest airports), local fast-food chains and nightclubs, and the houses and apartments of his family and friends. The series' narrative web is cast from his and the other characters' halting movements through the city: premonitory encounters on MARTA (the city's public transportation system), Uber rides that lead to police shootings, and friendly car jackings. Faltering shots of thresholds punctuate these mobile sequences, and their recurrence underscores the guarded precarity of the home as a space built on inclusion and exclusion.

An array of nonhuman animals—purebred and stray dogs, exotic pets, hunted wildlife, omnipresent birdsong—circulate in the series' traffic and introduce many of its most enigmatic moments. These animals confound the roles typically afforded animals on television: the only pet to appear is a caiman named Coach, and he is set loose by his human companion-captor, Uncle Willy (Katt Williams), the episode's titular "Alligator Man" (season 2, episode 1); the plot frequently involves dogs, but they take the decidedly uncompanionable forms of apparitions, icons, and commodities—all of them associated with Stanfield's character, Darius. Wildlife comes into view out of doors, in the green spaces enfolding the city, yet it is likewise at odds with conventional TV images of vast vistas of untouched nature: birdsong accompanies ubiquitous police sirens, and the aforementioned eviscerated deer turns up in some suburban woods behind a gas station. These animals share the orbit—which is to say, the violent systems of exchange—of the main characters, such that *Atlanta* frequently veers toward and away from the equation of Black human and nonhuman animal life, and thereby comments on the (im)possibilities of mobility for the African American characters, particularly the male leads, Earn and his cousin Al, who also goes by his rap name, Paper Boi.

Atlanta's traffic in human and nonhuman animals occurs at the intersection of the mode of satire and the televisual genre of the sitcom. Its distinctive serialization across a varied field of intertextual references

makes it distinctly hospitable to subversive human-animal pairings. Scholars have recently traced, across divergent threads of African American literary history, instances in which Black people and animals join, in Lindgren Johnson's analysis, in "mutually supporting resistances to both white *and* human exceptionalism,"[48] forging what Bénédicte Boisseron calls "interspecies alliances" that allow them to "assert their dignity."[49] When recognition of one's humanness/humanity is never assured, such moves carry enormous risks. It is remarkable, Joshua Bennett observes specifically of Black male writers, that

> even from within the midst of their own, systematic dehumanization—the hypersexualization of their bodies from childhood onward, lowered academic expectations, as well as the constant imposition of mortal fear from the outside world— . . . they are nonetheless willing to turn toward the nonhuman world and read fugitive possibility where others might only see confinement or despair.[50]

Atlanta, a series composed by an exclusively Black (though, importantly, not exclusively male) writing room, demonstrates the potential of this affiliative turn to animals to germinate in the audiovisual, serial form of television.

I refer to *Atlanta*'s gestures of interspecies alliances as instances of "wilding." Jones uses this term to describe the practice of furnishing domestic space with bits and pieces of the natural splendor of imperialism—"trophy heads of exotic game, cases of brightly plumaged songbirds, zoomorphic furniture and bespoke diorama displays"—in order to imbue "the great indoors with powerful messages of captivation, consumption and conquest."[51] This style that Jones identifies in nineteenth-century British interior decor persists, albeit in a more streamlined form, in the gray-walled living rooms of HGTV model homes; establishes a sinister undertone in the hunting-lodge chic of the villains' homes in *Get Out* and *STBY*; and surfaces in *Atlanta* in Teddy Perkins's (Donald Glover) palatial estate, which is outfitted with an ornate parlor where Perkins dines on soft-boiled ostrich eggs and a museum gift shop that he affirms he "designed [himself] to feel like a trophy room" ("Teddy Perkins," season 2, episode 6). Yet more frequently *Atlanta* takes up "wilding" in Stephen J. Mexal's sense of the term—as "a strategic performance of wilderness" or "strategic use of the language of wilderness in order to contest its role in sustaining racist discourse."[52] Mexal carves out this meaning by connecting the word's appearance to describe the

activities of five young Black men accused of raping a white female jogger named Trisha Meili in Central Park on April 19, 1989. This descriptor, breathtakingly racist in its flagrant animalization of the teenagers' behavior leading up the alleged event, was among the inciting embers in the media spectacle that erupted around the case, and the young men—Antron McCray, Kevin Richardson, Yusef Salaam, Raymond Santana, and Korey Wise—were wrongfully convicted and served lengthy sentences before a fellow inmate confessed to the crime. Countering the widespread misconception that this modern usage of wilding emerged fully formed with the Central Park Five, Mexal locates a prior invocation of it ("wildin'") in the rapper Ice-T's 1988 song "Radio Suckers," which he reads as "a reaction to both the limitations of traditional gender roles and to the value the consumer marketplace places on visible indicators of social status and wealth."[53] This sense of wilding as a concerted strategy of subversion—in Mexal's words, "a cultural maneuver that evokes preexisting stereotypes about black savagery or wildness only to undermine them"[54]—aligns with *Atlanta*'s expressions of a guarded interest in human-animal collaborations, including the aforementioned "alligator man," the various canines connected with Darius, the beastly Schnappviecher of "Helen" (season 2, episode 4), and especially Al's encounter with a dead deer. I focus on this last instance of wilding, arguing that it destabilizes the racist trope of the Black man as trophy precisely by inviting "wilderness" and "wild" animals into the diegeses in ways that disrupt reductive equivalencies of black lives and animal lives.

To make sense of the series' (and specifically Al's) subversion of tropes that yoke together Black men and animals, *Atlanta* is best understood as working in multiple genres, but as most fully inhabiting the sitcom, a genre that is set and destined for consumption in domestic space. In doing so, it satirizes that genre's abiding investment in idealized forms of white middle-class domesticity. *Atlanta*'s satire subverts the sitcom's domesticity specifically through its focus on a character who is unhoused, and its settings in unhomely interiors and quietly menacing exteriors, the most memorable of which are wilded by unlikely animals. The first season casts Earn as a Goldilocks figure who doesn't quite fit in the homes of his friends and family members, and who finds refuge in that quintessential space of suburban-transition-turned-stasis, the storage locker. The series' introductory and transitional sequences insistently locate these homes in the "real world" of Atlanta; most notably, the intro sequences of the first episodes of the first two seasons splice together aerial shots of McMansions and urban blight, creating a

juxtaposition that points at "real-world" circumstances such as the disproportionate effects of and uneven recovery from the Great Recession on housing in Black neighborhoods, a disparity particularly acute in metro Atlanta,[55] before cutting to drone shots of the verdant woods in which the city is enmeshed. These transitory views of city spaces enfold the many material and metaphorical animals that move through the series' (un)homely spaces.

Atlanta's idiosyncratic framing of domestic and urban space resonates with Charles Rutheiser's use of "imagineering"—the Walt Disney Company's term for its approach to engineering picture-perfect theatrical and theme park spaces, often cast as "nature" and "wilderness"—to describe the city of Atlanta's self-image-making for the 1996 Olympics. Greater Atlanta is, in Rutheiser's view, "a polynucleated sprawl of sylvan suburbs, slums, and shopping malls surrounding a central archipelago of fortified fantasy islands rising out of a sea of parking lots—the whole tenuously linked by expressways, television, and a fragile sense of imagined *communitas*."[56] Produced twenty years later, *Atlanta* centers its critique of this imagineered geography on the appropriation and commodification of Black popular culture, an ever-intensifying strain of the city's "intense form of boosterism."[57] By situating this critique within a constructed geography that is shot through with decidedly un-Disneyfied views of the city's nonhuman and not-yet-built environment, the series asks viewers to consider how the commercialization of Black culture, and specifically Black music, is shaped by familiar binaries separating inside from outside, city from nature, and human from animal. As Boisseron observes, "The human-animal divide is put into question when the unfamiliar intrudes upon the familiar in a sort of *unheimlich* (uncanny) effect."[58]

Atlanta's uncanny effects accumulate and amplify in its second season, the title of which, "Robbin' Season," plays on dual human and animal meanings: winter in the city sees an uptick in robberies to keep up with holiday spending ("Everybody gotta eat . . . or be eaten," Darius and Earn explain in the season's first episode), as well as the arrival of American robins that come to Georgia to breed.[59] In its coupling of violent symbiosis and pastoral passage, this pun inheres in the season's ten-episode arc. The significance of this diffused wordplay comes into focus if we consider the series' content and form as traffic. Traffic circulates in *Atlanta* in all senses of the word: in the audiovisual backdrop of vehicles moving through a city that is synonymous with sprawl and deadlock; in plotlines that foreground the frequently illicit, usually mun-

dane, and always complicated transmission of commodities (CDs, drugs, guns, phones, dogs, pianos); in narrative detours into surrealist or magical realist modes that sneak in metaphorical meanings; and in the series' structure as serial television. This last meaning of traffic returns us to Williams's concept of "flow." *Atlanta*'s enigmatic animals play outsized roles in connecting the pieces of its serialized narrative—they conduct its flow. Take, for example, the business of dogs: in "The Streisand Effect," Darius helps Earn trade his phone for an ancient-seeming sword and then a Cane Corso, yet Earn doesn't "comes up off" the trade—the sale of the puppies bred by the dog—for seven more episodes, by which time (in "Sportin' Waves," season 2, episode 2) he's all but forgotten that he's in line for $4,000. Or consider Yvonne, the human whom Uncle Willy holds captive along with Coach in "Alligator Man": she is played by Monique Grant, who appears (as Yvonne or some other character—it's unclear) in Ahmad White's commercial for his psychic services in "B.A.N." The Nutella-sandwich-eating White (Emmett Hunter) also appears on the bus in "The Big Bang" (season 1, episode 1), only to disappear into the woods after the dog that will witness the parking-lot shooting that nominally sets off the series. These serial iterations introduce narrative connections that alternately appear to be utterly inconsequential and massively important. As such, they introduce and sustain the possibility of meaningful meetings between humans and animals.

As if to introduce them as an unknown quantity, animals first appear in *Atlanta* as palpably absent signifiers: one of the series' promotional images presents the three male leads with peaches plugging their mouths, as if the city's commercial imaginary is gagging them, readying these hip young Black men for the proverbial spit. Earn and Alfred both invoke animals in early episodes to assert what they are not. Earn makes his first and only explicit reference to his housing status in the series premiere, when he, Darius, and Al leave the latter's apartment to smoke weed on a couch that's been tossed outside: "I'm not real homeless," Earn assures them. "I'm not using a rat as a phone or something." In "Streets on Lock" (season 1, episode 2), Alfred explains to Darius his preference for getting takeout while they wait for their wings at J.R. Crickets: "I don't like people watching me eat; make me feel like I'm in a zoo." In these jokes, Earn and Alfred distance themselves from animals in ways that at once resist visual objectification and assert their belonging in domestic space. Yet as *Atlanta* develops it unhomely spaces, this realm emerges as at odds with the homogenous, hermetically sealed homes of sitcoms past, and its assortment of animals in fact becomes essential to establishing these spaces as permeable and hospitable to different forms of life.

The animals of *Atlanta* are "commensal," Boisseron's term for animals that do "not abide by a dichotomy of private-public space."[60] Boisseron has in mind species such as urban deer and rats, both of which circulate in *Atlanta*, along with other animals that move outside their conventional categories (undomesticated dogs, the house pet caiman). In their marked presence in, outside, and at the threshold of the characters' homes, these animals establish Atlanta as a city that, built on sharp divisions of racial and economic inequality, nevertheless holds within it possibilities of encounter and exchange. "Alligator Man" and "Woods" stake out complementary realms of commensality. Both episodes hinge on "condensed" human-animal doublings, to use Carpio's term for the various temporal moves that the series makes to refurbish figures who might otherwise appear hackneyed. With reference to Coach and Uncle Willy, she writes,

> *Atlanta* invokes the spirit of the much-sentimentalized trickster, a figure so over-determined it signifies saccharine banality at worst, romance at best, [and] it does so strategically. The show uses long-standing tropes in the Black tradition in condensed fashion— compressed to better re-gather their potency and reclaim them from overuse.

Carpio understands these compressions as balanced against moments of "dilation" that enable visual yet not uncritical pleasure—here, the succinct use of slow motion paired with the Delfonics' "Hey Love" to express Coach's "swag."[61] My reading further locates these thickenings in the series' layered traffic, which stitches together frayed planes of reality to meld a televisual space-time in which it becomes possible to imagine the bright lines between nature and city, home and not-home, external performance and interior thought, coming undone.

When situated in this traffic, the condensation of the deer guts in "Woods" can be understood as satirizing an animal metaphor with deep historical connections to Black southern masculinity and a particularly enduring presence in American media. If Willy embodies the trickster, deploying Coach as "his avatar but also his decoy,"[62] then Wally (Reggie Alvin Green), a man Al encounters in the woods, serves as one of several incarnations of the "magical Negro," a stereotypical Black character who, having no narrative arc of his own, offers kindly assistance, often of the spiritual sort, to a leading white character who has been set adrift. *Atlanta* satirizes this Hollywood trope through its serial insertion of char-

acters like Wally and Ahmad White, who appear out of nowhere to minister to the main characters, only the magic they traffic in is likely derived not from "folk wisdom" but from hallucinogens and psychic quackery—and the men they pretend to help are Black.[63]

The first season's tracing of Earn's search for a leg up and a place to stay gives way, in the second season, to Alfred's pursuit of frustratingly unattainable basics like a haircut and a hold on "realness." Al's journey culminates in "Woods," an episode that opens with a stock sitcom moment: a mother chiding her son for not doing his chores. Alfred's mother, Lorraine (Diane Sellers), appears in the background of his dining area, scolding him as he sleeps on the couch in the foreground. Yet as the pilot's exposition of Alfred's residual anger at Earn established, his mother has been dead for a year. Her presence, then, is of a piece with the series' intermittent slippage into different metaphysical spaces, here stylistically signaled only by the slow dimming of the kitchen light as she recedes. Reality resumes with the buzzing of Alfred's phone, and a text from an unnamed number and a call from Earn indirectly reference the anniversary of Lorraine's death by asking if Alfred is okay. Al rouses himself and enters the kitchen to find Darius making pasta from scratch, and this largely unmarked transition back to mundane reality turns the ongoing joke of Darius's unlikely domesticity (he is introduced in the series wielding a knife and plate of freshly baked cookies) into a sharper suggestion that he fulfills a substitutive maternal role as Al's housemate. Al then goes on a perambulatory date with Ciara (Angela Wildflower), a woman who embraces her influencer status and scorns Alfred's discomfort with it; when this tension boils over while the two are getting pedicures in a strip mall somewhere in East Point, Alfred angrily decides to walk home. En route, three younger Black men posing as admiring fans rob him at gunpoint. Alfred manages to fend them all off and takes refuge in some woods, where he crosses paths with Wally. They stumble on and then circle back by a deer carcass, which spurs the following exchange:

WALLY: That's you. Deer guts. That's what I'll call you. Big ol' black-boy deer guts. [Laughs] You're stubborn. You're stubborn and you're black. [Laughs].

ALFRED: I'm serious man. Leave me the fuck alone.

WALLY: Boy, you is just like your mama.

ALFRED: What?

WALLY: [Laughs] What's the matter? You lookin' all crazy.

Time passes and Wally continues to trail Alfred, until he eventually takes a boxcutter to Alfred's throat, confirming that the most dangerous thing in these woods is human. Alfred escapes and tumbles out of the woods into a brightly lit gas station, where he gets a cold drink and invites a selfie with a white kid.

Wally's exclamation that Alfred is "deer guts," made the instant the two encounter the animal remains, asserts an equation between Alfred and the deer that summons the racial slur and trope of the "Black buck." This stereotypical image of a hypersexualized Black man who is defiant of white authority has deep roots in American culture and literature, yet it gains a particularly strong currency in film, where, as Donald Bogle explains, it plays a defining role in two moments pivotal to the representation of Black men: D. W. Griffith's *Birth of a Nation* (1915) and the blaxploitation era of the 1970s.[64] Whereas Griffith's film is blatantly racist in its portrayal of Gus and Lynch as "brutal black bucks," films made in what Bogle dubs "the age of the buck" are more insidious in their use of "tenacious buck protagonists" styled to appeal to Black audiences and affirm Black identity, as they were made mostly by whites in pursuit of commercial profit.[65] In its pairing of a deer carcass and can't-win rapper, *Atlanta* satirizes the figure of the Black buck, expressing a specifically televisual form of the "buck theory" that Bennett traces in recent work by and about Black men. Observing that "the buck—in all of its power, grace, and vulnerability to unexpected, untimely death at the hands of another—has appeared in the work of Black men from the nineteenth century up until the present day," Bennett proposes, from his vantage point as a Black male writer, that poets such as Tommye Blount and Terrance Hayes, along with Jordan Peele in *Get Out*, approach "the buck not only as figure or animal familiar, but as pharmakon. The poison and the cure. The enfleshment of what we, necessarily, refuse and what has been refused us."[66] Alfred is all too aware that, in the eyes of many, he embodies the stereotype of the Black buck. Through his self-aware performance of this role and the particularly gory enfleshment of deer guts, "Woods" seeks a satirical cure for this poisonous view of Black masculinity.

The buck also holds meaning specific to Atlanta. The glitziest part of the city—the part most visible to non-Atlantans through TV shows like *The Real Housewives of Atlanta* (Scott Dunlop, Bravo, 2008–)—is Buckhead, so-called because the man to whom its original parcel of land was deeded after being taken from its Cherokee and Creek inhabitants reputedly hung a buck's head as a sign marking its incipient commercial intersection. In the twentieth century, the summer homes and estates of

Atlanta's white elite sprouted around this trophy to the city's north.[67] In 1952, Mayor William Hartsfield, in an ambitious bid to greatly expand Atlanta's white voters and its tax base, annexed Buckhead. It has remained a majority-white neighborhood and the wealthiest one in metro Atlanta, although it also has strong connections to Black popular culture; for example, the rapper Offset, who appears in "Go for Broke" (season 1, episode 3), owns a palatial estate in Buckhead with his wife, the rapper Cardi B. In the summer of 2020, spurred in part by protests that turned destructive as they turned northward after the police killing of Rayshard Brooks, a movement for "Buckhead City" to secede from Atlanta took off, garnering the support of Republican gubernatorial candidate David Perdue and raising millions of dollars. Buckhead City's website declares its goal to be "to improve the safety in our streets, ensure that our city services align with our tax dollars, build infrastructure and preserve our parklike setting through keeping tree canopy and zoning"—in short, to "save Buckhead"—and it is aptly outfitted with the emblem of gilded deer antlers rising like flames, evoking Atlanta's Phoenix-like rise from the ashes of the Civil War.[68] Dan Immergluck sums up the ironic reversal at work in the budding successionist movement: "The annexation [of Buckhead] was driven by racism, and the drive to secede is driven by racism."[69] In staking its critique of the white evisceration of Black culture on the image of a disemboweled deer, "Woods" acknowledges this trope's longevity in American—and Atlantan—racial politics.

As it recalls buck figures from in and outside the series, the dead deer in "Woods" collects several satirical challenges to the buck stereotype. (The monetary meaning of "a buck" as a dollar is also always there: Al needs to make money.) The episode picks up on a scene in "Da Club" (season 1, episode 8) when the DJ plays Crime Mob's "Knuck If You Buck" and no one dances, a reaction to the hometown hit that, Sierrianna Terry notes, Black Twitter found perplexing and which she explains as "possibly a subtle challenge to the expectations of blackness by black people."[70] This quiet refusal to comply with expectations to exuberantly perform an aggressive sociality—expressed in the lyrics' literal meaning, "Knuckle up if you're buck wild"—finds an echo in Paper Boi's "Mucking" (though that song title is, Alfred explains, a comically absurd portmanteau of a more obvious word), which so laughably fails at the sexual bravado expected of Black rappers. Along with these aural echoes, the deer carcass recalls an obscure animal remainder from TV history: an upended buck trophy that appears, inexplicably, in an investigation room in the pilot of *Twin Peaks* (ABC, 1990–91) (fig. 20). If Lynch's pres-

Fig. 20. An overturned buck mount inexplicably appears in *Twin Peaks*

tige drama seems far afield from the sitcom lineage this chapter has thus far staked out, it's worth recalling *Twin Peaks*' driving fascination with exploring horror in the domestic everyday—as well as Glover's remark that making "*Twin Peaks* with rappers" was the impetus for *Atlanta*.[71]

The deer guts of *Atlanta* and the trophy of *Twin Peaks* appear in medium shots that are markedly similar in their composition, with the torso and head splayed horizontally, antlers tipping into the screen's righthand third of visual interest. In all other ways, they differ. Indeed, *Atlanta*'s shot of deer guts flashes a mirror image to the stately trophy of *Twin Peaks*, much as *Atlanta*'s Atlanta presents the inverse of the fabricated, almost exclusively white town of Twin Peaks. Special Agent Dale Cooper and Sheriff Harry S. Truman momentarily acknowledge the upturned trophy, and it remains in the scene as a surreal invocation of the association between hunting and detective mastery, their job being to find the murderer of Laura Palmer, the beauty queen whose status as "trophy" is established in the intro sequence's framing of her photograph in the high-school trophy case. The revelatory shot of the deer guts in *Atlanta* is handheld, from Alfred's perspective, which, coupled with Wally's assertion ("That's you"), identifies Alfred with it. The trophy in *Twin Peaks* is a classically naturalist mount"—of a large deer, more properly a stag—that has been fastidiously crafted to recreate the animal

in the throes of "liveness," its staging here brightly lit to underscore the nuances of that handiwork. The deer guts of *Atlanta* are just that: guts, aswarm with flies. The limbs have been removed, leaving only the torso and head. This isn't roadkill (cars don't do this kind of damage) but, more likely, a hunting spoil—the meat taken and the rack, small and unimpressive, abandoned. Discovered at night, the carcass is difficult to discern amid the dark underbrush of leaves. It is far from living color. Yet the deer guts nevertheless function as a trophy, in both senses of the word: the modern—this is a triumphant display of the killing of an animal; and the ancient—they mark a turning point in Al's battle with who he understands himself to be in relation to how others see him.

If we understand *Atlanta* as an African American satire that is woven from conversation with television genre and place, then the deer guts emerge as a subversive incarnation of the buck, one that Alfred tentatively takes on when he coaches the wan teen to "give, like, a mob face, man" under the fluorescent lights of the convenience store. Alfred grimace-smiles here, showing his teeth, still bloodied from the attack hours earlier. The pose makes him look tough, yet, in recalling the deer guts, it also declares that he won't be dressed up (contrary to Ciara's insistence that he trade in his "sweaty hoodie") and made to represent something he is not. The celebrity selfie is a particular sort of headshot, one that functions explicitly as a trophy—a souvenir of the fan's momentary triumph over the celebrity's attention and personal space. As a digital artifact that is captured, preserved, and circulated as a public commodity on smartphones, the selfie is also a markedly diminutive and thus possessable kind of headshot, one that, as Frosh puts it, offers "a countenance one can hold in one's hand."[72] In this light, this culminating scene indicates Al's acquiescence to a role imposed on him, while also suggesting that he maintains some control by soliciting the shot and managing the pose.

Al's tentative turn toward the buck, signified by the knowing front he assumes, constitutes a wilding in Mexal's sense—this is Al pushing up against and back on "both the limitations of traditional gender roles and . . . the value the consumer marketplace places on visible indicators of social status and wealth."[73] As Al acknowledges in an early episode in season 1, "I scare people at ATMs, I have to rap" ("The Streisand Effect," episode 4). He recommits to this survival strategy in "Woods," with the episode self-reflexively underscoring it as a pose at multiple turns. The scene cuts to black with a credit that reads, "In Loving Memory of Willow Dean Kearse." As many episode recaps and tweets have noted, Kearse

is the mother of actor Brian Tyree Henry; she died suddenly in 2016, just as the crew was wrapping the show's first season. This dedication thus forms a bookend with the opening scene's reverie of Lorraine, such that "Woods" unfolds as a story about Alfred's/Henry's disorientation not just with self and celebrity, but with grieving and vulnerability. Bennett understands Black male writers' turn to the figure of the buck as "a unique form, we might say, of Du Boisian second sight."[74] In the poems he reads and in *Get Out*, this split vision acknowledges the spectacular and frequently denigrating connotations of this animal metaphor, yet it also demands that we "think instead about the interior worlds of Black men as they live and breathe, their childhood dreams and critical optimism, their lifelong fears and unimpeachable joy."[75] Black mothers, he points out with reference to Chris's mother in *Get Out*, are central to those childhood dreams and the lives they inspire.[76] In gesturing to the ongoing presence of Lorraine and Kearse in Alfred's and Henry's lives, the framing of "Woods" likewise invites attention to these men's interiority, underscoring that they are not just homebodies but, having recently lost their mothers, profoundly homesick.

This detour in "Woods" is just one route through which *Atlanta* invites viewers to think deeply about its characters, their dreams, and their grasp on home. This subversive play with the figure of the Black buck offers a complex and specifically televisual commentary on Black southern masculinity in a series that consistently if obliquely critiques the dialectical regime of invisibility-hypervisibility that governs Black cultural production. And although it would be a stretch to suggest that the series likewise undertakes a critique of the violent regimes of (in)visibility that structure animal life, its idiosyncratic serialization of human-animal metaphors goes well beyond the traditional use of animal ciphers in satire, a mode whose long history Tom Tyler sums up as almost invariably treating animals as "empty, transposable placeholders who fulfil a vital function but have no significance in their own right."[77] The animals of *Atlanta* may bear little significance in their own right, yet in its recurrent turn to animals as "avatars and decoys" for the Black male leads, the series insists that these beings are worthy allies in the small subversive gestures needed to chip away at the frequently violent commodification of Black life.

Conclusion

Hey, what's going on everybody? You know what's really interesting about what's happening in America right now is that a lot of people don't seem to realize how dominoes connect, how one piece knocks another piece that knocks another piece, and in the end creates a giant wave. Each story seems completely unrelated and yet at the same time, I feel like everything that happens in the world connects to something else, in some way, shape, or form. And I think this news cycle that we witnessed in the last week [May 25 to May 29, 2020] was a perfect example of that—Amy Cooper, George Floyd, and the people of Minneapolis. Amy Cooper was, for many people I think, the catalyst. And by the way I should mention that all of this is like against the backdrop of coronavirus, you know? People stuck in their houses for one of the longest periods we can remember. People losing more jobs than anyone can ever remember. People struggling to make do more than they can ever remember. And I think all of that compounded by the fact that there seems to be no genuine plan from leadership. Like, no one knows what's gonna happen. You know, no one knows how long they're supposed to "be good," how long they're supposed to stay inside, how long they're supposed to flatten the curve. No one knows any of these things. And so what happens is you have a group of people who are stuck inside, all of us, our society, we're stuck inside. And we then start to consume, we see what's happening in the world, and I think Amy Cooper was one of the first moments that, you know, one of the first dominoes that we saw get knocked down post-corona for many people. And that was a world where you quickly realized that, while everyone is facing the battle against coronavirus, Black people in America are still facing the battle against racism and coronavirus. And the reason I say it's a domino is because, think about how many Black

Americans just have read and seen the news of how Black people are disproportionately affected by coronavirus, and not because of something inherently inside Black people, but rather because of the lives Black people have lived in America for so long. You know, coronavirus exposed all of it. And now here you have this woman who—we've all seen the video now—blatantly, blatantly knew how to use the power of her whiteness to threaten the life of another man and his Blackness. What we saw with her was a really, really powerful, explicit example of an understanding of racism in a structural way.

—TREVOR NOAH, MAY 29, 2020

As I finished writing this book in the fall of 2021, dominoes continued to fall apace as the "post-corona" era stretched into seeming perpetuity. The "giant wave" of the summer of 2020's racial reckoning had crested, and in its wake flowed media that screened human and nonhuman animal life and death in mostly familiar terms. The second season of *Tiger King* debuted on Netflix, but nobody seemed to watch it, much less meme it. The host of NBC's *Late Night with Seth Meyers* mocked Fox News for promoting the use of the antiparasitic drug Ivermectin to treat COVID-19, calling the drug "literal horse pills."[1] Chipotle aired a sequel to its 2011 commercial featuring Willie Nelson, only in this one Kacey Musgraves crooned Coldplay's lyrics—"I will fix you"—over a smooth tracking shot that arrays the spaces of industrial agricultural production and domestic consumption like obedient dominos, as if to promise the immediate repair of a global supply chain in freefall.[2] Whereas the initial commercial maintains an explicit, if highly sanitized, focus on animal processing, the sequel only briefly includes a smattering of cows, sheep, and pigs, a shift that points, on one hand, to the uptake in the last decade of plant-based foods by companies like Chipotle (the chain now offers shredded tofu as a burrito filling), and, on the other, to the intensified obfuscation of the industrial places and practices of meat production. During the trial that would convict three white men of murdering Ahmaud Arbery, a Black man they chased and gunned down on February 23, 2020, as he went for a run in their predominantly white neighborhood in Brunswick, Georgia, news headlines led with the words of one the defendants, Greg McMichael, recounting the events in a police interview: "He was trapped like a rat."[3] His six-word simile was deemed sufficient to use against him as a summation of his disregard for Arbery's life and the absence of any mitigating cause for snuffing it out.

As Trevor Noah pointed out just months into the pandemic, "Coro-

navirus exposed all of it": structural racism, profound inequality of every stripe, the breathtaking precariousness of the global economy. These revelations have sparked remarkable developments in the field of representation and the world it depicts: two weeks after George Floyd's murder, Paramount TV canceled *Cops*, a series that for more than three decades had reaped enormous profits from its "packaging of police work in poor and BIPOC neighborhoods into commercial television entertainment."[4] In April 2021, Derek Chauvin was convicted of killing Floyd, and in November Gregory McMichael, his son Travis McMichael, and their neighbor William Bryan were convicted in the murder of Arbery—rare instances of white people being held accountable for annihilating Black life. Yet these moves toward substantive change have been countered at every step by the entrenchment of status quo systems of inequality and the hegemonic values that make them possible. Most relevant to this book, the coronavirus's exposure of myriad social imbalances that intersect along lines of race, gender, class—and, to a less recognized extent, species—has been met with consumption-fueled efforts to fortify the home as a unit that atomizes the nuclear family.

This retreat into domestic space pairs what the vast majority of experts agree are essential public-health measures with tried-and-true capitalist responses to collective trauma. In the aftermath of World War II, advertisements held up televisions and refrigerators as devices that "made the suburban household its own world."[5] Efforts to retrofit all manner of twenty-first-century domestic spaces to accommodate living, working, schooling, and socially distant socializing—that is, to make them into their own worlds—have largely been ad hoc, yet more recently enterprises have begun to manufacture such homes whole cloth. In the summer of 2021, Garman Homes unveiled its "Covid concept home" in a planned community in Pittsboro, North Carolina, an exurb of the Research Triangle. Designed based on responses from over seven thousand participants in the "America at Home Study," a survey of "consumer sentiment in light of COVID-19 [undertaken] to understand the design changes consumers want in new homes and communities,"[6] the model home features "flexible" spaces that can be used for school and for work from home, a stand-alone guest suite that facilitates quarantine, and an "escape room" for parents to use when escaping to the outside world is impossible and escaping by watching TV in the living or family room is insufficient. Whereas popular postwar consumer discourse idealized the home as a space of leisurely escape, the Covid concept home prioritizes all-encompassing productivity: as Alaina Money-Garman, CEO

and cofounder of Garman Homes, asserts, "A home should be like a James Bond car with all the tools to help people within the house so they can cope with anything." The all-purpose domicile is dressed in HGTV's characteristic gray-white aesthetic, the signature antiseptic subway tiles of which, it turns out, owe to the previous century's Spanish flu epidemic, as do the large built-in closets and downstairs powder rooms that so frequently make the "must-have" lists of its makeover series.[7]

The most salient change to homes reconfigured by quarantine and its prolonged—and profoundly unequal—repercussions on work and schooling has likely been the addition of screens and a marked increase in the amount of time spent with them. This change in domestic environments promises, in the best-case scenario, to capture our attention and marshal it toward demanding changes to or even the dismantling of the systems of brutally violent inequality that structure our world: "We're stuck inside. We start to consume, we see what's happening in the world," Noah mused as the largest protests against racist practices since the civil rights movement began to take shape in the summer of 2020. And yet, as Tressie MacMillan Cottom aptly summed up Garman Homes' model home after taking a tour of it, "The Covid concept home demonstrates both the exuberant quality of American consumption—that we can buy our way out of everything—and its limits as a solution."[8] Consumption more often just begets more consumption, diverting attention from other potentially more meaningful shifts in actions and habits.

This book has developed an understanding of film and television as media that collect, domesticate, and facilitate the consumption of animals, and it has explored how this reliance on animals as bits and pieces of heterogeneous content seeps into representations of other groups deemed Other, namely Black men. It has examined how film and television participate in what Derrida identifies as our "organized disavowal" of animal suffering,[9] and has identified media that challenge this denial and related forms of racial violence. Echoing Derrida's anaphoric acknowledgment of this disavowal, Noah remarks, "We've all seen the video by now": the video of the white police officer killing an unarmed Black man, the video of one atrocity after another at the factory farm, the video of the hospital overwhelmed with Covid-19 patients. Indeed, we saw these videos long before the pandemic pushed us inside and, by and large, we just continued to watch more videos, allowing the systems, practices, and habits they document to persist. *Bits and Pieces* does not offer any neat answers for where to go or what to do with the knowledge disclosed by these "terrifying and intolerable pictures."[10] It suggests,

rather, that by attending to the connections between ostensibly disparate practices and to the history of how we represent ourselves entangled with animal life, we might begin to repair or remake that relationship, however incrementally and imperfectly. At the very least, paying attention to these interlocking practices and histories may help us to avoid becoming lost and immobilized in the flow of horrific images.

Filmography

This list began as a compendium of films that include footage documenting the unsimulated killing of animals (that is, the "real" slaughter of animals on-screen). All lists are arguments about what does and does not count within the purview of the list. And as with most steps in writing this book, the impossibility of completing this task with any degree of certainty soon became apparent. The disclaimer "No animals were harmed in the making of this film" applies only to films made in the United States after 1939; furthermore, "Things are not always as they seem" when it comes to determining whether a film's production involves the cruel treatment or killing of animals, to use the words of Richard Craven, the first head of the American Humane Association's Hollywood Office and the person tasked with establishing its initial definitions of cruelty.[1] Although I found many unequivocal examples of animal killing instrumentalized as filmic art, I came up with just as many examples that point to the contradictions and complexities underlying the history of animal death in film.

The question of where to draw the line is fundamental. The skin, bones, and tissues of cattle, sheep, and pigs are ground into the gelatin emulsion that makes film stock light-sensitive, and thus every movie shot on film or transferred onto it for projection (that is, many films with a theatrical release) incorporates animal killing into its very materiality.[2] Gelatin is also recommended as a reliable Foley material to produce squishy sounds, and thus animal remains may also inhere invisibly in the soundtracks of films and television, producing often delightful aural effects.[3] In light of the fact that animal matter shapes all film, I initially

narrowed my focus to examples in which, to borrow Vivian Sobchack's phrasing, animals were killed "*by* and *for* the film."[4] This distinction applies to many of the films included here (e.g., *The Rules of the Game*), yet it also opens up other questions: what about films that include found footage documenting the killing of animals (e.g., *Strike*)? Is there a substantive difference between producing and reusing/repurposing indexical images of killing? What if an animal is killed by and for a film, but its body is ultimately used for another purpose, say meat—does this justify the killing? Such multipurposing allegedly occurred in the production of *Andrei Rublev*: a live horse was taken from an abattoir, killed on set, and then returned to the abattoir to be turned into meat. What about animals that are killed by the film (that is, during its production) but whose deaths do not appear, or do not appear as such, on-screen? Nature documentaries come to mind here; to give just one example, the British nature documentarian Gerald Thompson reports that the lights necessary to shoot insects for Disney's True-Life Adventures *Nature's Half Acres* produced so much heat that the caterpillars that appear to be squirming vivaciously in the film are in fact "writhing in their death throes because they were being cooked by the lights."[5] In a similar vein, what about films in which the killing of animals is not intentional or scripted—for example, "Barack Obama Swats Fly: 'I Got the Sucker'"?[6] Clearly, including the latter two types of films would make this list endless—presumably, flies are swatted and innumerable other animals unceremoniously dispatched in the day-to-day production of all films.

I do not include the viral footage of the former American president's masterly act of killing here, not because it is not an important instance of a filmed animal killing that circulated widely and spurred a great deal of conversation (it is), but because it would lead to listing an endless array of online videos from YouTube and other online sources. I have likewise excluded television programming, though I turn to that medium in the second half of this book. In creating this filmography, my strategy has been to include films that come up (or that could reasonably be expected to surface) in discussions of animal killing or slaughter on film. With the exception of several representative "sponsored films" and more recent documentaries that have been released exclusively on online streaming platforms, most of the films listed here received theatrical release.

This list emphasizes North American films, though it also includes international films that have achieved some level of critical and/or commercial acclaim in North America. Given the cultural specificity of animal killing (and especially the making and eating of meat), much prom-

ising work stands to be done on slaughter cinema from any number of (trans)local, (trans)national, (trans)regional, or global perspectives. I include films from different countries that repeatedly came up in readings and discussions as I was writing this book, with the knowledge that this is a small fraction of what exists.

Although this list is long, it is by no means complete. I encountered many of these films in scholarly literature on the intersection of film, animals, and death. To my knowledge, the most comprehensive attempts to inventory animal life and death in cinema are the expansive list Michael Lawrence includes in his examination of real animal death in Michael Haneke's oeuvre, and Belinda Smaill's filmography in *Regarding Life: Animals and the Documentary Moving Image*.[7] Numerous colleagues and acquaintances also generously recommended titles.

In conclusion, many—though, importantly, not all—of the films listed below include documentary images of animal killing. All the films insist that viewers consider difficult questions about how cinema implicates the killing of animals.

L'albero degli zoccoli (*The Tree of Wooden Clogs*, Ermanno Olmi, Italy, 1978)
American Dream (Barbara Kopple, US, 1990)
American Meat (Graham Meriwether, US, 2013)
Andrei Rublev (Andrei Tarkovsky, Soviet Union, 1966)
The Animal Condition (Michael Dahlstrom, Australia, 2014)
Animals (Arik Alon, UK, 2003)
The Animals Film (Victor Schonfeld and Myriam Alaux, UK, 1982)
Apocalypse Now (Francis Ford Coppola, US, 1979)
Au hasard Balthazar (Robert Bresson, France, 1966)
Bacon, le Film (*Bacon, the Film*, Hugo Latulippe, Canada, 2001)
Baraka (Ron Fricke, US, 1992)
Behind the Mask: The Story of People Who Risk Everything to Save Animals (Shannon Keith, US, 2006)
Ben-Hur: A Tale of the Christ (Fred Niblo, US, 1925)
Benny's Video (Michael Haneke, Austria/Switzerland, 1992)
The Big Idea (Edward M. Grabill, US, 1951)
Bontoc Eulogy (Marlon Fuentes, Philippines/US, 1995)
Brother's Keeper (Joe Berlinger and Bruce Sinofsky, US, 1992)
Caché (*Hidden*, Michael Haneke, France/Austria/Germany/Italy, 2005)
Cannibal Ferox (*Make Them Die Slowly*, Umberto Lenzi, Italy, 1981)
Cannibal Holocaust (Ruggero Deodato, Italy, 1980)
Carne (*Meat*, Gaspar Noé, France, 1991)
Carving Magic (Herschell Gordon Lewis, US, 1959)
La Charcuterie mécanique (*The Mechanical Butcher*, Louis Lumière, France, 1895)
The Charge of the Light Brigade (Michael Curtiz, US, 1936)
Un chien andalou (*An Andalusian Dog*, Luis Buñuel, France, 1929)

Cidade de Deus (*City of God*, Fernando Meirelles, Brazil/France/Germany, 2002)
La Ciénaga (*The Swamp*, Lucrecia Martel, Argentina/France/Spain/Japan, 2001)
Le Cochon (*The Pig*, Jean-Michel Barjol and Jean Eustache, France, 1970)
Cockfighter (Monte Hellman, US, 1974)
The Cove (Louie Psihoyos, US, 2009)
A Cow at My Table (Jennifer Abbott, Canada, 1998)
Darwin's Nightmare (Hubert Sauper, Austria/Belgium/France/Germany, 2004)
A Day in the Life of a Massachusetts Slaughterhouse (PETA, US, 1998)
Deliverance (John Boorman, US, 1972)
Divine Horsemen: The Living Gods of Haiti (Maya Deren, Cherel Ito, and Teiji Ito, US, 1993)
Drifters (John Grierson, UK, 1929)
Earthlings (Shaun Monson, US, 2005)
L'effet boeuf (*Beef, Inc.*, Carmen Garcia, Canada, 1999)
Electrocuting an Elephant (Thomas Edison, US, 1903)
The End of the Line (Rupert Murray, UK, 2009)
The Exorcist (William Friedkin, US, 1973)
Faena (*Slaughter*, Humberto Ríos, Argentina, 1960)
Fast Food Nation (Richard Linklater, UK/US, 2006)
Fehér isten (*White God*, Kornél Mundruczó, Hungary/Germany/Sweden, 2014)
Flicka (Michael Mayer, US/UK, 2006)
Fruitvale Station (Ryan Coogler, US, 2013)
Food Inc. (Robert Kenner, US, 2009)
Fowl Play (Adam Durand, US, 2009)
Grass: A Nation's Battle for Life (Merian C. Cooper and Ernest B. Schoedsack, US, 1925)
The Godfather (Francis Ford Coppola, US, 1972)
The Hart of London (Jack Chambers, Canada, 1970)
Heaven's Gate (Michael Cimino, US, 1980)
La hora de los hornos: Notas y testimonios sobre el neocolonialismo, la violencia, y la liberación (*The Hour of the Furnaces*, Octavio Getino and Fernando Solanas, Argentina, 1968)
The Hunter (Daniel Nettheim, Australia, 2011)
Las Hurdes (*Land without Bread*, Luis Buñuel, Spain, 1933)
In einem Jahr mit 13 Monden (*In a Year with 13 Moons*, Rainer Werner Fassbinder, West Germany, 1978)
Japón (*Japan*, Carlos Reygadas, Mexico, 2002)
Jesse James (Henry King, US, 1939)
Killer of Sheep (Charles Burnett, US, 1978)
The Killing Floor (Bill Duke, US, 1985)
Kinoglaz (*Kino-Eye*, Dziga Vertov, Soviet Union, 1924)
Koneko monogatari (*The Adventures of Milo and Otis*, Masanori Hata, Japan, 1986)
Leviathan (Lucien Castaing-Taylor and Véréna Paravel, US, 2012)
The Lie of the Land (Molly Dineen, UK, 2007)
Le Monde du silence (*The Silent World*, Jacques Cousteau and Louis Malle, France, 1956)
Les maîtres fous (*The Mad Masters* or *The Manic Priests*, Jean Rouch, France, 1955)
Maîtresse (*Mistress*, Barbet Schroeder, France, 1975)

Manderlay (Lars von Trier, Denmark/Sweden/Netherlands/France/Germany/ UK/Italy/US, 2005)

Meat (Frederick Wiseman, US, 1976)

Meat the Truth (Karen Soeters and Gertjan Zwanikken, Netherlands, 2007)

Meet Your Meat (Bruce Friedrich, PETA, US, 2002)

Memoirs of a Plague (Robert Nugent, Australia/Ethiopia/Egypt/Tanzania, 2011)

Mondo Cane (Paolo Cavara, Gualtiero Jacopetti, and Franco Prosperi, Italy, 1962)

La montaña sagrada (*The Holy Mountain*, Alejandro Jodorowsky, Mexico/US, 1973)

Moses und Aron (*Moses and Aaron*, Danièle Huillet and Jean-Marie Straub, Austria/France/West Germany/Italy 1975)

Mouchette (Robert Bresson, France, 1967)

Los muertos (*The Dead*, Lisandro Alonso, Argentina/France/Netherlands/ Switzerland, 2004)

Nature's Half Acres (James Algar, US, 1951)

Novecento (*1900*, Bernardo Bertolucci, Italy/France/West Germany, 1976)

Oldeuboi (*Oldboy*, Park Chan-wook, South Korea, 2003)

La Parka (*The Reaper*, Gabriel Serra, Mexico, 2013)

Pat Garrett and Billy the Kid (Sam Peckinpah, Mexico/US, 1973)

Pets or Meat: The Return to Flint (Michael Moore, US, 1992)

Pig Business (Tracy-Louise Ward, UK, 2009)

Pink Flamingos (John Waters, US, 1972)

Primate (Frederick Wiseman, US, 1974)

Red River (Howard Hawkes and Arthur Rosson, US, 1948)

La règle du jeu (*The Rules of the Game*, Jean Renoir, France, 1939)

Retour en Normandie (*Back to Normandy*, Nicolas Philibert, France, 2007)

The Rhythm (Karol Orzechowski, Canada, 2010)

Rien que les heures (*Nothing but Time*, Alberto Cavalcanti, France, 1926)

Roar (Noel Marshall, US, 1981)

Roger & Me (Michael Moore, US, 1989)

Le sang des bêtes (*Blood of the Beasts*, Georges Franju, France, 1949)

Sans soleil (*Sunless*, Chris Marker, France, 1983)

Sátántangó (Béla Tarr, Hungary/Germany/Switzerland, 1994)

The Serpent's Egg (Ingmar Bergman, US/West Germany, 1977)

Seul contre tous (*I Stand Alone*, Gaspar Noé, France, 1998)

Slaughterhouse: The Task of Blood (Brian Hill, UK, 2005)

Slaughterhouse: What the Meat Industry Hides (Aitor Garmendia, Mexico, 2018)

Stachka (*Strike*, Sergei Eisenstein, Soviet Union, 1925)

Stagecoach (John Ford, US, 1939)

"The Stockyard Series" (Selig Polyscope Co., US, 1901): set of sixty-odd films commissioned by the meatpacking giant Swift and Co. that includes titles such as *Arrival of Train of Cattle, Stunning Cattle, Dumping and Lifting Cattle, Sticking Cattle*, and *Koshering Cattle*. Swift also sponsored a number of films in the 1950s, including *The Big Idea* (1951) and *Carving Magic* (1959)

Tampopo (Jûzô Itami, Japan, 1985)

Le temps du loup (*Time of the Wolf*, Michael Haneke, France/Austria/Germany, 2003)

The Texas Chainsaw Massacre (Tobe Hooper, US, 1974)

This Is Hormel (F. R. Furtney and the Hormel Co., US, 1965)

Time Indefinite (Ross McElwee, US, 1993)

Touki Bouki (*Journey of the Hyena*, Djibril Diop Mambéty, Senegal, 1973)

Unser täglich Brot (*Our Daily Bread*, Nikolaus Geyrhalter, Germany/Austria, 2005)

Unsere Afrikareise (*Our Trip to Africa*, Peter Kubelka, Austria, 1966)

Untitled documentary on British export of live horses for slaughter in Belgium (Pathé for the RSPCA, circa 1914)[8]

Viva la muerte (*Long Live Death*, Fernando Arrabal, France/Tunisia, 1971)

Wake in Fright (Ted Kotcheff, Australia/US, 1971)

Week-end (Jean-Luc Godard, France, 1967)

White Hunter, Black Heart (Clint Eastwood, US, 1990)

Workingman's Death (Michael Glawogger, Austria/France/Germany/Indonesia, 2005)

A Zed & Two Noughts, or *ZOO* (Peter Greenaway, UK/Netherlands, 1985)

Notes

INTRODUCTION

1. It's unclear exactly how television-viewing habits changed during the pandemic, partly because the pandemic made it difficult to measure television-viewing habits. Nielson reports that although its measure Total Usage of Television spiked during "peak quarantine" in March 2020, it quickly returned to the patterns of general decline that the agency has observed over the past several years. The Nielsen Company, "Assessment of Audience Estimates during Covid-19," April 2021. https://www.nielsen.com/wp-content/uploads/sites/3/2021/04/2020-2021-Nielsen-National-TV-COVID-Evaluation.pdf

2. Amanda Hess, "The Rise of the Coronavirus Nature Genre," *New York Times*, April 17, 2020, https://www.nytimes.com/2020/04/17/arts/coronavirus-nature-genre.html. See also Jonathon Turnbull, Adam Searle, and William M. Adams, "Quarantine Encounters with Digital Animals: More-Than-Human Geographies of Lockdown Life," *Journal of Environmental Media* 1, Supplement (2020): 6.2, 6.4–6.5; Benjamin Schultz-Figueroa, "Abandoned Aquariums: Online Animal Attractions during Quarantine," *Journal of Environmental Media* 1, Supplement (August 2020): 5.1–5.8; Helen Macdonald, "Animals Are Rewilding Our Cities. On YouTube, at Least," April 15, 2020, *New York Times Magazine*, https://www.nytimes.com/2020/04/15/magazine/quarantine-animal-videos-coronavirus.html

3. The coronavirus nature genre's invitations to adopt this gaze are often inventively monetized: animal sanctuaries sell cameo appearances of their animals in Zoom meetings, and rescue groups host donation-raising virtual tours in which participants can "Zoom-pet" the animals. Animals of some repute began to appear on Cameo, an app that allows users to buy personalized videos made by celebrities, as it began its rise in the era of social distancing. "Fiona the Hippo's Celebrity Status Has Raked in $65,000+ on Cameo App," WLWT5, November 17, 2020, https://www.wlwt.com/article/fiona-the-hippos-celebrity-status-has-raked-in-dollar65000-on-cameo-app/34701214#

4. Laurie Ouellette, "Talking Television in a Pandemic: Epistemology," *Aca-media* podcast, episode 1, hosted by Lynne Joyrich, May 25, 2020, https://www.aca-media .net/news/2020/5/25/talking-television-in-a-pandemic-episode-1-epistemology

5. Emma Grey Ellis, "Thanks to Sheltering in Place, Animal Shelters Are Empty," *Wired*, April 10, 2020, https://www.wired.com/story/coronavirus-pet-adoption -boom/

6. Becky Alexis-Martin, "Sensing the Deathscape: Digital Media and Death during COVID-19," *Journal of Environmental Media* 1, Supplement (2020): 11.3, 11.6.

7. Gabby DaRienzo, "Exploring Grief in *Animal Crossing*," *The Order of the Good Death*, May 13, 2020, https://www.orderofthegooddeath.com/article/exploring-grief -in-animal-crossing-new-horizons/

8. Eric Schlosser, "America's Slaughterhouses Aren't Just Killing Animals," *The Atlantic*, May 12, 2020, https://www.theatlantic.com/ideas/archive/2020/05/essent ials-meatpeacking-coronavirus/611437/; Sophie Kevany, "Millions of US Farm Animals to Be Culled by Suffocation, Drowning and Shooting," *The Guardian*, May 19, 2020, https://www.theguardian.com/environment/2020/may/19/millions-of-us-fa rm-animals-to-be-culled-by-suffocation-drowning-and-shooting-coronavirus

9. *The Daily Show* with Trevor Noah, "George Floyd, Minneapolis Protests, Ahmaud Arbery & Amy Cooper" | The Daily Social Distancing Show, May 29, 2020, https://www.youtube.com/watch?v=v4amCfVbA_c

10. Sydney Trent, "Trump's Warning That 'Vicious Dogs' Would Attack Protesters Conjured Centuries of Racial Terror," *Washington Post*, June 1, 2020, https://www.was hingtonpost.com/history/2020/06/01/trump-vicious-dogs-protesters-civil-rights-slav ery/

11. Killer Mike, "Killer Mike's Emotional Speech at Atlanta Mayor's Press Conference (May 29, 2020)," May 30, 2020, https://www.youtube.com/watch?v=Vy9io6VEt5 8&t=3s

12. Rayshard Brooks, "Rayshard Brooks: In His Own Words," interview with Sam Hotchkiss, Reconnect, February 2020, posted June 17, 2020, https://reconnect.io/ra yshard-brooks-in-his-own-words/

13. John David Rhodes, *Spectacle of Property: The House in American Film* (Minneapolis: University of Minnesota Press, 2017), 12. Rhodes is intentional in his application of Laura Mulvey's term for Hollywood cinema's treatment of women as spectacle, as am I throughout this book.

14. Amelie Hastie, in "Talking Television in a Pandemic."

15. Lynn Spigel, "Installing the Television Set: Popular Discourses on Television and Domestic Space, 1948–1955," *Camera Obscura* 16.1 (1988): 134.

16. Lynne Joyrich, "Talking Television in a Pandemic."

17. To give just one particularly productive starting point for this line of inquiry: André Bazin, "Death Every Afternoon," trans. Mark A. Cohen, *Rites of Realism: Essays on Corporeal Cinema*, ed. Ivone Margulies (Durham: Duke University Press, 2003), 27–31.

18. Jacques Derrida, "The Animal That Therefore I Am (More to Follow)," *Critical Inquiry* 28.2 (Winter 2002): 394.

19. *Oxford English Dictionary Online*, s.v. "tour (*n.*)," September 2021, https://www -oed.com.proxy01.its.virginia.edu/view/Entry/203923?rskey=URrgR2&result=1

20. Judith Hamera, *Parlor Ponds: The Cultural Work of the American Home Aquarium, 1850–1970* (Ann Arbor: University of Michigan Press, 2012), 24.

21. Salomé Aguilera Skvirsky, *The Process Genre: Cinema and the Aesthetics of Labor* (Durham: Duke University Press, 2020), 15.

22. Skvirsky, *The Process Genre*, 3.

23. Skvirsky, *The Process Genre*, 16.

24. Skvirsky, *The Process Genre*, 16.

25. Skvirsky, *The Process Genre*, 2–4, 34.

26. Christian Metz, "Problems of Denotation in the Fiction Film," *Film Language: A Semiotics of the Cinema*, trans. Michael Taylor (Chicago: University of Chicago Press, 1974), 115.

27. Nichole Shukin, *Animal Capital: Rendering Life in Biopolitical Times* (Minneapolis: University of Minnesota Press, 2009), 92.

28. Jonathan Burt, *Animals in Film* (London: Reaktion Books, 2002), 173.

29. Rhodes, *Spectacle of Property*, 23–24.

30. Tichi refers to early TV cabinets as "carapaces" in *Electronic Hearth: Creating an American Television Culture* (Oxford: Oxford University Press, 1991), 18. Spigel discusses how television was marketed as, among other things, the "new family pet" in *Make Room for TV: Television and the Family Ideal in Postwar America* (Chicago: University of Chicago Press), 50.

31. Rachel Poliquin, *The Breathless Zoo: Taxidermy and the Cultures of Longing* (College Park: Pennsylvania State Press, 2013), 18; Cynthia Chris, *Watching Wildlife* (Minneapolis: University of Minnesota Press, 2006), 46–47.

32. Nicole Shukin, *Animal Capital: Rendering Life in Biopolitical Times* (Minneapolis: University of Minnesota Press, 2009), 95–97.

33. Jody Berland, *Virtual Menageries: Animals as Mediators in Network Cultures* (Cambridge: MIT Press, 2019), 17.

34. Upton Sinclair, *The Jungle* (New York: New American Library, 1906), 38.

35. Jonathan Burt, "Conflicts around Slaughter in Modernity," *Killing Animals*, ed. the Animal Studies Group (Urbana: University of Illinois Press, 2003), 121–24.

36. Apoorva Mandavilli, "Small Gatherings Spread the Virus, but Are They Causing the Surge?," *New York Times*, November 23, 2020, https://www.nytimes.com/2020/11/23/health/coronavirus-holiday-gatherings.html

37. "Stripper Mouse—Tallulah," OhStuffinell Taxidermy, https://www.etsy.com/listing/793352593/stripper-mouse-tallulah; U/BirdoTheMan, "Someone was selling dead beetles dressed up as *Jurassic Park* characters on Etsy," September 25, 2020, https://www.reddit.com/gallery/izxyt4

38. Kara Wentworth, "Sensing Sentience and Managing Microbes: Lifedeath in the Slaughterhouse," *Mosaic* 48.3 (September 2015): 142.

39. Dorothee Brantz, "Recollecting the Slaughterhouse," *Cabinet* 4 (Fall 2001): 123.

40. Mick Smith, "The 'Ethical' Space of the Abattoir: On the (In)human(e) Slaughter of Other Animals," *Human Ecology Review* 9.2 (2002): 51.

41. Skvirsky, *The Process Genre*, 95.

42. Skvirsky, *The Process Genre*, 5.

CHAPTER 1

1. Dziga Vertov, *Kino-Eye: The Writings of Dziga Vertov*, trans. Kevin O'Brien, ed. Annette Michelson (Berkeley: University of California Press, 1984), 5.

2. Noëlie Vialles, *Animal to Edible*, trans. J. A. Underwood (Cambridge: Cambridge University Press, 1994), 53–54.

3. Tom Gunning, "Re-newing Old Technologies: Astonishment, Second Nature, and the Uncanny in Technology from the Previous Turn-of-the-Century," *Rethinking Media Change: The Aesthetics of Transition*, ed. David Thorburn, Henry Jenkins, and Brad Seawell (Cambridge: MIT Press, 2003), 45.

4. Of course, access to the film in VHS format and to a VCR is required to perform this precise comparison (to reverse the reversal). Given the growing obsolescence of videotape technology, spectators today are likely to encounter *Kino-Eye* in this format only if they happen seek it out at a library that, like mine, had yet to update its holdings.

5. It's worth noting here that Vertov's contemporary, Sergei Eisenstein, produced a sequence that presents the inverse of Vertov's undoing of the bull. In *The Old and the New* (*Staroye i novoye*, also known as *The General Line*, Soviet Union, 1929), a series of edits creates a time lapse that not so seamlessly shows the growth of a bull from calf to mature adult.

6. Nadia Bozak, *The Cinematic Footprint: Lights, Camera, Natural Resources* (Newark: Rutgers University Press, 2011), 100.

7. Bozak, *The Cinematic Footprint*, 101.

8. See, for example, Sesame Street, "*Sesame Street*: Big Bird Visits a Farm," YouTube video, https://www.youtube.com/watch?v=z6P6OxwDwVo

9. Anne Nesbet, *Savage Junctures: Sergei Eisenstein and the Space of Thinking* (New York: I.B. Tauris, 2003), 33. Nesbet also describes the sequence as visually akin to packing luggage.

10. Jonathan Burt, *Animals in Film* (London: Reaktion Books, 2002), 173.

11. Burt, *Animals in Film*, 173–74.

12. Pao-Chen Tang, "Of Dogs and Hot Dogs: Distractions in Early Cinema," *Early Popular Visual Culture* 15.1 (2017): 45.

13. Tang, "Of Dogs and Hot Dogs," 53.

14. Tang, "Of Dogs and Hot Dogs," 52–53.

15. Nesbet explains that Vertov "began his documentary . . . with the claim that it would catch life '*vrasplokh*,' a term meaning 'unawares' but also 'unexpectedly,' and indeed throughout *Cine-Eye* the tension persists between presenting a documentary portrayal of Soviet life and showing everyday things unexpectedly." *Savage Junctures*, 32–33.

16. Kathleen M. Peplin reflects, for example, that Thomas Edison's 1903 *Electrocuting an Elephant* is "forever linked in my training [as a film scholar] as a prototypical early motion picture." "Construction and Constraint: The Animal Body and Constructions of Power in Motion Pictures" (PhD diss., University of Michigan, 2016), 1.

17. James Cahill, "A YouTube Bestiary: Twenty-Six Theses on a Post-cinema of Animal Attractions," *New Silent Cinema*, ed. Katherine Groo and Paul Flaig (London: Routledge, 2015), 264.

18. Jenara Nerenberg, "Oscar-Winning Documentary Director Mass Mailed His DVD—Did He Help Save Dolphins in the Process?," *Fast Company*, March 1, 2011, https://www.fastcompany.com/1732870/oscar-winning-documentary-director-mass-mailed-his-dvd-did-he-help-save-dolphins-process

19. Amy Villarejo, *Film Studies: The Basics* (New York: Routledge, 2007), 105.

20. Hugo Martin, "Think SeaWorld's Turnaround Satisfied Animal Rights Activists? Think Again," *Los Angeles Times*, April 30, 2016, https://www.latimes.com/business/la-fi-seaworld-next-20160430-story.html

21. André Bazin, "Death Every Afternoon," trans. Mark A. Cohen, *Rites of Realism: Essays on Corporeal Cinema*, ed. Ivone Margulies (Durham: Duke University Press, 2003), 31.

22. Mary Ann Doane, *The Emergence of Cinematic Time: Modernity, Contingency, the Archive* (Cambridge: Harvard University Press, 2002), 92.

23. Jonathan Burt, "*A Day in the Life of a Massachusetts Slaughterhouse*" (review), *Society and Animals* 13 (2005): 350.

24. Rick Prelinger, *The Field Guide to Sponsored Films* (San Francisco: National Film Preservation Foundation, 2006), vi, http://www.filmpreservation.org/userfiles/image/PDFs/sponsored.pdf

25. Timothy Pachirat, *Every Twelve Seconds: Industrialized Slaughter and the Politics of Sight* (New Haven: Yale University Press, 2011), 196.

26. Burt, "*Day in the Life*," 350.

27. Leo Braudy, "The Genre of Nature: Ceremonies of Innocence," *Refiguring American Film Genres: History and Theory*, ed. Nick Browne (Berkeley: University of California Press, 1998), 280.

28. Cynthia Chris, *Watching Wildlife* (Minneapolis: University of Minnesota Press, 2006), 108.

29. Burt, *Animals in Film*, 87.

30. Anat Pick, *Creaturely Poetics: Animality and Vulnerability in Literature and Film* (New York: Columbia University Press, 2011), 169.

31. Pick, *Creaturely Poetics*, 219 n. 12.

32. Laura Mulvey, *Death 24x a Second: Stillness and the Moving Image* (London: Reaktion Press, 2006), 8.

33. Mulvey, *Death 24x a Second*, 144.

34. Sarah O'Brien, "Why Look at Dead Animals?," *Framework: Journal of Cinema and Media* 57.1 (Spring 2016): 52.

35. Bosley Crowther, "Movies to Kill People By," *Screening Violence*, ed. Stephen Prince (New Brunswick: Rutgers University Press, 2000), 51.

36. *Oxford English Dictionary Online*, s.v. "slaughter (*n.*)," September 2021, https://www-oed-com.proxy01.its.virginia.edu/view/Entry/181459?rskey=RdSgD2&result=1&isAdvanced=false

37. *Oxford English Dictionary Online*, s.v. "slaughter (*v.*)," September 2021, https://www-oed-com.proxy01.its.virginia.edu/view/Entry/181460?rskey=RdSgD2&result=2&isAdvanced=false

38. Rachel Poliquin, *The Breathless Zoo: Taxidermy and the Cultures of Longing* (College Park: Pennsylvania State Press, 2012), 156; emphasis added.

39. Amy Fitzgerald, "A Social History of the Slaughterhouse: From Inception to Contemporary Implications," *Research in Human Ecology* 17.1 (2010): 61.

40. Jonathan Burt, "Conflicts around Slaughter in Modernity," *Killing Animals*, ed. the Animal Studies Group (Urbana: University of Illinois Press, 2003), 120.

41. For an exacting ethnographic account of this distribution, see Pachirat's *Every Twelve Seconds*. For a contrasting account of how human workers literally feel out and manage the moment of an animal's death on smaller kill floors, see Kara Wentworth, "Sensing Sentience and Managing Microbes: Lifedeath in the Slaughterhouse," *Mosaic* 48.3 (2015): 141–56.

42. Vivian Sobchack, *Carnal Thoughts: Embodiment and Moving Image Culture* (Oakland: University of California Press, 2004), 234–35.

43. Jacques Derrida, "'Eating Well,' or the Calculation of the Subject," *Points: Interviews, 1974–1994*, trans. Avital Ronell (Stanford: Stanford University Press, 1995), 278.

44. Cathy B. Glenn, "Constructing Consumables and Consent: A Critical Analysis of Factory Farm Industry Discourse," *Journal of Communication Inquiry* 28 (January 2004): 63.

45. Joan Dunayer, *Animal Equality: Language and Liberation* (Derwood, MD: Ryce, 2001), 125.

46. Carol J. Adams, *The Pornography of Meat* (New York: Continuum, 2004), 22; emphasis in original.

47. Daniel Thomas, "Would You Call this a Vegetable Tube?" *BBC News*. June 19, 2019. https://www.bbc.com/news/business-48676145

48. Glenn, "Constructing Consumables," 67.

49. Kathryn Gillespie, "How Happy Is Your Meat? Confronting 'Humane' Slaughter in the 'Alternative' Meat Industry," 22, 3, paper delivered at "Animals and Animality across the Humanities and Social Sciences" conference at Queen's University in Kingston, ON, June 26, 2010. Gillespie draws from *Webster's International Unabridged Second Edition*, 1931. A revised version of her essay, which does not include this etymology, is published as "How Happy Is Your Meat? Confronting (Dis)connectedness in the 'Alternative' Meat Industry," *Brock Review* 12.1 (2011): 100–128.

In producing this etymology, Gillespie's larger point is to highlight the dissonance within terms such as *humane slaughter* by replacing the component words with various of their synonyms: "'altruistic carnage,' 'considerate massacre,' 'merciful murder,' 'kindly tearing to pieces,' 'compassionately slain flesh,' or a 'sympathetic blow.'" Her substitutive wordplay discloses the oxymoronic absurdity of such terms, which have quickly gained currency as legitimate descriptors for ethical practices of meat production and consumption.

50. Belinda Smaill, *Regarding Life: Animals and the Documentary Moving Image* (Albany: SUNY Press, 2016), 26.

51. Akira Mizuta Lippit, *Electric Animal: Toward a Rhetoric of Wildlife* (Minneapolis: University of Minnesota Press, 2000) and "The Death of an Animal," *Film Quarterly* 56.1 (Autumn 2002), 9–22.

52. See Burt, *Animals in Film*; Pick, *Creaturely Poetics*; Nicole Shukin, *Animal Capital: Rendering Life in Biopolitical Times* (Minneapolis, University of Minnesota Press, 2009). For a condensed, accessible overview of the central films and theoretical questions in

this conversation, see Barbara Creed, "Animal Deaths on Screen: Film and Ethics," *Relations* 2.1 (June 2014): 15–31.

53. To note just two examples: Belinda Smaill, "New Food Documentary: Animals, Identification, and the Citizen Consumer," *Film Criticism* 39.2 (Winter 2014–15): 79–102; Jamie Lorimer, "Moving Image Methodologies for More-Than-Human Geographies," *Cultural Geographies* 17.2 (2010): 237–58. *Society and Animals* and the *Journal for Critical Animal Studies* have also published numerous reviews and articles about documentary films that expose animal mistreatment and killing.

54. Carol Vernalis, *Unruly Media: YouTube, Music Video, and the New Digital Cinema* (New York: Oxford University Press, 2013), 13.

55. Shukin, *Animal Capital*, 257.

56. Fitzgerald, "Social History," 60.

57. For a detailed accounting of these divergences, compare the various perspectives in *Meat, Modernity, and the Rise of the Slaughterhouse*, ed. by Paula Young Lee (Durham: University of New Hampshire Press, 2008).

58. Paula Young Lee, "Siting the Slaughterhouse: From Shed to Factory," *Meat, Modernity, and the Rise of the Slaughterhouse*, ed. Young Lee (Durham: University of New Hampshire Press, 2008), 51.

59. Mick Smith, "The 'Ethical' Space of the Abattoir: On the (In)human(e) Slaughter of Other Animals," *Human Ecology Review* 9.2 (2002): 51. See also Brantz, "Recollecting the Slaughterhouse," *Cabinet* 4 (Fall 2001): 119.

60. Fitzgerald, "Social History," 60.

61. Smith, "Ethical Space," 50.

62. Smith, "Ethical Space," 50.

63. Brantz, "Recollecting," 119. See also Brantz, "Stunning Bodies: Animal Bodies, Judaism, and the Meaning of Humanity in Imperial Germany," *Central European History* 35.2 (2002): 169.

64. Wentworth, "Sensing Sentience," 142.

65. Roger Horowitz, *Putting Meat on the American Table: Taste, Technology, Transformation* (Baltimore: Johns Hopkins University Press, 2006).

66. Fitzgerald, "Social History," 60.

67. Vialles, *Animal to Edible*, 47.

68. Vialles, *Animal to Edible*, 22–23.

69. Vialles, *Animal to Edible*, 23.

70. Vialles, *Animal to Edible*, 22.

71. Brantz, "Recollecting," 119–21.

72. Horowitz, *Putting Meat*, 50.

73. Brantz, "Recollecting," 121.

74. Brantz, "Recollecting," 121.

75. Shukin, *Animal Capital*, 95. Shukin cites the New American Library edition of *The Jungle* (New York, 1960).

76. Shukin, *Animal Capital*, 20.

77. Shukin, *Animal Capital*, 92.

78. Lynne Kirby, *Parallel Tracks: The Railroad and Silent Cinema* (Durham: Duke University Press, 1997), 8, quoted in Shukin, *Animal Capital*, 100.

79. Shukin, *Animal Capital*, 92.

80. Jane Giles, "The White Horse, *Seul contre tous*, and Notes on Meat as Metaphor in Film," *Vertigo* 1.9 (1999): 42; emphasis added.

81. Brantz, "Recollecting," 118.

82. Roger Horowitz, "Holiday at the Abattoir: The Rise and Fall of Slaughterhouse Tourism in America," interview by Heather Smith, *Meatpaper* 9 (Fall 2009): 14.

83. Shukin, *Animal Capital*, 96.

84. Cora Diamond, "Eating Meat and Eating People," *Animal Rights: Current Debates and New Directions*, ed. Cass R. Sunstein and Martha C. Nussbaum (New York: Oxford University Press, 2004), 96.

85. Horowitz, *Putting Meat*; see in particular chapter 1.

86. Shukin, *Animal Capital*, 95.

87. Justin Marceau, "Ag Gag Past, Present, and Future," *Seattle University Law Review* 38.4 (2015): 1318.

88. Shukin, *Animal Capital*, 101.

89. Shukin, *Animal Capital*, 101.

90. Shukin, *Animal Capital*, 96–97. Swift's 1903 *Visitors Reference Book* is archived at the John W. Hartman Center for Sales, Advertising and Marketing History, Duke University, https://idn.duke.edu/ark:/87924/r4d21t73c

91. Christian Metz, *The Imaginary Signifier: Psychoanalysis and the Cinema*, trans. Celia Britton, Annwyl Williams, Ben Brewster, and Alfred Guzzetti (Bloomington: Indiana University Press, 1982).

92. Horowitz, "Holiday at the Abattoir," 14.

93. Horowitz, *Putting Meat*, 68.

94. Horowitz, *Putting Meat*, 35.

CHAPTER 2

1. Official PETA, "Official 'Glass Walls' Video by Paul McCartney," Vimeo video, https://vimeo.com/489187615

2. Jacques Derrida, "The Animal That Therefore I Am (More to Follow)," trans. David Wills, *Critical Inquiry* 28 (Winter 2002): 370, 393–94.

3. Derrida, "Animal I Am," 394.

4. Derrida, "Animal I Am," 394–95.

5. Derrida, "Animal I Am," 395; emphasis added.

6. Derrida, "Animal I Am," 395.

7. Garrett M. Broad, "Animal Production, Ag-Gag Laws, and the Social Production of Ignorance: Exploring the Role of Storytelling," *Environmental Communication* 10.1 (2016): 46.

8. Linda Williams, *Hard Core: Power, Pleasure, and the "Frenzy of the Visible"* (Berkeley: University of California Press, 1999), iv.

9. Jason Middleton, "Documentary Horror: The Transmodal Power of Indexical Violence," *Journal of Visual Culture* 14.3 (December 2015): 287.

10. Smithfield Foods, "Animal Care—Taking the Mystery Out of Pork Production," https://www.schooltube.com/media/Introduction+%26+Overview–Taking+the+Mystery+out+of+Pork+Production+/1_r52p76e7. This video is no longer hosted on the

company's site. According to my notes, I encountered it on Smithfield's website on February 4, 2011.

11. Rick Prelinger, *The Field Guide to Sponsored Films* (San Francisco: National Film Preservation Foundation, 2006), 12, 17. https://www.filmpreservation.org/dvds-and -books/the-field-guide-to-sponsored-film

12. Nicole Shukin, *Animal Capital: Rendering Life in Biopolitical Times* (Minneapolis: University of Minnesota Press, 2009), 255.

13. "PETA's Milestones for Animals," https://www.peta.org

14. Broad, "Animal Production," 49. A glance at related recent article titles confirms the centrality of revelatory vision to the growing discourse on the policing of agricultural discourse. See, for example, Nicole E. Negowetti, "Opening the Barnyard Door: Transparency and the Resurgence of Ag-Gag and Veggie Libel Laws," *Seattle University Law Review* 38.4 (2015): 1345–98; Pamela Fiber-Ostrow and Jarret S. Lovell, "Behind a Veil of Secrecy: Animal Abuse, Factory Farms, and Ag-Gag Legislation," *Contemporary Justice Review: Issues in Criminal, Social, and Restorative Justice* 19.2 (2016): 230–49.

15. Walzer, "Temple Grandin Appears in Smithfield Foods Videos," *Virginian-Pilot*, April 10, 2011, https://www.pilotonline.com/business/article_a9285413-1f5d-5ff5-93 e2-a7799a079b57.html

16. Broad, "Animal Production," 48–49.

17. Jonathan Burt, *Animals in Film* (London: Reaktion Books, 2002), 173–74.

18. Burt, *Animals in Film*, 174–75.

19. Owain Jones, "(Un)ethical Geographies of Human-Nonhuman Relations: Encounters, Collectives, and Spaces," *Animal Spaces, Beastly Places: New Geographies of Human-Animal Relations*, ed. Chris Philo and Chris Wilbert (New York: Routledge, 2000), 268.

20. Burt, "Conflicts around Slaughter in Modernity," *Killing Animals*, ed. Animal Studies Group (Urbana: University of Illinois Press, 2003), 121–24.

21. Jamie Lorimer, "Moving Image Methodologies for More-than-Human Geographies," *Cultural Geographies* 17.2 (2010): 249.

22. Burt, *Animals in Film*, 173.

23. Benjamin's draft notes for "The Work of Art in the Age of Mechanical Reproduction," quoted in Miriam Hansen, "Room for Play: Benjamin's Gamble with Cinema," *Canadian Revue of Film Studies / Revue Canadienne d'Etudes Cinemématographique* 13.1 (2003): 5.

24. Carol J. Adams, *The Pornography of Meat* (New York: Continuum, 2004), 74.

25. Adams, *The Pornography of Meat*, 107.

26. Adams, "The Pornography of Meat," keynote lecture at "Animals and Animality across the Humanities and Social Sciences" conference at Queen's University, Kingston, Ontario, June 26, 2010. Personal conference notes.

27. Shukin and Sobchack suggest as much in their reworkings of the structuralist metaphor of the raw. Shukin, *Animal Capital*, 3; Vivian Sobchack, *Carnal Thoughts: Embodiment and Moving Image Culture* (Oakland: University of California Press, 2004), 256.

28. Burt, *Animals in Film*, 173–74.

29. Anat Pick, "Three Worlds: Dwelling and Worldhood on Screen," *Screening*

Nature: Cinema beyond the Human, ed. Anat Pick and Guinevere Narraway (New York: Berghahn Books, 2013), 28–32.

30. Nicole Seymour, *Bad Environmentalism: Irony and Irreverence in the Environmental Age* (Minneapolis: University of Minnesota Press, 2018), 90–91.

31. Anat Pick, introduction to *Screening Nature: Cinema beyond the Human*, ed. Anat Pick and Guinevere Narraway (New York: Berghahn Books, 2013), 2.

32. Roland Barthes, *Camera Lucida: Reflections on Photography*, trans. Richard Howard (New York: Hill and Wang, 2010), 5.

33. Ted Genoways, "The Spam Factory's Dirty Secret," *Mother Jones*, July–August 2011, 1.

34. Upton Sinclair, *The Jungle* (New York: New American Library, 1960), 34.

35. Roger Horowitz, *Putting Meat on the American Table: Taste, Technology, Transformation* (Baltimore: Johns Hopkins University Press, 2006), 2.

36. William Cronon, *Nature's Metropolis: Chicago and the Great West* (New York: Norton, 1991), 229.

37. Dorothee Brantz, "Recollecting the Slaughterhouse," *Cabinet* 4 (Fall 2001): 121.

38. Belinda Smaill, *Regarding Life: Animals and the Documentary Moving Image* (Albany: SUNY Press, 2016), 27.

39. "Back to the Start" was created and initially circulated in the summer of 2011 as an online video on Chipotle's website, yet it garnered so much attention that the chain's marketing department purchased spots for it as a prefilm commercial in American movie theatres and at the 2012 Grammy Awards Show. Maureen Morrison, "Chipotle Leaps Forward with 'Back to the Start,'" *Adage*, November 26, 2012, https://adage.com/article/special-report-marketer-alist-2012/chipotle-leaps-forward-back-start/238415

40. Salomé Aguilera Skvirsky, *The Process Genre: Cinema and the Aesthetics of Labor* (Durham: Duke University Press, 2020), 36.

41. Skvirsky, *The Process Genre*, 140–41.

42. Skvirsky, *The Process Genre*, 223, 225.

43. Skvirsky, *The Process Genre*, 141.

44. For discussion of one particularly resonant example, listen to "The Wilhelm," *On the Media* podcast, December 25, 2009, http://www.wnyc.org/story/132618-the-wilhelm/

45. Susan Sontag, *Regarding the Pain of Others* (New York: Farrar, Straus and Giroux, 2003), 118.

46. Sinclair, *The Jungle*, 40.

47. Williams, *Hard Core*, 53.

48. Williams, *Hard Core*, 49.

49. For a more in-depth exploration of cinema's striving to capture death, see Sarah O'Brien, "Why Look *at* Dead Animals?," *Framework: The Journal of Cinema and Media* 57.1 (Spring 2016): 32–57.

50. Williams, *Hard Core*, 72–73.

51. Williams, *Hard Core*, 94.

52. Williams, *Hard Core*, 122–23.

53. O'Brien, "Why Look," 46–48.

54. Mick Smith, "The 'Ethical' Space of the Abattoir: On the (In)human(e) Slaughter of Other Animals," *Human Ecology Review* 9.2 (2002): 50, 53.

55. Mary Ann Doane, "The Voice in the Cinema," *Yale French Studies* 60 (1980): 39. Quoted in Williams, *Hardcore*, 125.

56. Williams, *Hard Core*, 124–25.

57. Smith, "Ethical Space," 50, 53.

58. Nicole Shukin and Sarah O'Brien, "Being Struck: On the Force of Slaughter and Cinematic Affect," *Animal Life and the Moving Image*, ed. Michael Lawrence and Laura McMahon (London: Palgrave Macmillan / British Film Institute, 2015), 187–202.

59. Janet Walker, "Eavesdropping in *The Cove*: Interspecies Ethics, Public and Private Space, and Trauma under Water," *Eco-Trauma Cinema*, ed. Anil Narine (New York: Routledge, 2015), 197.

CHAPTER 3

1. Taxidermy has also provided fertile ground for documentary films, such as *Furever* (Amy Finkel, US, 2013) and *Stuffed* (Erin Derham, Canada/US, 2019). Nicolas Philobert's documentaries *Un animal, des animaux* (*Animals and More Animals*, France, 1996) and *Nénette* (France, 2010) include striking depictions of taxidermy.

2. Christina Colvin, "Freeze-Drying Fido: The Uncanny Aesthetics of Modern Taxidermy," *Mourning Animals*, ed. Margo DeMello (East Lansing: Michigan State University Press, 2016), 65–66.

3. Mimi White, "A House Divided," *European Journal of Cultural Studies* 20.5 (2017): 575–76, 589.

4. Karen Jones, "The Rhinoceros and the Chatham Railway: Taxidermy and the Production of Animal Presence in the 'Great Indoors,'" *History* 101 (December 2016): 728.

5. "Too Much Taxidermy," *The Most Embarrassing Rooms in America*, season 1, episode 2, HGTV, September 14, 2013.

6. Patrick A. Morris writes, "By the 1950s, stuffed animals had become 'old fashioned,' part of a pre-war life, recalling a bygone age that was no part of the new future that lay ahead following the end of the Second World War." *A History of Taxidermy: Art, Science, and Bad Taste* (Ascot, England: MPM Publishing, 2010), 4–5.

7. David L. Haynes, "A Super-Fan Creates One Magnificently Detailed 'Fixer Upper' Dollhouse," https://www.hgtv.com/shows/fixer-upper/articles/a-super-fan -creates-one-magnificently-detailed-fixer-upper-dollhouse, accessed September 6, 2022.

8. For additional examples of taxidermy in recent home-renovation series, see "Family Seeks Dream House in Park City, Utah," *House Hunters*, season 126, episode 4, HGTV, 2017; "On Budget in Bigfort, Montana," *Living Big Sky*, season 2, episode 14, HGTV, 2015; "A Taxidermy Turnout," *Cash & Cari*, season 3, episode 1, HGTV, 2013; and "Hoboken Busy Bachelor," *Home by Novogratz*, season 1, episode 4, HGTV, 2011.

9. When my local library offered a free craft-making session for teens called "Stuffed Animal Taxidermy," it immediately filled up. Dekalb Public Library, https:// events.dekalblibrary.org/event/6668725

10. Rachel Poliquin, *The Breathless Zoo: Taxidermy and the Cultures of Longing* (College Park: Pennsylvania State University Press, 2013), 18; Cynthia Chris, *Watching Wildlife* (Minneapolis: University of Minnesota Press, 2006), 46–47.

11. Lynn Spigel, "Installing the Television Set: Popular Discourses on Television and Domestic Space, 1948–1955," *Camera Obscura* 16.1 (1988): 32.

12. Jane Feuer, "The Concept of Live Television: Ontology as Ideology," *Regarding Television—Critical Approaches: An Anthology*, ed. E. Ann Kaplan (Frederick, MD: University Publications of America, 1983), 14.

13. Poliquin, *The Breathless Zoo*, 108.

14. Jane Desmond, "Displaying Death, Animating Life: Changing Fictions of 'Liveness' from Taxidermy to Animatronics," *Representing Animals*, ed. Nigel Rothfels (Bloomington: Indiana University Press, 2002), 160.

15. Anne Coote, Alison M. Haynes, Jude Philp, and Simon Ville, "When Commerce, Science, and Leisure Collaborated: The Nineteenth-Century Global Trade Boom in Natural History Collections," *Journal of Global History* 12.3 (2017): 323–24.

16. *Oxford English Dictionary Online*, s.v. "wild (*v.*)," March 2020, https://www-oed-com.proxy01.its.virginia.edu/view/Entry/228989?rskey=WkSDq4&result=2&isAdvanced=false#eid

17. Jones, "Rhinoceros and Chatham Railway," 714.

18. Yi-Fu Tuan, *Dominance and Affection: The Making of Pets* (New Haven: Yale University Press, 1984), 99.

19. The *Oxford English Dictionary Online*'s entry on "wild (*v.*)" cites an April 22, 1989, article in the *New York Times* as the first to identify this usage of "wilding"—the article references a police chief who attributes the police department's first knowledge of the term to teenagers who were brought in for questioning about the events of April 19. The *OED Online* notes that this verb usage of wilding exists "only in the progressive and as *present participle*." The miniseries *When They See Us* (Ava DuVernay, Netflix, 2019) renewed the term's currency by questioning whether it was simply the product of sloppy handwriting in a police officer's report.

20. My turn to "wilding" draws from Stephen J. Mexal's excavation of the term, discussed in greater detail in chapter 4: "The Roots of 'Wilding': Black Literary Naturalism, the Language of Wilderness, and Hip Hop in the Central Park Jogger Rape," *African American Review* 46.1 (Spring 2013): 101–2.

21. Cecelia Tichi, *Electronic Hearth: Creating an American Television Culture* (New York: Oxford University Press, 1991), 43.

22. Walter Benjamin, "The Work of Art in the Age of Mechanical Reproduction," *Illuminations: Essays and Reflections*, ed. Hannah Arendt, trans. Harry Zohn (New York: Schocken, 1969), 218–20.

23. Jody Berland, *Virtual Menageries: Animals as Mediators in Network Cultures* (Cambridge: MIT Press, 2019), 17.

24. Berland, *Virtual Menageries*, 7.

25. Berland, *Virtual Menageries*, 104–5.

26. Judith Hamera, *Parlor Ponds: The Cultural Work of the American Home Aquarium, 1850–1970* (Ann Arbor: University of Michigan Press, 2012), 17.

27. Hamera, *Parlor Ponds*, 20–21.

28. Hamera, *Parlor Ponds*, 24.

29. Hamera, *Parlor Ponds*, 1–3.

30. Hamera, *Parlor Ponds*, 17, 1.

31. Hamera, *Parlor Ponds*, 38.

32. Fatimah Tobing Rony, *The Third Eye: Race, Cinema, and Ethnographic Spectacle* (Durham: Duke University Press, 1996), 110.

33. Rony, *The Third Eye*, 115.

34. André Bazin, "Death Every Afternoon," trans. Mark A. Cohen, *Rites of Realism: Essays on Corporeal Cinema*, ed. Ivone Margulies (Durham: Duke University Press, 2003), 30–31.

35. Pauline Wakeham, *Taxidermic Signs: Reconstructing Aboriginality* (Minneapolis: University of Minnesota Press, 2008), 6.

36. J. M. Alberti, introduction to *The Afterlives of Animals*, ed. Alberti (Charlottesville: University of Virginia Press, 2011), 6.

37. Poliquin, *The Breathless Zoo*, 23.

38. Poliquin, *The Breathless Zoo*, 25.

39. Susan Leigh Star, "Craft vs. Commodity, Mess vs. Transcendence: How the Right Tool Became the Wrong One in the Case of Taxidermy and Natural History," *The Right Tools for the Job: At Work in Twentieth-Century Life Sciences*, ed. Adele E. Clarke and Joan H. Fujimura (Princeton: Princeton University Press, 1992), 267–69.

40. Mark Alvey, "The Cinema as Taxidermy: Carl Akeley and the Preservative Obsession," *Framework* 48.1 (Spring 2007): 40–41.

41. Poliquin, *The Breathless Zoo*, 41.

42. Melissa Milgrom, *Still Life: Adventures in Taxidermy* (Boston: Houghton Mifflin Harcourt, 2010), 5.

43. Poliquin, *The Breathless Zoo*, 10; Morris, *A History of Taxidermy*, 8.

44. Stephen T. Asma, *Stuffed Animals and Pickled Heads: The Culture and Evolution of Natural History Museums* (Oxford: Oxford University Press, 2003), 10.

45. Morris, *A History of Taxidermy*, 3.

46. The noun usages for "mount" are varied. The *OED Online* attributes the first instance of its most immediately relevant meaning, "6. A bird, mammal, or other animal preserved with a lifelike appearance by taxidermy or other means," to a caption of a photograph of Jumbo's taxidermic form in a 1928 issue of *Scientific Monthly*. This usage appears immediately after "II. Senses relating to support and display. 5. A support in or on which something is set or placed, or to which something is fixed, esp. for the purpose of display," a category that includes "b. An ornamental metal border, edge, or guard for an angle or prominent part of an object, as a piece of furniture, etc."; "c. A margin surrounding a picture, etc. a piece of card or other backing to which a drawing, etc. is attached for display"; "g. A base to which a cannon or other gun is attached; a support for a gun or for an attachment to a gun"; and "h. *Photography*. A fitting made to support a lens, *esp.* one on a camera with interchangeable lenses." The earliest of these usages date (for sense b) to 1739. In this movement, a "mount" shifts from being the frame or support for an object (a piece of furniture, a picture, a gun, a camera lens), to the taxidermic "thing itself." *Oxford English Dictionary Online*, s.v. "mount (*n.*)," September 2021, https://www.oed-com.proxy01.its.virginia.edu/view/Entry/122889?rskey=xRc7D3&result=2&isAdvanced=false#eid

47. Morris, *A History of Taxidermy*, 3, 8.

48. Morris, *A History of Taxidermy*, 8.

49. Morris, *A History of Taxidermy*, 39–42.

50. Desmond, "Displaying Death, Animating Life," 161.

51. Michelle Henning, "Skins of the Real: Taxidermy and Photography," *Nanoq: Flat Out and Bluesome: A Cultural Life of Polar Bears*, ed. Bryndís Snaebjörnsdóttir and Mark Wilson (London: Black Dog, 2006), 138.

52. Helen Gregory and Anthony Purdy, "Present Signs, Dead Things: Indexical Authenticity and Taxidermy's Nonabsent Animal," *Configurations* 23 (2015): 73.

53. Gregory and Purdy, "Present Signs, Dead Things," 69–70.

54. Jones, "Rhinoceros and Chatham Railway," 726.

55. For a cogent explication of television and digital video's indexicality, see John McMullan, "The Digital Moving Image: Revising Indexicality and Transparency," *Diegetic Life Forms Conference II Proceedings*, 2011.

56. Desmond, "Displaying Death, Animating Life," 161.

57. Poliquin, *The Breathless Zoo*, 115.

58. Milgrom, *Still Life*, 5, 10.

59. Milgrom, *Still Life*, 116. For more on the controversy surrounding the hall, see John Balzar, "Smithsonian Museum in Cross-Hairs of Debate," *L.A. Times*, March 21, 1999, https://www.latimes.com/archives/la-xpm-1999-mar-21-mn-19607-story.html

60. "Kenneth E. Behring Family of Mammals Hall," https://www.si.edu/exhibit ions/kenneth-e-behring-family-hall-mammals%3Aevent-exhib-197, accessed September 6, 2022.

61. Gregory and Purdy, "Present Signs, Dead Things," 65, 69. They cite Henning, "Skins of the Real," 139.

62. For more on the intersections between cameras and guns, see Matthew Brower, *Developing Animals: Wildlife and Early American Photography* (Minneapolis: University of Minnesota Press, 2010).

63. Nadine H. Roberts, *The Complete Handbook of Taxidermy* (New York: Tab Books, 1979), 275–86.

64. Garry Marvin, "Enlivened through Memory: Hunters and Hunting Trophies," *The Afterlives of Animals: A Museum Menagerie*, ed. Samuel J. M. M. Alberti (Charlottesville: University of Virginia Press, 2011), 211–12.

65. Morris, *A History of Taxidermy*, 3.

66. Valentin Schwind, K. Leicht, Solveigh Jäger, Katrin Wolf, and Niels Henze, "Is There an Uncanny Valley of Virtual Animals? A Quantitative and Qualitative Investigation," *International Journal of Human-Computer Studies* 111 (2017): 49–61.

67. ACME Film and Television ACME Directory, https://www.theacme.com/

68. Alvey, "The Cinema as Taxidermy," 32–33.

69. Alvey, "The Cinema as Taxidermy," 23, 34–35.

70. Desmond, "Displaying Death, Animating Life," 162.

71. Morris, *A History of Taxidermy*, 4.

72. Wakeham, *Taxidermic Signs*, 6.

73. Star, "Craft vs. Commodity," 262.

74. Star, "Craft vs. Commodity," 262–63.

75. Coote et al., "Commerce, Science, and Leisure," 326.

76. Alvey, "The Cinema as Taxidermy," 25.

77. Jones, "Rhinoceros and Chatham Railway," 722.

78. Jones, "Rhinoceros and Chatham Railway," 722.

79. Milgrom, *Still Life*, 95.

80. Coote et al. "Commerce, Science, and Leisure," 322.

81. Poliquin, *The Breathless Zoo*, 67.

82. Milgrom, *Still Life*, 169.

83. Jones, "Rhinoceros and Chatham Railway," 714.

84. Morris, *A History of Taxidermy*, 4.

85. Colvin, "Freeze-Drying Fido," 65.

86. Jones, "Rhinoceros and Chatham Railway," 711; Asma, *Stuffed Animals*, 5.

87. Ferrante Imperato, *Dell'hisotira Naturale de Ferrante Imperato Libri XXVII*, Naples, 1599: Nella stamparia à Porta Reale per Costantino Vitale, https://archive.org/detai ls/gri_c00033125008260594/page/n3/mode/2up, accessed September 6, 2022.

88. Morris, *A History of Taxidermy*, 11.

89. Poliquin, *The Breathless Zoo*, 13.

90. Poliquin, *The Breathless Zoo*, 30.

91. Poliquin, *The Breathless Zoo*, 16.

92. Wakeham, *Taxidermic Signs*, 77.

93. Jones, "Rhinoceros and Chatham Railway," 712, 714.

94. Raymond Williams, *Television: Technology and Cultural Form* (New York: Routledge, 2003), 86–87.

95. John David Rhodes, *Spectacle of Property: The House in American Film* (Minneapolis: University of Minnesota Press, 2017), 24–25. Amelia Hastie proposes a more subversive lineage deriving from early cinema's connections with cabinets of curiosity, identifying a body of work in everyday genres (cookbooks, memoirs, scrapbooks) produced by women in filmmaking as a "cupboard of curiosity": "an interior, usually domestic space over which women often hold sway, with the enclosed items awaiting their necessity, their discovery enabled by what Laura Mulvey calls 'feminist curiosity.'" *Cupboards of Curiosity: Women, Recollection, and Film History* (Durham: Duke University Press, 2007), 2–3.

96. Rhodes, *Spectacle of Property*, 23–24.

97. Tichi, *Electronic Hearth*, 30.

98. Lynn Spigel, *Make Room for TV: Television and the Family Ideal in Postwar America* (Chicago: University of Chicago Press, 1992), 50.

99. Spigel's endnote refers to an advertisement she subsequently mentions, for an Emerson television, in *Better Homes and Gardens*, December 1952, 133. This ad gestures to the idea but does not explicitly label television as the new "family pet." It may be the case that I am simply mistaking a loose reference or characterization for a direct quotation. Nonetheless, I found no explicit references to television as a "family pet" in issues of *Better Homes and Gardens* from 1948 to 1960. Spigel also refers to *House Beautiful* and *American Home*; a full inventory of these magazines was not possible. Perusal of the Ad*Access Project (https://repository.duke.edu/), Duke University's digital repository of advertisements for televisions (among other things) from the era, likewise turned up many images that resonated with the metaphor of TV as pet—but none that explicitly declared it.

Referencing Spigel and Tichi, Gregg Mitman likewise notes that "in the early

1950s, magazines such as *House Beautiful* and *American Home* helped tame this new technology by welcoming television as the newest family member, oftentimes described as 'the family pet.'" He does not provide a bibliographic reference for this slogan. *Reel Nature: America's Romance with Wildlife on Film* (Seattle: University of Washington Press, 2009), 134.

100. Spigel, *Make Room for TV*, 50. The girl and poodle appear as the dominant image in *Better Homes and Gardens*, December 1952, 133. The same image of the duo appears on a smaller set in the periphery of an Emerson advertisement in *Better Homes and Gardens*, April 1953, 185.

101. "New 21″ Admiral: TV Home Theatre in a Cabinet only 28″ Wide!," Admiral advertisement, *Better Homes and Gardens*, March 1952, 29.

102. "Here's the Gift That Sings, Talks, and Lives for Years," Motorola advertisement, *Better Homes and Gardens*, December 1948, 7.

103. Erica Fudge, *Pets* (Stocksfield: Acumen Publishing, 2008), 10.

104. Fudge, *Pets*, 16–17.

105. Fudge, *Pets*, 23.

106. Spigel, "Installing the Television Set," 134.

107. "Those Heavenly Carpets by Lees," Lees Carpets advertisement, *Better Homes and Gardens*, August 1951, 123.

108. "So Distinguished," Emerson advertisement, *Better Homes and Gardens*, June 1951, 129.

109. Elizabeth Hutchinson, *The Indian Craze: Primitivism, Modernism, and Transculturation in American Art, 1890–1915* (Durham: Duke University Press, 2009), 3.

110. Joseph H. Batty, *Practical Taxidermy, and Home Decoration: Together with General Information for Sportsmen* (New York: Orange Judd Co., 1885), 178.

111. Hamera, *Parlor Ponds*, 159.

112. "The Present with a Future," DuMont advertisement, *Better Homes and Gardens*, November 1950, 134.

113. Akira Mizuta Lippit, *Electric Animal: Toward a Rhetoric of Wildlife* (Minneapolis: University of Minnesota Press, 2000), 187.

114. See, for example, "Admiral: Magic Mirror Television," Admiral advertisement, *Better Homes and Gardens*, March 1949, 15.

115. "Which of These Beautiful RCA Victor Television Sets 'Belongs' in *Your* Home?," RCA Victor advertisement, *Better Homes and Gardens*, March 1953, 164–65.

116. "The Winner: Fashion Academy Award," Motorola advertisement, *Better Homes and Gardens*, October 1950, 139.

117. "Motorola TV with Glare Guard," Motorola advertisement, *Better Homes and Gardens*, December 1951, 132.

118. For yet another iteration (perhaps a donkey?), see "Combines TV-Radio-Phonograph with Exciting Price!," Sparton Radio-Television advertisement, 1950, Duke Ad*Access, https://idn.duke.edu/ark:/87924/r4jq0th4v, accessed September 6, 2022.

119. Tichi, *Electronic Hearth*, 18, 23. Frosh also cites Robert Pinsky's poem "To Television," in which the speaker exclaims of the televisual image, "oh strung shell!" "The Face of Television," *Annals of the American Academy of Political and Social Science* 625 (September 2009): 97.

120. Gaston Bachelard, *The Poetics of Space*, trans. Maria Jolas (Boston: Beacon Press, 1994), 105–35.

121. Benjamin, "Work of Art," 223.

122. Rhodes, *Spectacle of Property*, 22.

123. Frosh, "The Face of Television," 97.

124. Tichi, *Electronic Hearth*, 18–19.

125. Spigel, "Installing the Television Set," 35.

126. Paul Cook, "Entertainment in a Box: Domestic Design and the Radiogram and Television," *Music in Art* 35.1–2 (Spring–Fall 2010): 266.

127. Spigel, *Make Room for TV*, 50; Tichi, *Electronic Hearth*, 21.

128. "But One Standard: Quality," Zenith advertisement, *Better Homes and Gardens*, December 1951, 163; "Magic Mirror: Television Optional," Admiral advertisement, *Better Homes and Gardens*, June 1948, 32–33.

129. "Vintage TV Lamps," *Collectors Weekly*, https://www.collectorsweekly.com/lamps/tv, accessed.

130. Tichi, *Electronic Hearth*, 23.

131. Tichi, *Electronic Hearth*, 18.

132. "The Magnificent Magnavox Radio-Phonograph and Television," Magnavox advertisement, *Better Homes and Gardens*, October 1948, 199; "There Is Nothing Finer Than a Stromberg-Carlson," Stromberg-Carlson advertisement, *Better Homes and Gardens*, December 1953, 145.

133. Spigel, "Installing the Television Set," 15.

134. I owe the connection to *All That Heaven Allows* to Cook. Curiously, Cook misquotes the TV salesman as prefacing his spiel with "Here's a window to the world." The slogan is not far from the one he does parrot, "All life's parade at your fingertips." "Entertainment in a Box," 261.

135. Sirk's oeuvre has come to be understood in these terms, in both academic and popular film circles. Sam Adams, "Douglas Sirk," *AV Club*, June 24, 2010, https://www.avclub.com/douglas-sirk-1798220705

136. Spigel, "Installing the Television Set," 17.

137. In one advertisement, Flexalum, a brand of aluminum slats used in venetian blinds, deploys a kitten licking its paw to proclaim that the material "almost cleans itself." "A Venetian Blind Made of Flexalum Almost Cleans Itself," Flexalum advertisement, *Better Homes and Gardens*, June 1949, 168. In another, a girl and puppy playing fetch demonstrate that "dirt bounces off like a ball." "Dirt Bounces Off Like a Ball," Flexalum advertisement, *Better Homes and Gardens*, May 1950, 269.

138. "Window-Side Comfort Costs Little," Thermopane advertisement, *Better Homes and Gardens*, November 1949, 5.

139. Alvey, "The Cinema as Taxidermy," 27.

140. Hamera, *Parlor Ponds*, 38.

141. Hamera, *Parlor Ponds*, 24.

142. Hamera, *Parlor Ponds*, 26.

143. Hamera, *Parlor Ponds*, 27–28. Hamera cites Anne Friedberg, *The Virtual Window: From Alberti to Microsoft* (Cambridge: MIT Press, 2006), 113–14.

144. Paul Gansky, "Frozen Jet Set: Refrigerators, Media Technology, and Postwar Transportation," *Journal of Popular Culture* 48.1 (2015): 73–76.

145. Hutchinson, *The Indian Craze*, 36.

146. "The Biggest Window in the World," DuMont advertisement, Duke Ad*Access, 1944, https://repository.duke.edu/dc/adaccess/TV0448, accessed September 6, 2022.

147. Ella Shohat and Robert Stam, "The Imperial Imaginary," *Unthinking Eurocentrism: Multiculturalism and the Media* (London: Routledge, 1994), 100–136. They refer to "A Line in the Sand," series of three broadcast specials on the Gulf War, ABC, 1990–91, https://vimeo.com/75334504

148. Tichi, *Electronic Hearth*, 31.

149. Helen Adams, "TV Chair—Turns and Travels!," *Better Homes and Gardens*, November 1950, 13.

150. Hamera, *Parlor Ponds*, 13, 39.

151. Stephanie L. Hawkins, *American Iconographic: National Geographic, Global Culture, and the Visual Imagination* (Charlottesville: University of Virginia Press, 2010), 9, 13.

152. Hamera, *Parlor Ponds*, 199.

153. Poliquin, *The Breathless Zoo*, 18.

154. "You'll Be an Armchair Columbus!," DuMont advertisement, 1944, cited in Tichi, *Electronic Hearth*, 15.

155. Frosh, "The Face of Television," 97.

156. Michel Foucault, "Of Other Spaces, Heterotopias," trans. Jay Miskowiec, originally published in French in *Architecture, Mouvement, Continuité* 5 (October 1984): 46–49.

157. Berland, *Virtual Menageries*, 7–8, 20.

158. Chris, *Watching Wildlife*, xi–xii.

159. Chris, *Watching Wildlife*, xii–xiv. The year of the film's release is unavailable, but Chris notes the review as being published in a 1910 issue of *Variety*.

CHAPTER 4

1. This account of the logo's history is drawn from Mike Clark, "The NBC Peacock: The Colorful Story behind a Broadcasting Icon," Big 13: A Historical TV Web Site Dedicated to WTVT, Channel 13, http://www.big13.net/NBC Peacock/NBCPeacock1.htm (accessed January 24, 2020).

2. John Berger, "Why Look at Animals," *About Looking* (New York: Vintage, 1992), 26.

3. Akira Mizuta Lippit, *Electric Animal: Toward a Rhetoric of Wildlife* (Minneapolis: University of Minnesota Press, 2000), 187.

4. Jody Berland, *Virtual Menageries: Animals as Mediators in Network Cultures* (Cambridge: MIT Press, 2019), 101–2.

5. Lippit, *Electric Animal*, 187.

6. Thanks to the participants in "Color Transmissions: Aesthetics, Identity, and Mid-Century Television" panel at the 2019 meeting of the Society of Cinema and Media Studies, particularly Susan Murray and Kirsty Dootson, for spurring my thinking on the connections between color as "race and hue" in television.

7. Jennifer Jue-Steuck, "John J. Graham: Behind the Peacock's Plumage," *Design*

Issues 19.4 (2003): 91–92. NBC art director John J. Graham designed the logo, reportedly after his wife suggested the peacock as color mascot.

8. Disney produced fourteen films in its *True-Life Adventures* between 1948 and 1960, some of which were broadcast on ABC as *Disneyland / Walt Disney Presents* (1954–61) and, later, on NBC (1961–65). Cynthia Chris, *Watching Wildlife* (Minneapolis: University of Minnesota Press, 2006), 54.

9. Susan Murray, *Bright Signals: A History of Color Television* (Durham: Duke University Press, 2018), 205. Murray refers specifically to Mutual of Omaha's *Wild Kingdom* (NBC, 1963–71), *National Geographic Specials* (CBS, 1965–69), *The World of Jacques Cousteau* (CBS, 1966–68), and *The Undersea World of Jacques Cousteau* (ABC, 1968–75).

10. Murray, *Bright Signals*, 211.

11. "Short Takes: Living Colour Band Sues Fox," *LA Times*, May 8, 1990, https://www.latimes.com/archives/la-xpm-1990-05-08-ca-455-story.html

12. David Peisner, *Homey Don't Play That! The Story of "In Living Color" and the Black Comedy Revolution* (New York: Simon & Schuster, 2018), 100–102.

13. *Oxford English Dictionary Online*, s.v. "coloured | colored (*adj.* and *n.*)," September 2021, https://www-oed-com.proxy01.its.virginia.edu/view/Entry/36607?rskey=OC6Les&result=2&isAdvanced=false#eid. The *OED Online* notes in this entry that "*coloured* was adopted in the United States by emancipated slaves as a term of racial pride after the end of the American Civil War. It was rapidly replaced from the late 1960s as a self-designation by *black* . . . and later by *African-American*. . . . In Britain it was the accepted term for black, Asian, or mixed-race people until the 1960s."

14. Raymond Williams, *Television: Technology and Cultural Form* (New York: Routledge, 2003 [1974]), 106.

15. Williams, *Television*, 118.

16. Williams, *Television*, 114, 120.

17. Williams, *Television*, 105–6.

18. Brett Mills, *Animals on Television: The Cultural Making of the Non-human* (London: Palgrave-Macmillan, 2018), 10.

19. Mills, *Animals on Television*, 11.

20. Mills, *Animals on Television*, 189–91.

21. Mitman, Bousé, and Chris contextualize their audiovisual objects more precisely within the genres of "nature" *or* "wildlife"; for my purposes, I follow Nicole Seymour's adoption of "nature/wildlife programming" given that it is "more inclusive." Nicole Seymour, *Bad Environmentalism: Irony and Irreverence in the Environmental Age* (Minneapolis: University of Minnesota Press, 2018), 247 n. 3.

22. Chris, *Watching Wildlife*, xxi.

23. Derek Bousé, *Wildlife Films* (Philadelphia: University of Pennsylvania Press, 2000), 4.

24. Gregg Mitman, *Reel Nature: America's Romance with Wildlife on Film* (Cambridge: Harvard University Press, 1999), 3.

25. Mitman, *Reel Nature*, 206.

26. Mills, *Animals on Television*, 84. Mills draws on Helen Wheatley's provocative consideration of the distinctive expression of spectacle in "elevated" TV programming in *Spectacular Television: Exploring Televisual Pleasure* (London: I.B. Tauris, 2016), 898.

27. Lauren Burton and Francis L. Collins, "Mediated Animal Geographies: Symbolism, Manipulation and the Imaginary in Advertising," *Society and Cultural Geography* 16.3 (2015): 276.

28. Rachel Poliquin, *The Breathless Zoo: Taxidermy and the Cultures of Longing* (University Park: Pennsylvania State University Press, 2013), 6.

29. Rachel Poliquin, "Balto the Dog," *The Afterlives of Animals*, ed. Samuel J. M. M. Alberti (Charlottesville: University of Virginia Press, 2011), 96.

30. Melissa Milgrom, *Still Life: Adventures in Taxidermy* (New York: Mariner Books, 2011), 123.

31. Garry Marvin, "Enlivened through Memory: Hunters and Hunting Trophies," *The Afterlives of Animals*, ed. Samuel J. M. M. Alberti (Charlottesville: University of Virginia Press, 2011), 203.

32. Paul Frosh, "The Face of Television," *Annals of the American Academy of Political and Social Science* 625.1 (2009): 88.

33. Frosh, "The Face of Television," 87, 99–100.

34. Frosh, "The Face of Television," 93.

35. Salomé Aguilera Skvirsky, *The Process Genre: Cinema and the Aesthetics of Labor* (Durham: Duke University Press, 2020), 26.

36. Frosh, "The Face of Television," 93.

37. Marvin, "Enlivened through Memory," 210.

38. Karen Jones, "The Rhinoceros and the Chatham Railway: Taxidermy and the Production of Animal Presence in the 'Great Indoors,'" *History* 101 (December 2016): 728.

39. Milgrom, *Still Life*, 81.

40. Wakeham adds that Charles Darwin's *Expression of the Emotions in Men and Animals* (1872) was also important in "challeng[ing taxidermy] to enhance its realist techniques." An intensified concern with realistically capturing the emotive expressivity of taxidermic mounts, particularly in their faces, connects suggestively with the prominence of the close-up in early television. *Taxidermic Signs: Reconstructing Aboriginality* (Minneapolis: University of Minnesota Press, 2008), 11.

41. Karen Jacobs, Chantal Knowles, and Chris Wingfield, *Trophies, Relics, and Curios? Missionary Heritage from Africa and the Pacific* (Leiden: Sidestone Press, 2015).

42. *Oxford English Dictionary Online*, s.v. "trophy (*n.*)," September 2021, https://www-oed-com.proxy01.its.virginia.edu/view/Entry/206698?rskey=BNngQi&result=1&isAdvanced=false#eid

43. *Oxford English Dictionary Online*, s.v. "*trope* (*n.*)," September 2021, https://www-oed-com.proxy01.its.virginia.edu/view/Entry/206679?rskey=8KqEuU&result=1&isAdvanced=false#eid

44. Sarah Juliet Lauro and Caroline Hovanec, "Speaking Animals: Fables of Resistance in *Get Out, Sorry to Bother You*, and *Atlanta*," *Black Camera* 13.2 (Spring 2022): 115–38.

45. Anne DuCille, *Technicolored: Reflections on Race in the Time of TV* (Durham: Duke University Press, 2018), 59.

46. Danielle Fuentes Morgan, *Laughing to Keep from Dying: African American Satire in the Twenty-First Century* (Urbana: University of Illinois Press, 2020).

47. Glenda Carpio, "Alligator Man," *ASAP Journal* 4.1 ("Black One Shot"), July 16, 2018, https://asapjournal.com/b-o-s-4-1-alligator-man-glenda-r-carpio/

48. Lindgren Johnson, *Race Matters, Animal Matters: Fugitive Humanism in African America, 1840–1930* (Oxfordshire, UK: Routledge, 2017), 25.

49. Bénédicte Boisseron, *Afro-Dog: Blackness and the Animal Question* (New York: Columbia University Press, 2018), xx. See also Colin Dayan for an examination of the correspondences between humans and animals, especially dogs, enacted in and by the legal system. *The Law Is a White Dog: How Legal Rituals Make and Unmake Persons* (Princeton: Princeton University Press, 2011).

50. Joshua Bennett, "Buck Theory," *Black Scholar* 49.2 (2019): 27–37.

51. Jones, "Rhinoceros and Chatham Railway," 722.

52. Steven J. Mexal, "The Roots of 'Wilding': Black Literary Naturalism, the Language of Wilderness, and Hip Hop in the Central Park Jogger Rape," *African American Review* 46.1 (Spring 2013): 102.

53. Mexal, "The Roots of Wilding," 107–8.

54. Mexal, "The Roots of Wilding," 107.

55. Scott N. Markley, Taylor J. Hafley, Coleman A. Allums, Steven R. Holloway, and Hee Cheol Chung, "The Limits of Home Ownership: Racial Capitalism, Black Wealth, and the Appreciation Gap in Atlanta," *International Journal of Urban and Region Research* 22.2 (2020): 316.

56. Charles Rutheiser, *Imagineering Atlanta: The Politics of Place in the City of Dreams* (New York: Verso, 1996), 4.

57. Rutheiser, *Imagineering Atlanta*, 4.

58. Boisseron, *Afro-Dog*, 82–83.

59. Terry W. Johnson, "Out My Backdoor: Winter Robins," Georgia Department of Natural Resources, December 2015, https://georgiawildlife.com/out-my-backdoor-winter-robins

60. Boisseron, *Afro-Dog*, xxiii.

61. Carpio, "Alligator Man."

62. Carpio, "Alligator Man."

63. Cerise L. Glenn and Landra J. Cunningham, "The Power of Black Magic: The Magical Negro and White Salvation in Film," *Journal of Black Studies* 40.2 (November 2009): 138.

64. Donald Bogle, *Toms, Coons, Mulattoes, Mammies and Bucks: An Interpretive History of Blacks in American Films*, 5th ed. (London: Bloomsbury, 2016), 10, 210.

65. Bogle, *Toms*, 10, 219.

66. Bennett, "Buck Theory," 28, 31.

67. Dan Whisenhunt, "Origins of Buckhead Name Revisited," *Reporter Newspapers & Atlanta Intown*, February 5, 2013, https://reporternewspapers.net/2013/02/05/origins-of-buckhead-name-revisited/

68. "Buckhead City Welcomes You," Buckhead City Exploratory Committee, 2022, https://www.becnow.com/

69. Miles Bryan, "How History Made This Atlanta Neighborhood a Secession Battleground," *Vox*, February 16, 2022, https://www.vox.com/2022/2/16/22937599/buckhead-atlanta-today-explained-noel-king

70. Sierriana Terry, "Black Atlanta: Musical Counternarratives of 'Authentic' Blackness in Donald Glover's *Atlanta*," masters thesis, University of North Carolina, 2018, 67, https://doi.org/10.17615/6tbn-qf37

71. Greg Cwik, "Donald Glover Wants *Atlanta* to Be '*Twin Peaks* with Rappers,'" *Vulture*, January 16, 2016, https://www.vulture.com/2016/01/donald-glover-on-doing-twin-peaks-with-rappers.html

72. Frosh, "The Face of Television," 99–100.

73. Mexal, "'The Roots of Wilding,'" 107–8.

74. Bennett, "Buck Theory," 31.

75. Bennett, "Buck Theory," 30.

76. Bennett, "Buck Theory," 33.

77. Tom Tyler, "Cows, Clicks, Ciphers, and Satire," *NECSUS: European Journal of Media Studies* 4.1 (2015): 202.

CONCLUSION

1. *Late Night with Seth Meyers*, "FDA Warns People Not to Use Horse De-Wormer Ivermectin to Treat COVID: A Closer Look," August 26, 2021, https://www.youtube.com/watch?v=VwntyCN7lGM

2. Chipotle Mexican Grill, "A Future Begins: A Short Film Supporting Farmers," November 16, 2021, https://www.youtube.com/watch?v=HnwzRmqbWwE

3. "Defendant: Ahmaud Arbery 'Trapped Like a Rat' before Slaying," *NBC News*, November 10, 2021, https://www.nbcnews.com/news/us-news/defendant-ahmaud-arbery-trapped-rat-slaying-n1283687

4. For a critique of the limits of each of these corporate and ultimately financially motivated gestures, see Brandy Monk-Peyton, "Tele-Visionary Blackness," Public Books, June 26, 2020, https://www.publicbooks.org/tele-visionary-blackness/; Laurie Oulette, "Cancelling *Cops*," Quorum, *Film Quarterly*, June 17, 2020, https://filmquarterly.org/2020/06/17/cancelling-cops/

5. Paul Gansky, "Frozen Jet Set: Refrigerators, Media Technology, and Postwar Transportation," *Journal of Popular Culture* 48.1 (2015): 74.

6. Nancy Keenan, Teri Slavik-Tsuyuki, and Belinda Sward, America At Home Survey, hosted by Gazelle Global Research, responses collected in April 2020 and October 2020, https://americaathomestudy.com/

7. Michelle Lerner, "A Home of the Future, Shaped by the Coronavirus Pandemic," *Washington Post*, August 19, 2021, https://www.washingtonpost.com/realestate/a-home-of-the-future-shaped-by-the-coronavirus-pandemic/2021/08/18/5e3a2032-d426-11eb-ae54-515e2f63d37d_story.html

8. Tressie McMillan Cottom, "A Home Built for the Next Pandemic," *New York Times*, October 21, 2021, https://www.nytimes.com/2021/10/15/opinion/covid-home-concept.html

9. Jacques Derrida, "The Animal That Therefore I Am (More to Follow)," trans. David Wills, *Critical Inquiry* 28 (Winter 2002): 395.

10. Derrida, "Animal I Am," 395.

FILMOGRAPHY

1. Kathleen M. Peplin provides a succinct history of the AHA's oversight as it evolved alongside the Motion Picture Production Code (the Hays code). "Construction and Constraint: The Animal Body and Constructions of Power in Motion Pictures" (PhD diss., University of Michigan, 2016), 86.

See also I-Lien Tsay, "'No Animals Were Harmed': The Rhetoric of the Animal Actor and Animal Rights" (PhD diss., University of California, Irvine, 2002). For the field-defining theoretical reflection on the injunction against harming animals during film production, see Akira Mizuta Lippit, "The Death of an Animal," *Film Quarterly* 56.1 (2002): 9–22.

2. Nicole Shukin, *Animal Capital: Rendering Life in Biopolitical Times* (Minneapolis: University of Minnesota Press, 2009), 104–14.

3. ProSound Effects, "Gelatin Squishing / Sound Design and Foley, Plops, Squishes, Gelatin, Jello, Squish, Squishy, Slime," YouTube video, https://www.youtube.com/watch?v=05TCnTGWXGM. See also Philip Rodrigues Singer, "Art of Foley," http://www.marblehead.net/foley/specifics.html

4. Vivian Sobchack, *Carnal Thoughts: Embodiment and Moving Image Culture* (Oakland: University of California Press, 2004), 247.

5. Cited in Susan Murray, *Bright Signals: A History of Color Television* (Durham: Duke University Press, 2018), 207–8. Murray cites Gerald Thompson, interview by Christopher Parsons, *Wild Film History*, March 9, 1998, www.wildfilmhistory.org/oh/21/Gerald+Thompson.html

6. Nawaat, "Barack Obama Swats Fly: 'I Got the Sucker,'" CNBC interview, You-Tube video, https://www.youtube.com/watch?v=Qfv2c0wTZg4

7. Michael Lawrence, "Haneke's Stable: The Death of an Animal and the Figuration of the Human," *On Michael Haneke*, ed. Brian Price and John David Rhodes (Detroit: Wayne State University Press, 2010), 79–80 n. 7.

8. J. Keri Cronin details an unnamed cinematic text—something between "footage" and "clips" and a finished film that, according to Arthur W. Moss, amounted to the "'first time the ciné-camera had been used in the fight against [animal] cruelty'"—that documented the British export of live horses for slaughter in Europe. The project was conceived and overseen by activist Ada Cole, with funding and support from the RSPCA, which hired Pathé to produce. The footage was shot clandestinely, and while sections of it were screened in several cinemas in and around London in 1914, it was deemed too graphic for wider circulation. *Art for Animals: Visual Culture and Animal Advocacy, 1870–1914* (College Park: Pennsylvania State University Press, 2018), 77.

Index

Note: All films are indexed by their English titles. Films that appear only in the filmography are not included in the index. Italicized page numbers indicate images.

Sunless, 25, 31
supplementary logic, 23, 28–29, 37–42, 64, 74–75, 96, 124
surreal aesthetic qualities, 18–19, 136, 145, 150
Swift and Co., 39, 41–43, 49–50

"Taking the Mystery Out of Pork Production," 49–51, 57, 68
Tang, Pao-Chen, 20
Target (store), 12, 14
taste. *See* distinction, class-based forms of
taxidermy: authenticity of, 93–94, 97, 133; connections with television, 8–9, 82–88; etymology, 92; faux, 82, 92; films about, 175n1; industrial scale of, 83–84, 98; liveness of, 83, 151; mount and mounting, 82, 177n46; ontology of, 97; resistance to automation, 97–98; semiotics of, 90, 93–94; use of in film, 96. *See also* dioramas; indexicality of taxidermy; trophies, hunting
taxonomic structure, 57–58, 100–101, 128, 131
television: being alone, together, quality of, 4, 105, 117; as box, container, or shell, 109–11; color, 9, 83, 123–27, 139–40, 151; contingent nature of, 1, 105; flow, 8–9, 27, 33, 101, 125, 127–29, 131, 140, 145, 157; intimacy of viewing experience, 1, 2, 4, 130–31; lamps, 112; liveness of, 4, 83, 105–6; as mass medium, 83, 111, 116, 140; ontology of, 125; placement in home, 85–86, 105; post-network era of, 121, 123–24, 139; seriality, 125, 141–42, 145–47, 152; television sets, 92, 106–13, 125, 132, 138; as window to the world, 90, 101–2, 113–20. *See also* taxidermy: connections with television and taxidermy: television as family pet
Terry, Sierrianna, 149
The Texas Chainsaw Massacre, 69
thingification, 16–19, 29. *See also* fragmentation of animal bodies
This Is Hormel, 8, 53–61, 103
thresholds, 59, 61, 141, 146
Tichi, Cecilia, 9, 85–86, 90, 102, 109–20 *passim*, 167n30
Tiger King, 2, 154
to-be-looked-at-ness, 4, 89, 91–92, 102, 117, 145
Top of the Lake, 79

Torres, Sasha, 127
tours: of country houses, 8; definition of, 6; filmic tours of slaughterhouses, 13, 50, 59, 60; filmic tours of zoos, 121; guides, 11, 41–43, 65, 69; of homes in reality TV, 77–78, 102; Swift's *Visitors Reference Book*, 41–42, 50, 172n90; touristic media, 5–6, 9–10, 113, 119, 140; tourist's pose, 95; of slaughterhouses, 8, 10, 13, 15, 37–43, 50
traffic, 140–47
trains and train cars. *See* railroads
transparency, 6, 8, 18, 43, 50, 88, 113–19, 140. *See also* glass
Trial & Error, 79
trophies, hunting: 84, 89, 95, 99, 131–39, 142–52; etymology of, 134; mounted in homes, 77–82, 85, 91, 95, 99, *137*; mounted in museums, 95, 98; Nanook (Allakariallak) as trophy, 89
True Detective, 79
Trump, Donald, 3
Tsay, I-Lien, 187n1
Tuan, Yi-Fu, 84, 103–5
Twin Peaks, 79, 149–50
Tyler, Tom, 152

uncanny, 96, 144
undercover filmmaking, 21, 22, 46, 47, 49, 51–53
The Undersea World of Jacques Cousteau, 88

Vernalis, Carol, 171n54
Vertov, Dziga, 7, 15–18, 23, 168n5, 168n15
Vialles, Noëlie, 15, 17, 23, 26, 36–37
viewing habits and practices, 111; during COVID-19 pandemic, 1–5, 153–57, 165n1; delayed viewing, 26; pausing images, 27; reviewing, rewinding, and replaying film and television, 7–8, 15, 23, 26–27, 89, 123; pensive and possessive spectatorship, 26–27, 73
violence, police, 3–4, 134–35, 154; racial, 11, 139, 153–57
viscera: 11, 17–18, 37, 71, 91, 92, *139*, 141, 146–51; visceral reactions, 48, 69

Wakeham, Pauline, 90, 97, 101
Waldrop, Cory, 81, 134–35
Walker, Janet, 73
Ward's Natural Science Establishment, 80, 98, 133

Wentworth, Kara, 13, 35–36
Wheatley, Helen, 131
White, Mimi, 80
whiteness, 41–42, 77–79, 81–82, 135, 140–43, 149, 150, 155
wilding, 83–85, 105, 142, 151, 176n19
Williams, Linda, 48, 70–74
Williams, Raymond, 101, 127–29, 132, 134, 145

Wiseman, Frederick, 6, 19, 24, 53–54
wonder, 6, 11, 16–17, 26, 52, 55, 61
wonder cabinets. *See* curiosity cabinets
Wonder Showzen, 69

YouTube, 27, 160

zoos, 2, 23, 86–88, 121, 131, 145. *See also* filmic tours of zoos